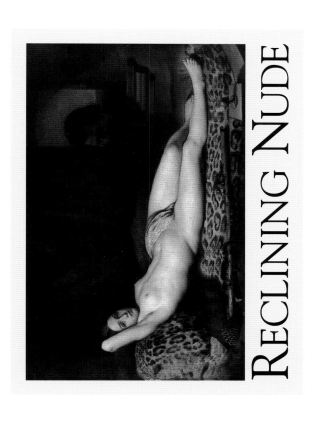

RECLINING NUDE

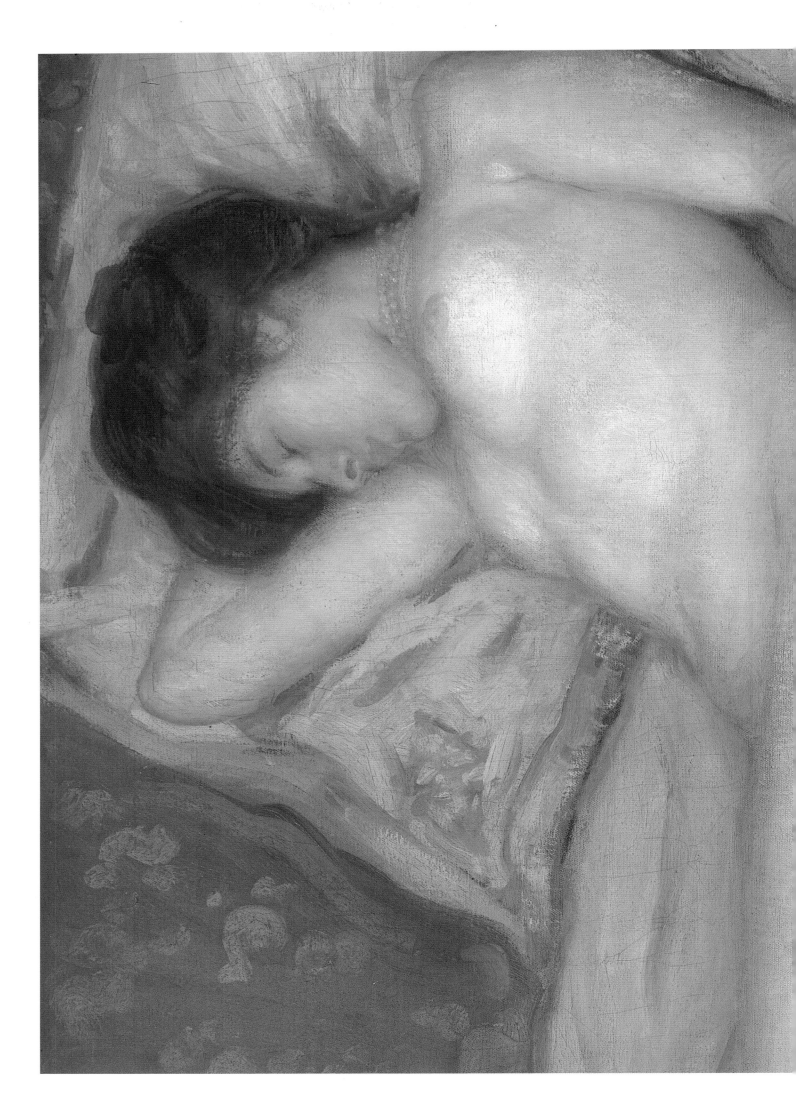

RECLINING NUDE

Lidia Guibert Ferrara

Introduction by Frances Borzello

Thames & Hudson

To my mother, Rita Guibert
and to my husband, Corrado Serra

First published in the United Kingdom in 2002 by Thames & Hudson Ltd,
181A High Holborn, London WC1V 7QX
www.thamesandhudson.com

© 2002 Thames & Hudson Ltd, London
Introduction © 2002 Frances Borzello

British Library Cataloguing-in-Publication Data
A catalogue record for this book is available from the British Library

ISBN 0-500-23797-2

Printed and bound in China by CS Graphics

CONTENTS

INTRODUCTION
Frances Borzello

The words 'reclining nude' do more than describe a popular subject of fine art. They possess the power to conjure up the image of an artist at work, of a daringly bohemian way of life, of spectators variously scandalized by or appreciative of the subject on the canvas. Even more than the categories of still life, landscape or portraiture, the reclining nude is shorthand for the world of art, a world in which the artist is predominantly male and the nude is always female.

In fact, the female reclining nude is a recent arrival in the history of art. In the classical world, the fountainhead of Western art, it was the beauty of the standing male nude that signified moral perfection. The male nudes who people the walls of art galleries carry on the classical tradition of the standing male nude as the expression of virility. Samson shown upright and active is a hero; lying supine, the victim of Delilah's wiles, he is unmanned. The most famous reclining male nude in Western art is the dead Jesus, cradled by his mother like a child.

With the exception of the standing statues of Venus, goddess of love, carved with her genitals modestly covered by her hand, the Greeks were not interested in the nude female body, seeing women as ill-proportioned creatures who could not be made to fit into the pattern of male perfection. The classical hostility to the female was taken over by Judaism and Christianity, with Eve inheriting Pandora's role as the source of all evils and female bodies seen as sacks of sin which oozed and leaked. Despite rare early sightings, a maenad on the side of a classical sarcophagus, an Eve reclining awkwardly on a medieval church, the reclining female nude is a Renaissance invention, a product of the Venetian painter Giorgione.

The figure that launched a thousand reclining nudes was first seen in all her glory on a canvas measuring 5 x 3 feet in the home of the Venetian intellectual Gerolamo Marcello, painted perhaps for his marriage in 1507. Its appearance at this time celebrated a humanist way of thought, one that honoured the senses instead of attempting to conquer them as the medieval world had done.

Although there are not painted predecessors for Giorgione's nude, there are hundreds of successors who fall into line behind her. In no way are these reclining nudes homogeneous. They are fine art's version of music's variations on a theme. They display the front of their body, the back of their body. They look at the spectator, they ignore the spectator, they sleep oblivious to the spectator's gaze. They are voluptuous, they are slim. Sometimes they lie in a landscape, their hummocks and hollows echoing nature itself, and sometimes they rest indoors, as luxuriously displayed as the costly fabrics on which they lie. Very few are completely naked. They wear a necklace, a bracelet, a hat. And they have hair. Not pubic hair but hair on their head, curling, flowing and as wayward and beautiful as the feminine ideal itself.

The reclining nude is never a picture of reality. It is an artistic genre in which the live model is transformed into a carrier of meanings: she becomes nature, or vice, or a figure from mythology. It is this artistic category, 'reclining nude', which distances the nude from its embarrassing links with intimacy and makes it suitable for public consumption. Despite this, some nudes escape from the conventions of high art and allow a sexual element to intrude. Penetration is suggested with Danae drenched in a shower of the coins which are actually a disguise for Zeus, and famously, through light, by Balthus. A faint odour of lesbianism, masochism and sadism emanates from the polished bodies and sinuous contortions of Ingres's houris. The hand that protects a woman's modesty occasionally suggests more private pleasures. Genitals appear with increasing boldness from the end of the nineteenth century, sometimes transposed to the folds of the surrounding sheets.

It is fifty years since Kenneth Clark pointed out that while nakedness is you and I when we step out of a bath, the nude is an artistic category, cosmeticized and accessorized for the viewer. It is thirty years since John Berger took the lid off the complexities of the relationship between the spectator and the reclining nude: 'Men of state, of business, discussed under paintings like this. When one of them felt he had been outwitted, he looked up for consolation. What he saw reminded him that he was a man.' The growth of art history as an academic discipline in the last four decades has added thousands of words about the body, the nude, the role of the reclining nude in defining the maleness of art and its artists. Meanwhile, the object of them all lies peacefully, the focus of the historians' theories, the artists' styles and the spectators' fascination.

AUTHOR'S NOTE
Lidia Guibert Ferrara

This book is a collection of paintings of reclining female nudes as portrayed from the fifteenth century to the present. It does not represent an art historian's selection, but rather a personal point of view. I started collecting these images some years ago in Italy, beginning with Titian and Giorgione. Being a graphic designer and a product of New York in the late 1960s, I was mainly interested in twentieth-century abstract art in its purest form. My views about women were those of the contemporary woman in the Western world and, more specifically, in New York. Originally, I looked at the Old Master paintings of reclining nudes not so much for their formal artistic beauty but for the artist's perception and portrayal of women, particularly when reclining. As time went on, and influenced by my life in Italy, its art history and pictorial traditions, I began to find these images genuinely beautiful, sensual and meaningful. At that point I became interested in collecting representations of reclining nudes whenever I came across them in books and museums around the world.

It is fascinating to notice not only the similarities of the painters' approach to the subject but also the change and evolution of these images through the centuries. This is a subject that had been an obsession for artists in all periods, including those who did not paint nudes. With time, it has also become mine.

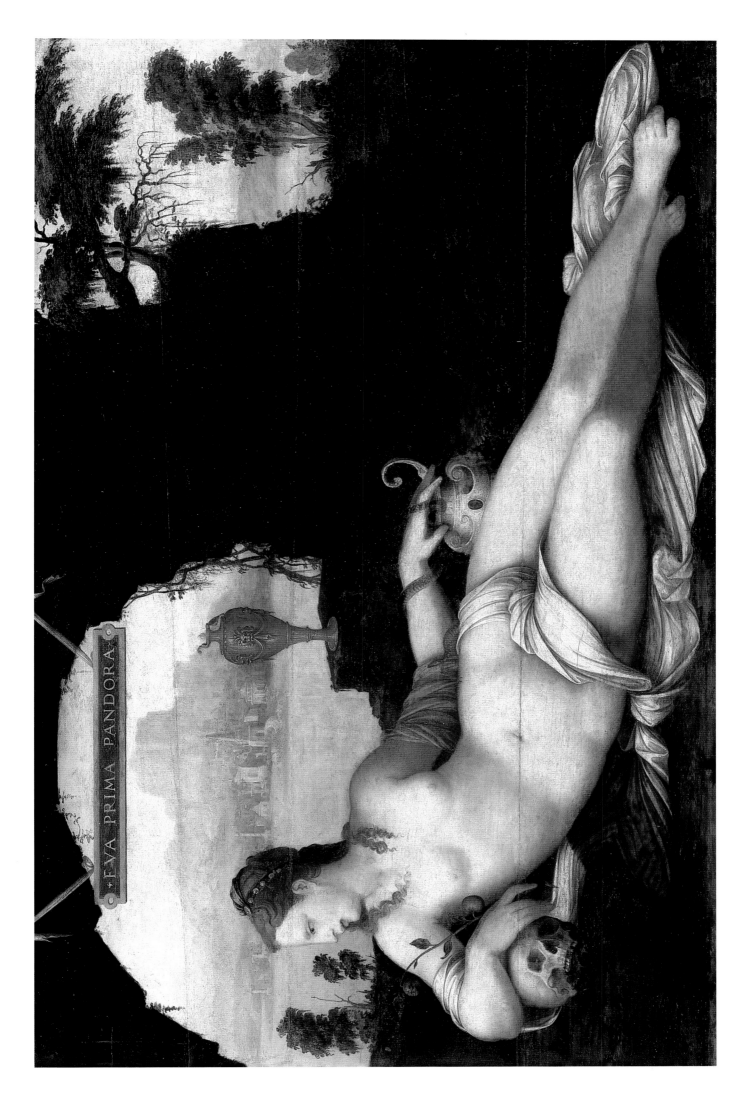

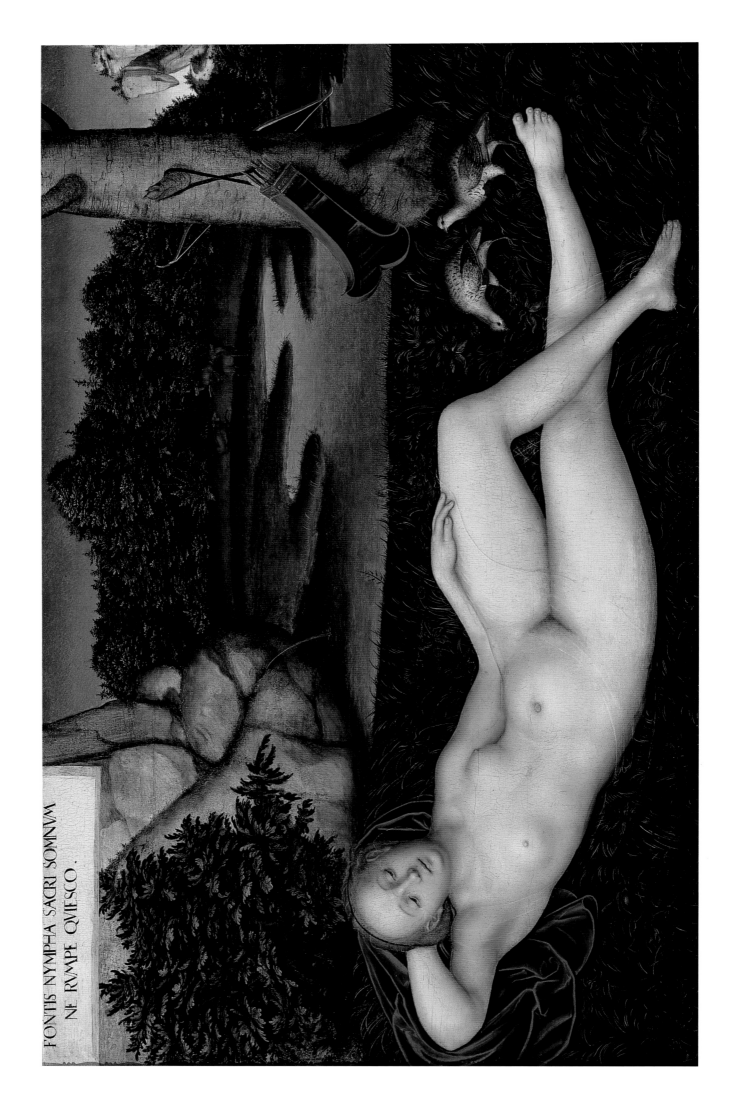

FONTIS NYMPHA SACRI SOMNVM NE RVMPE QVIESCO.

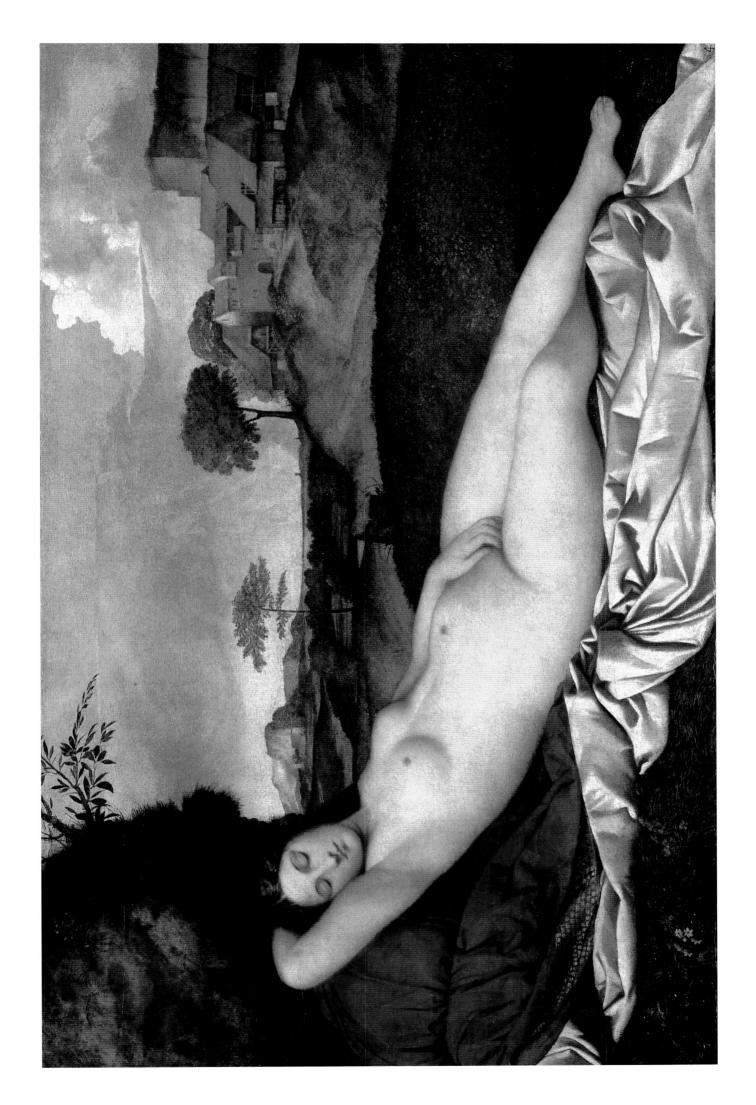

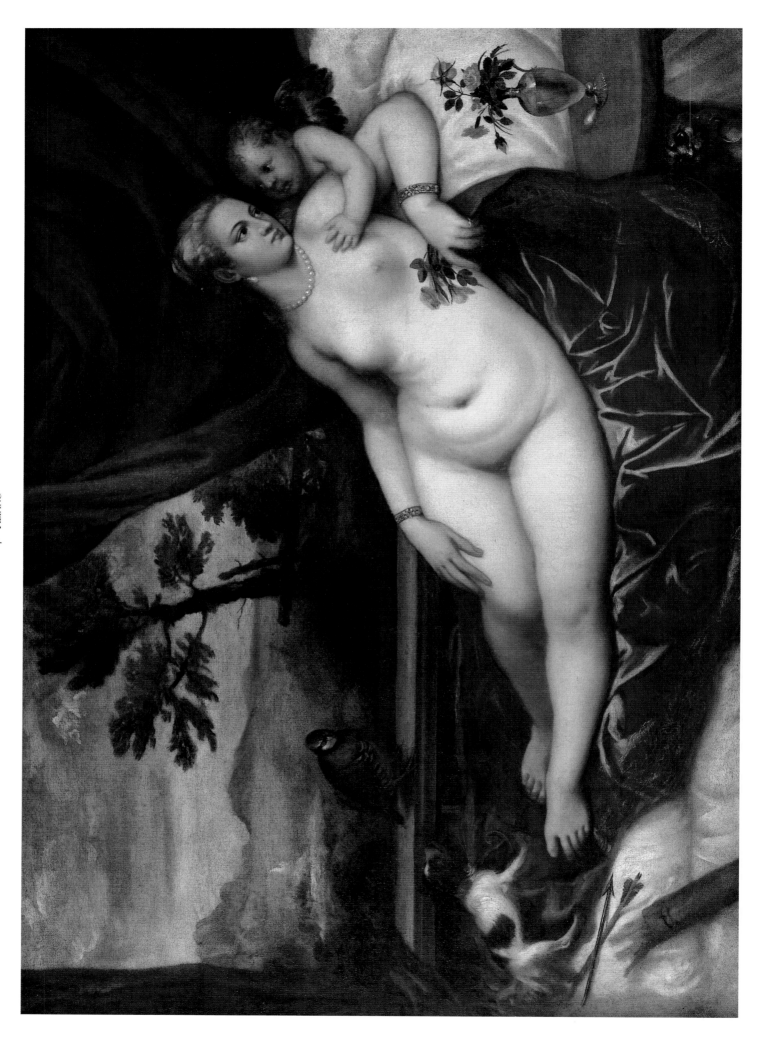

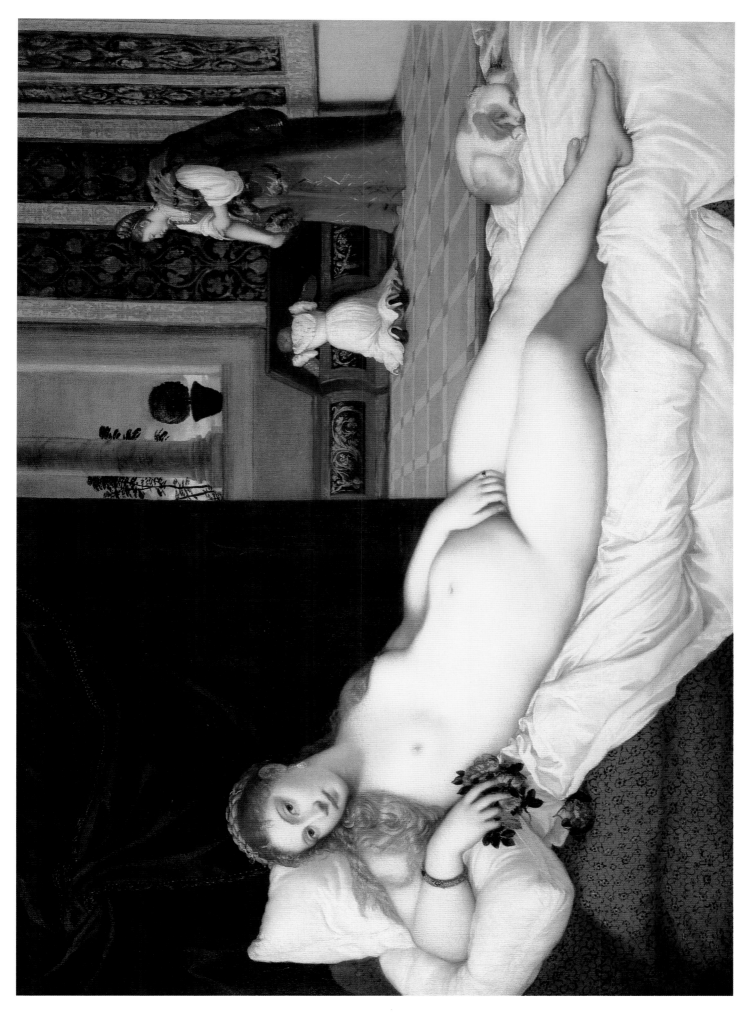

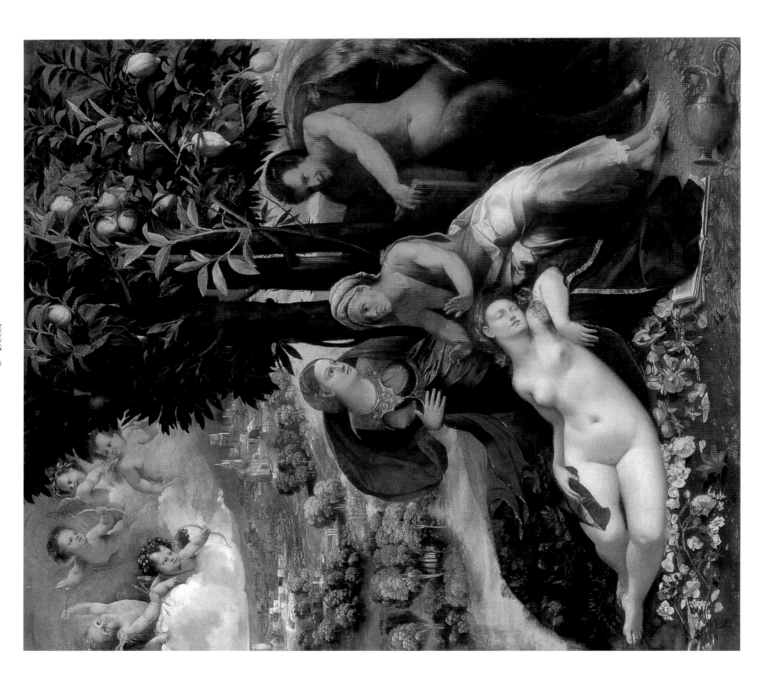

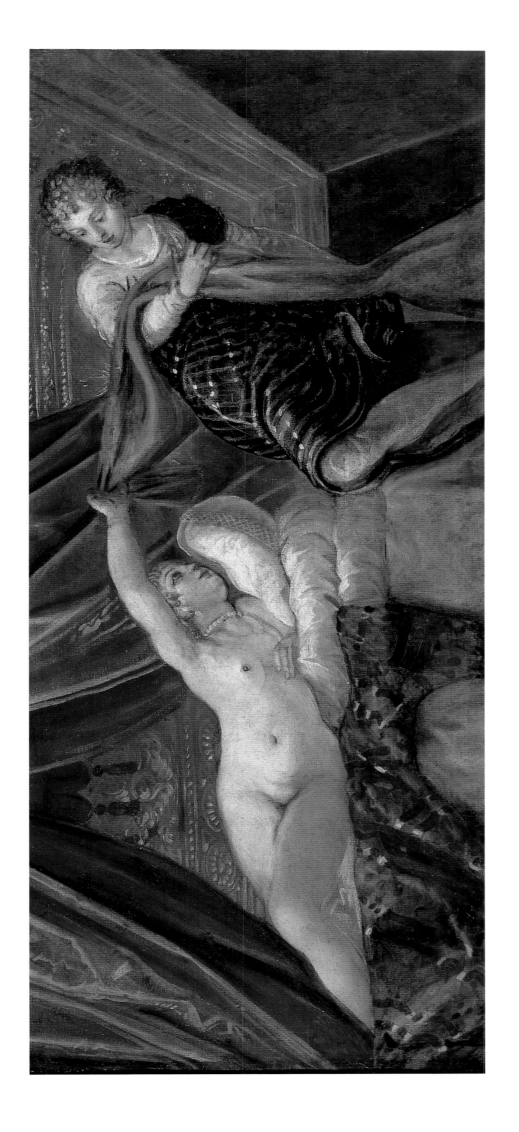

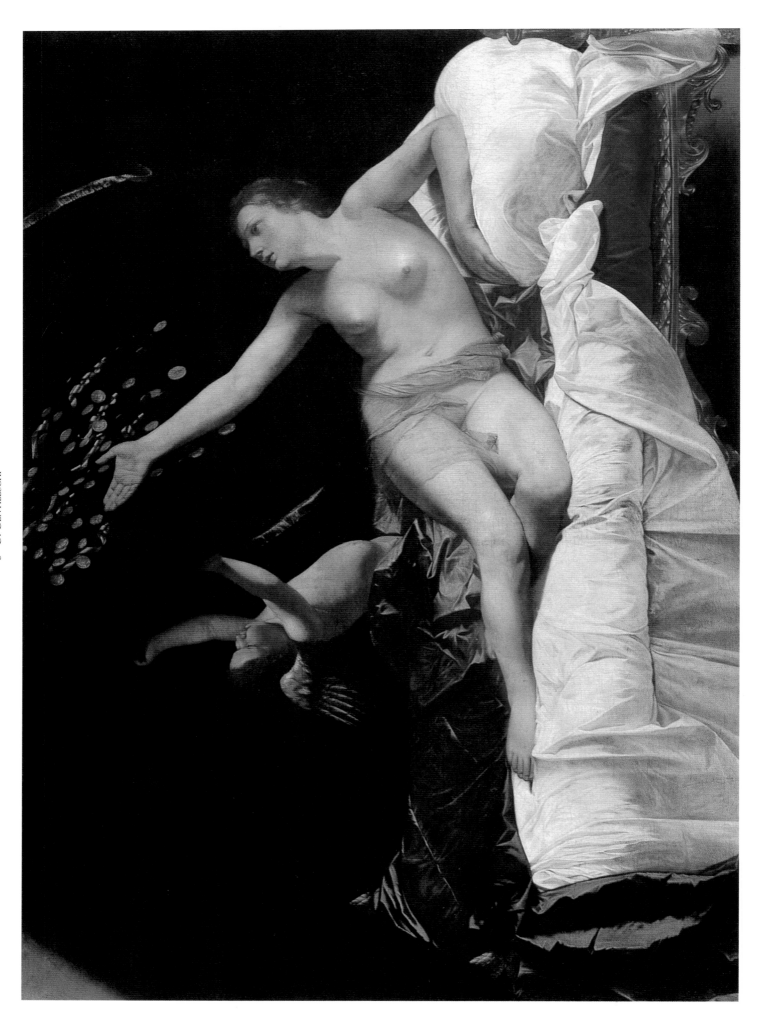

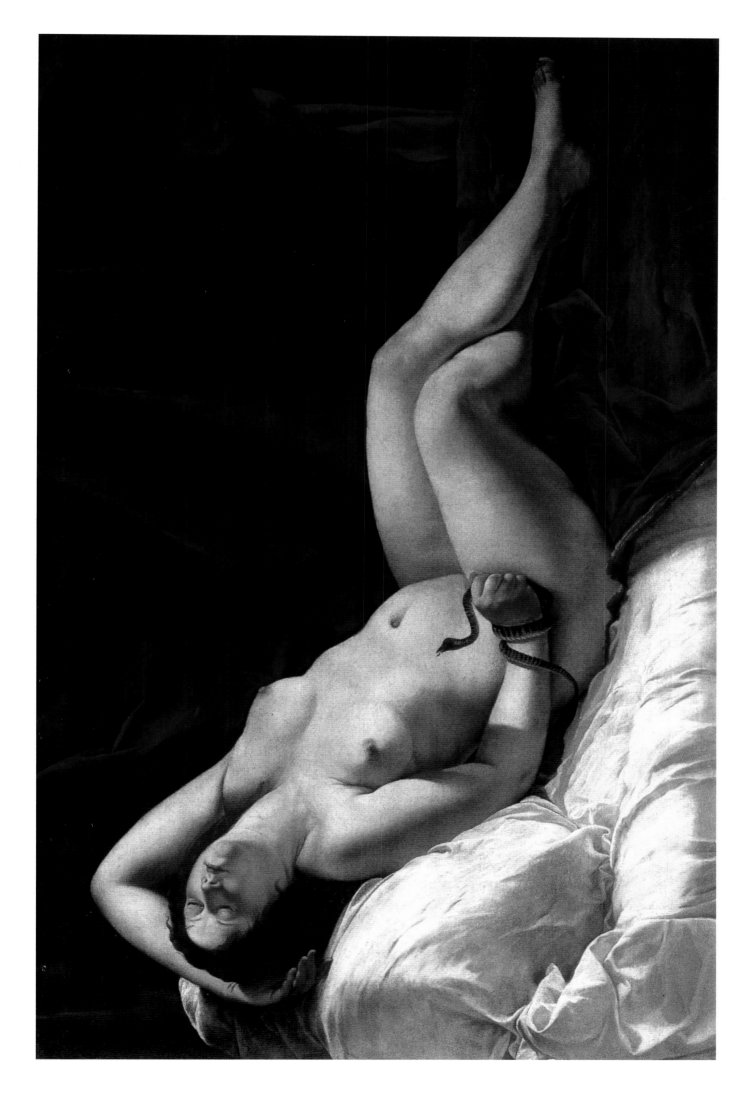

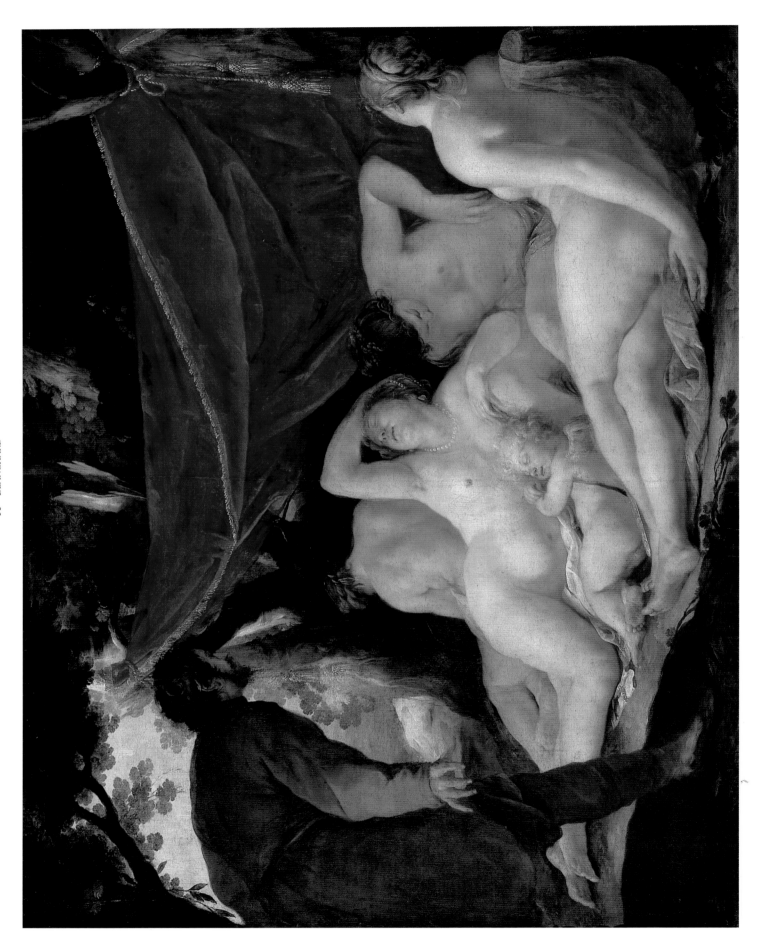

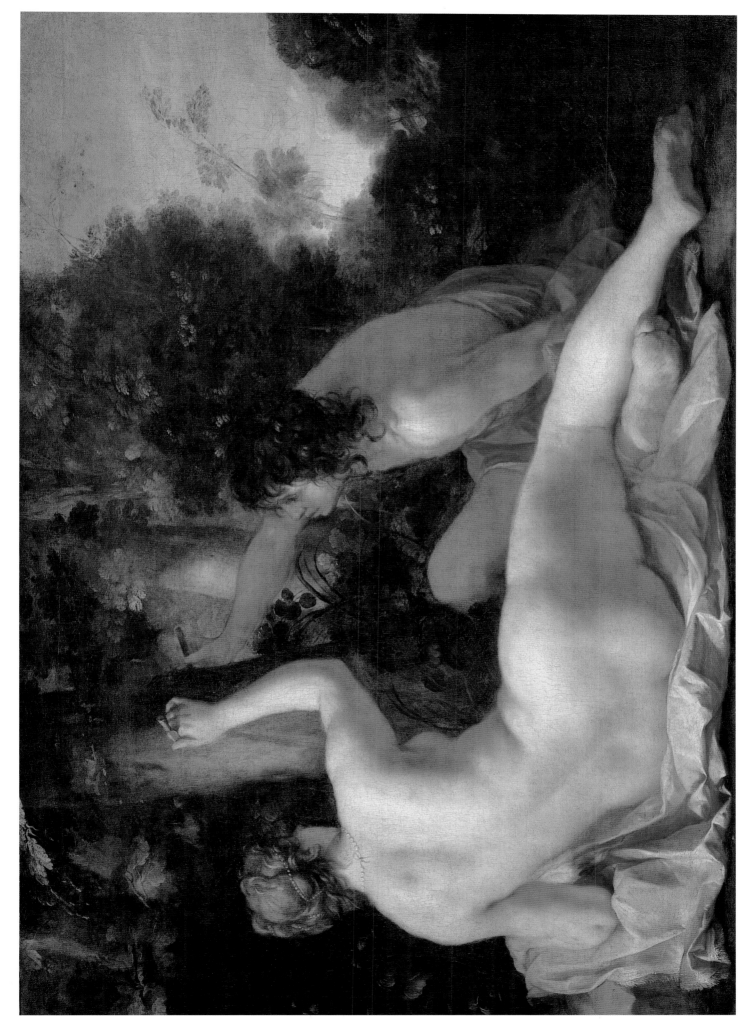

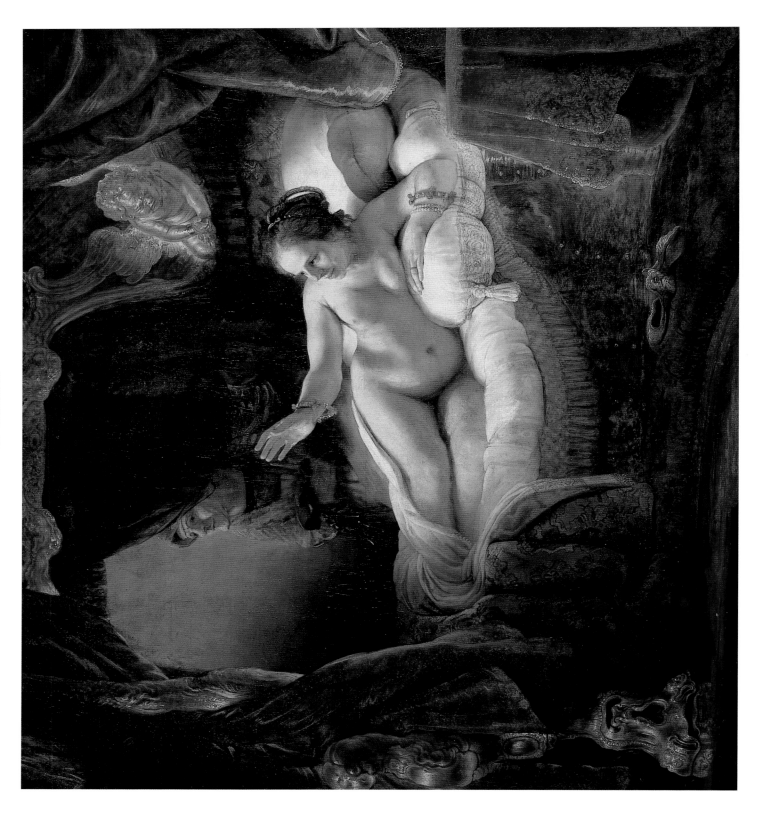

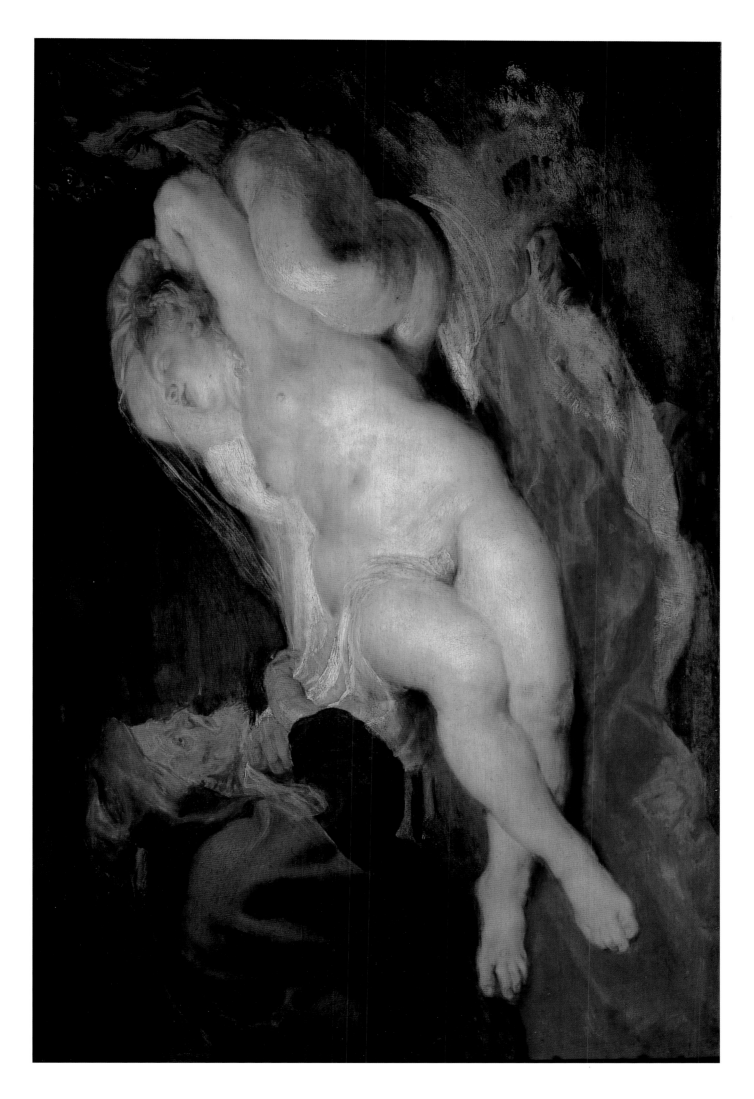

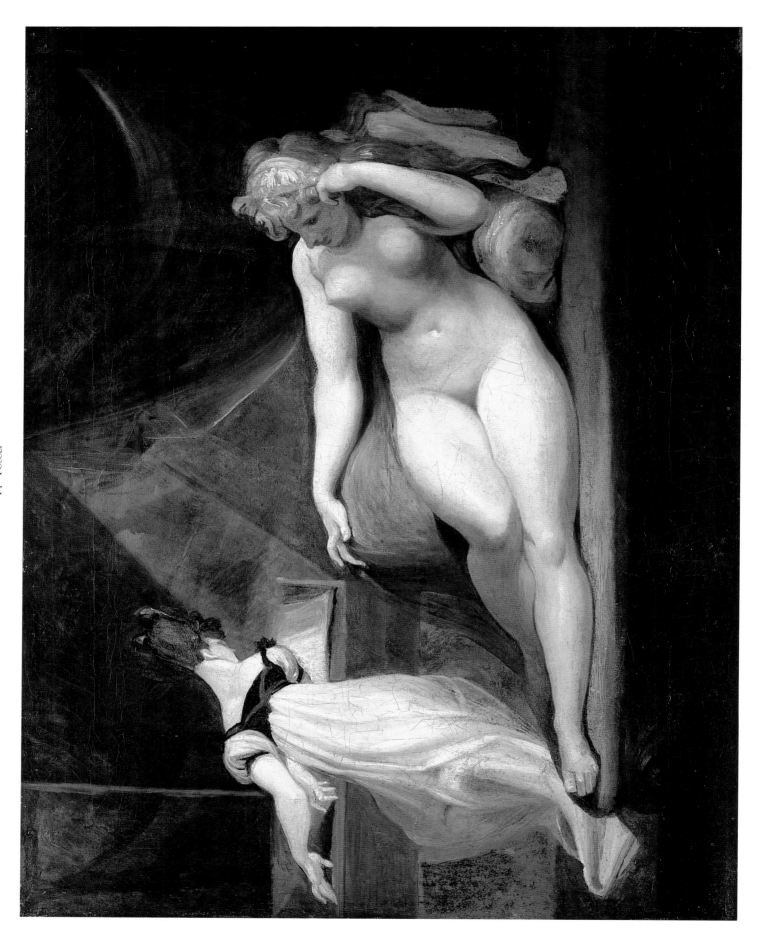

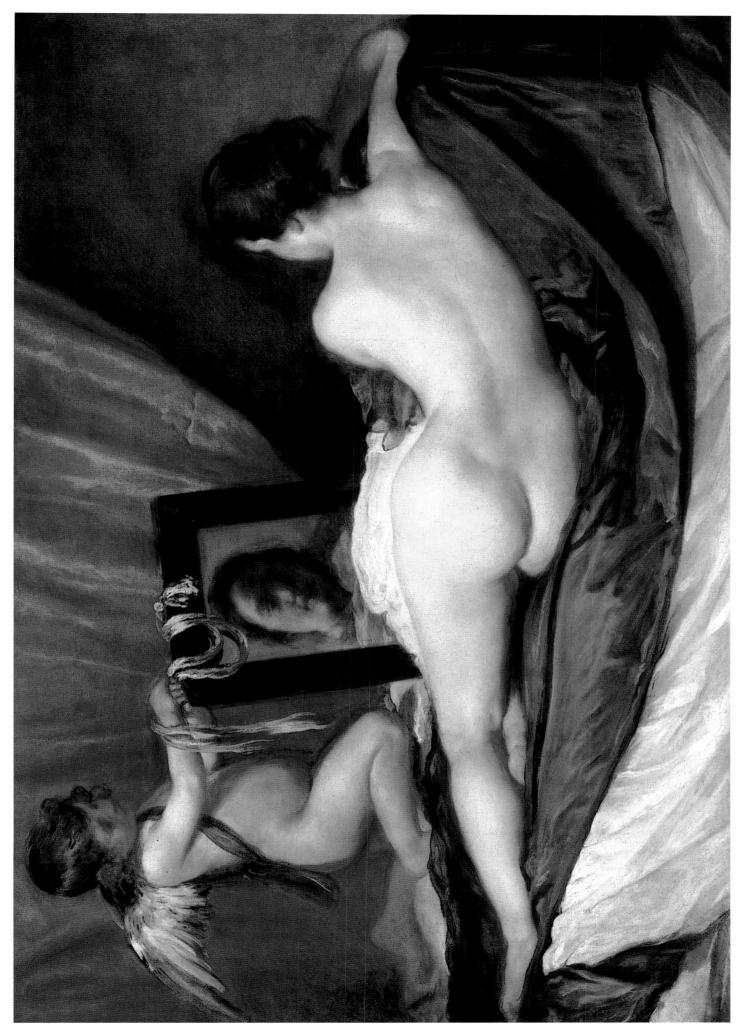

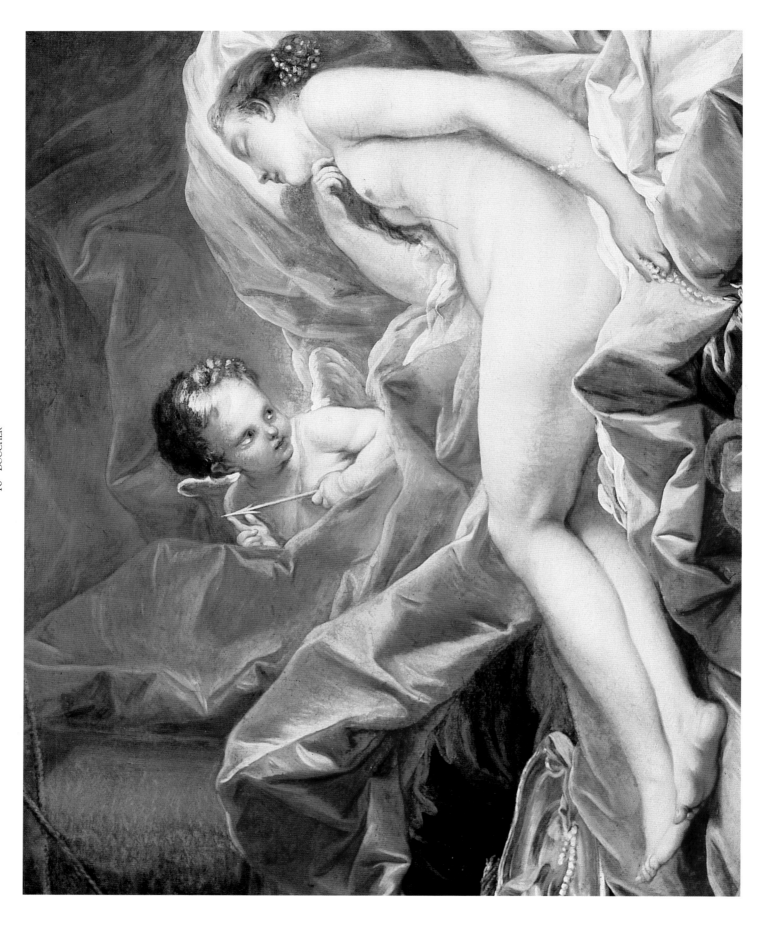

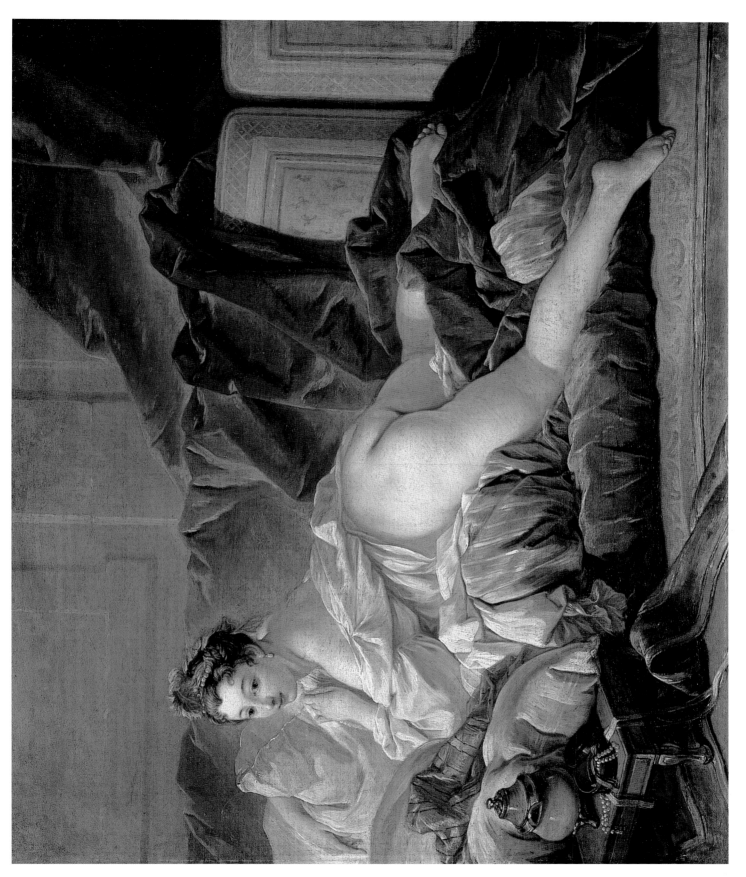

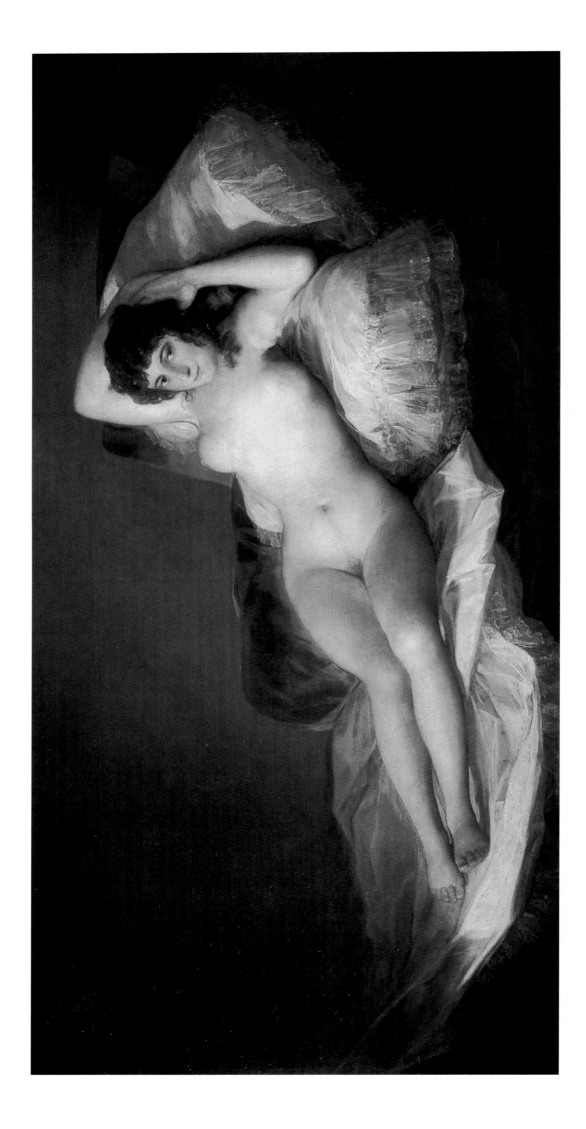

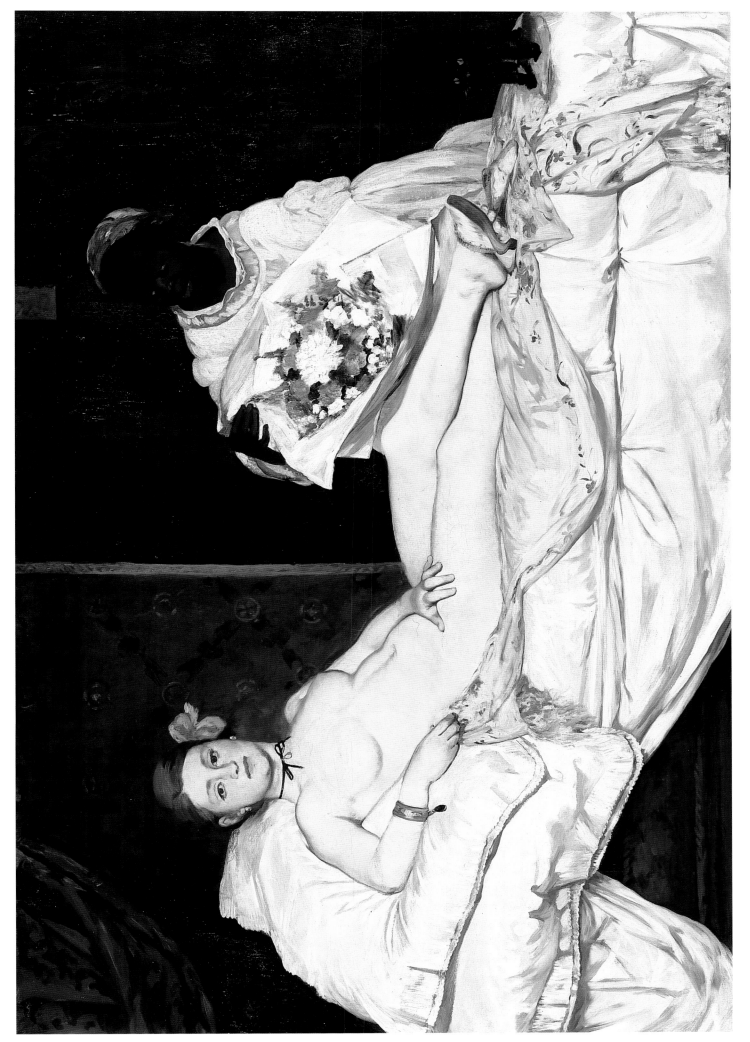

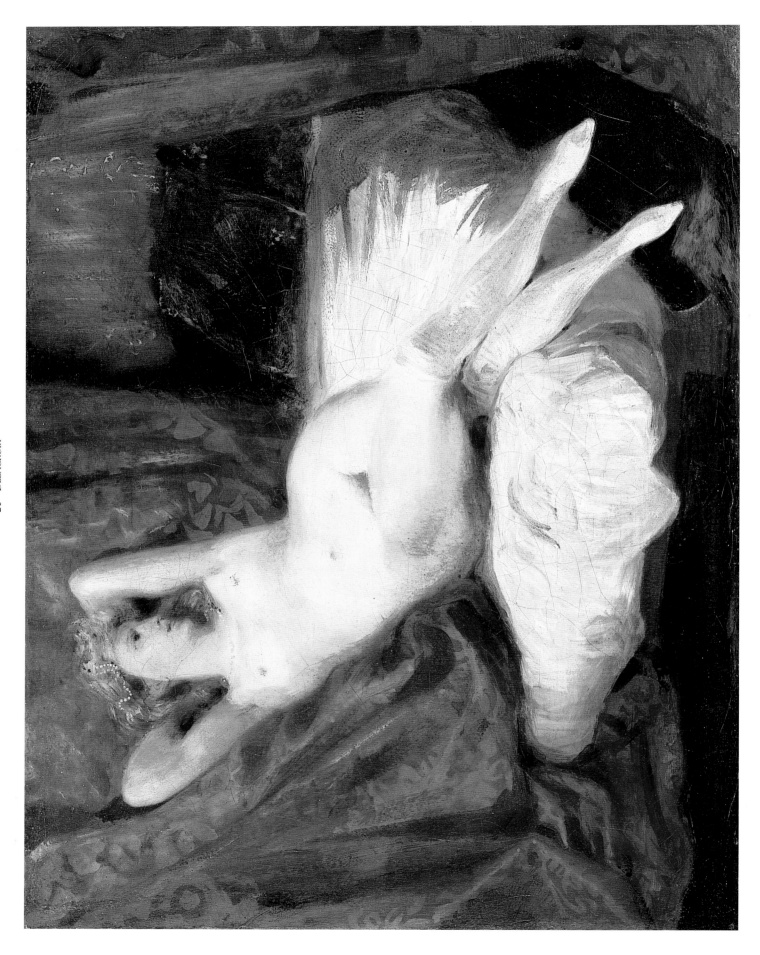

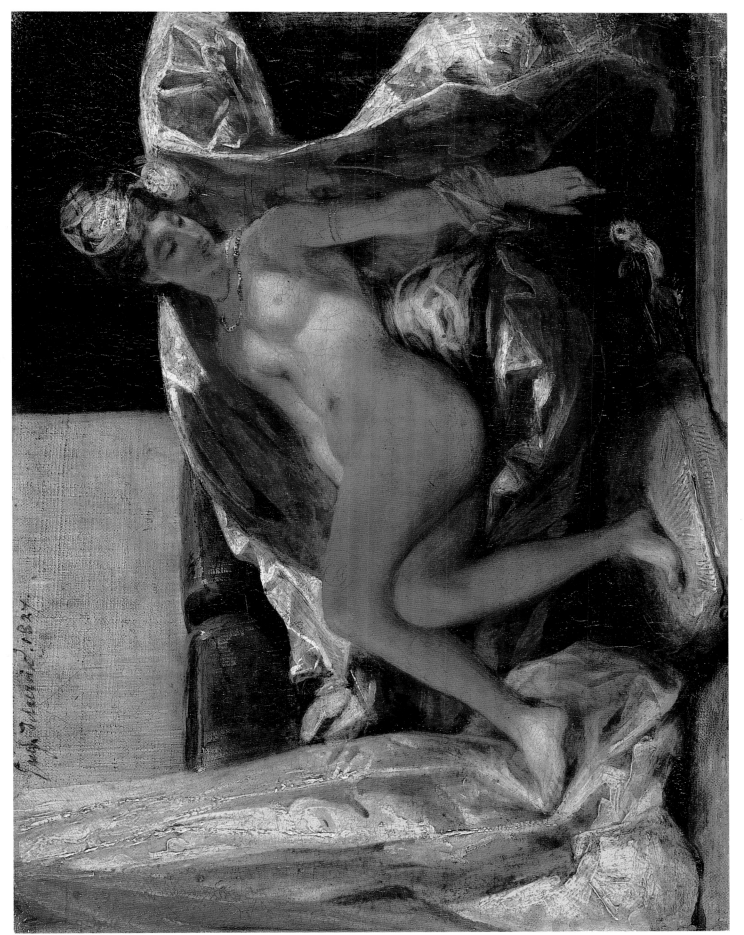

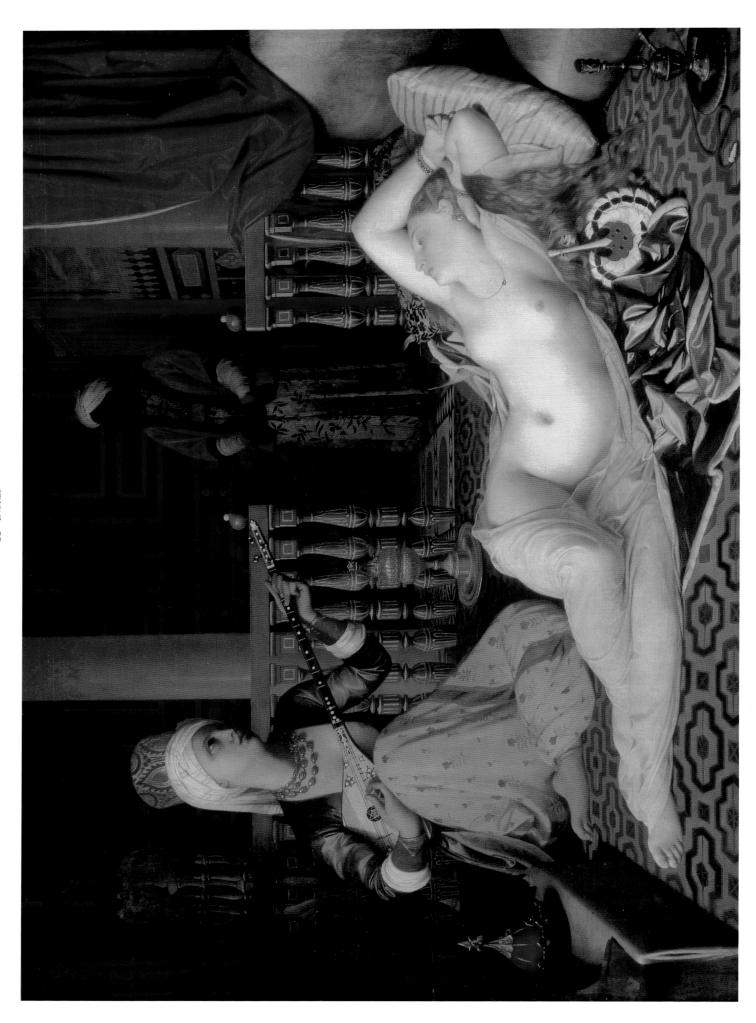

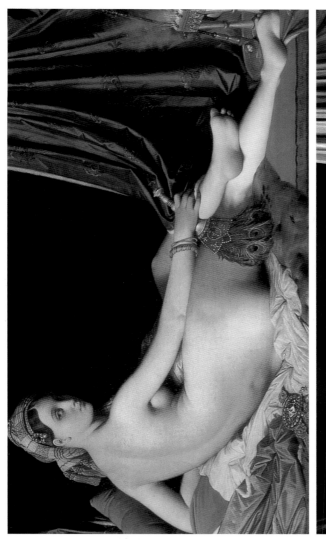

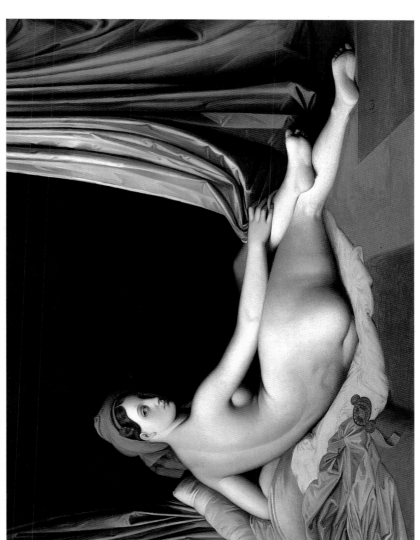

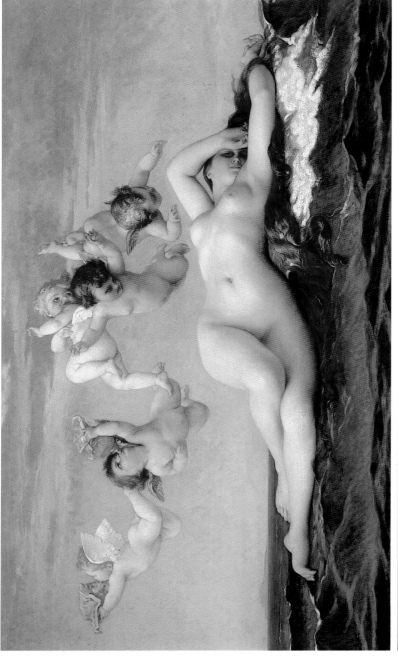

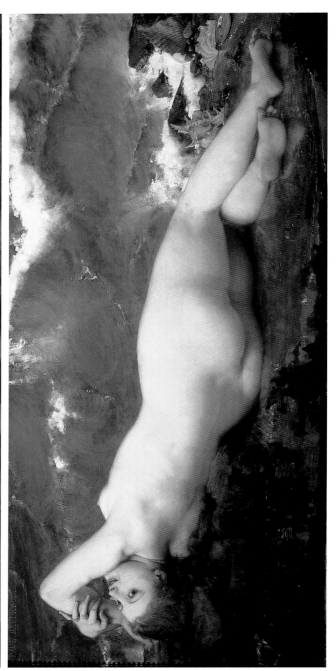

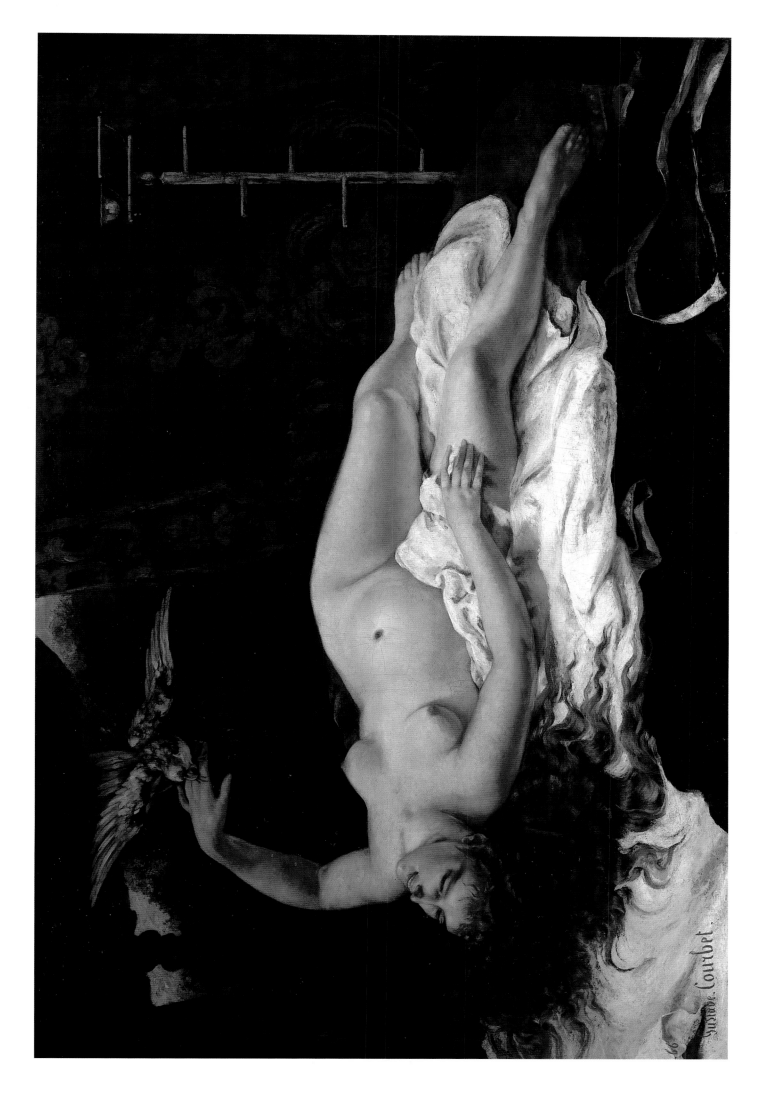

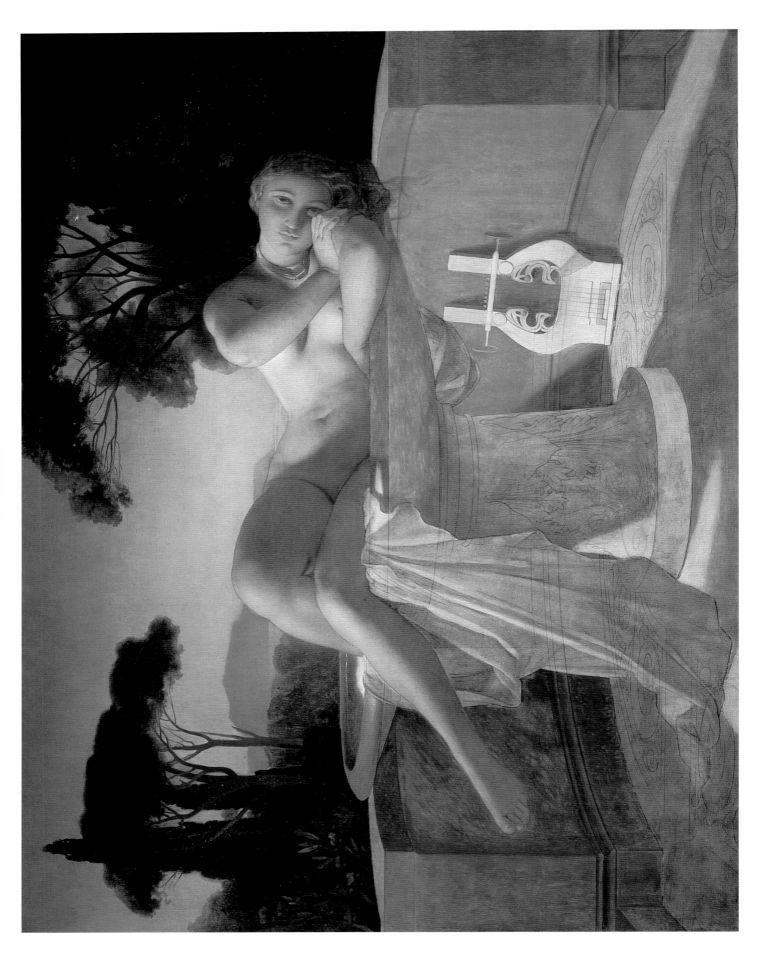

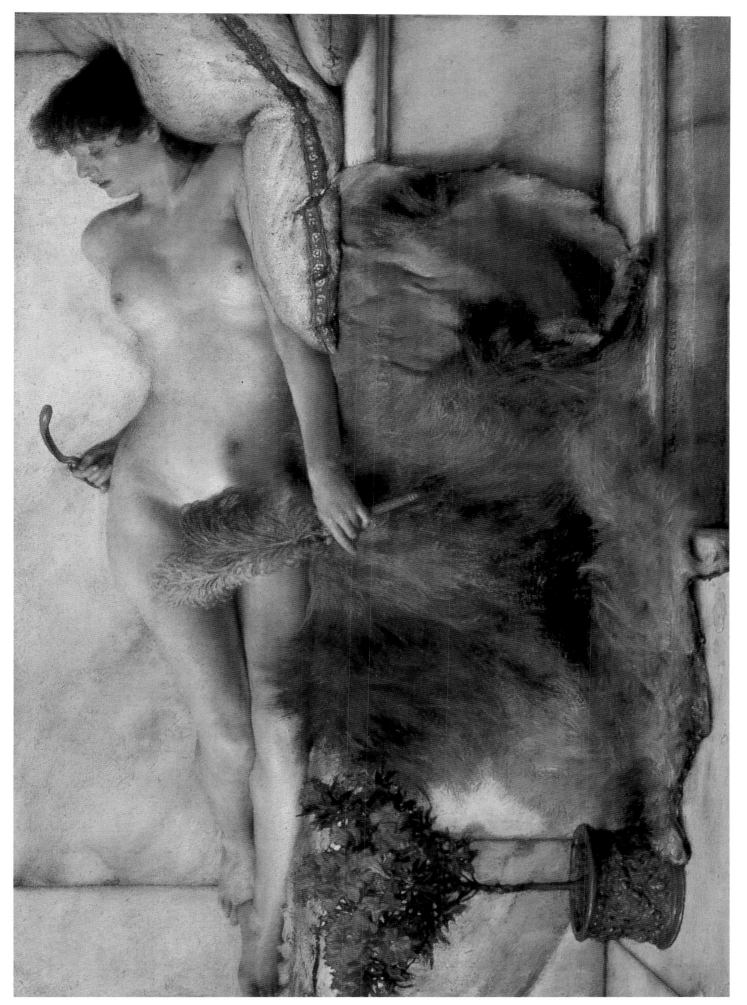

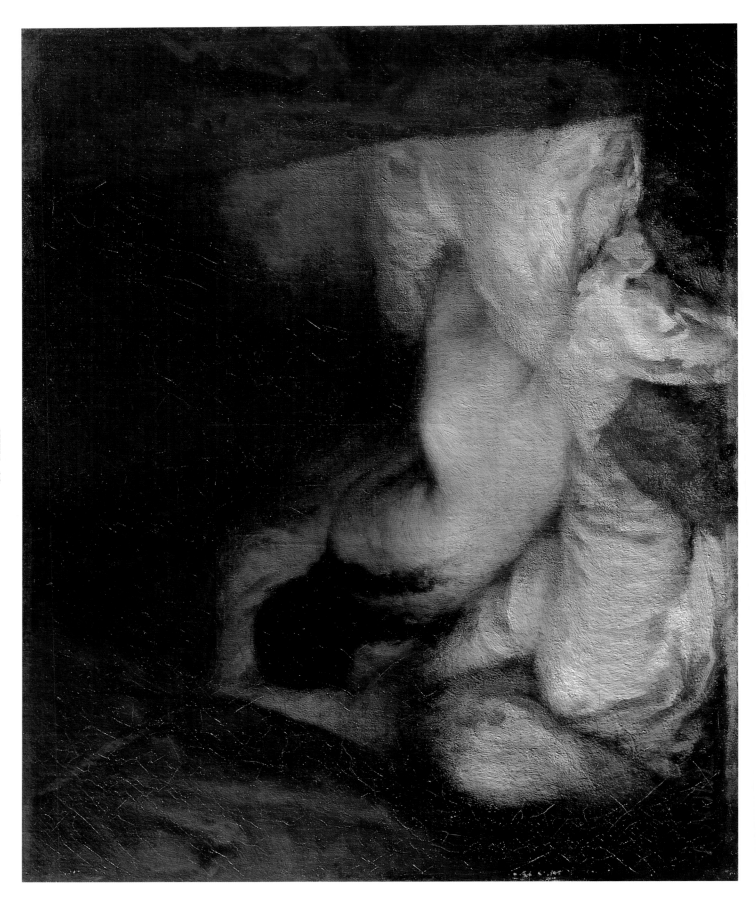

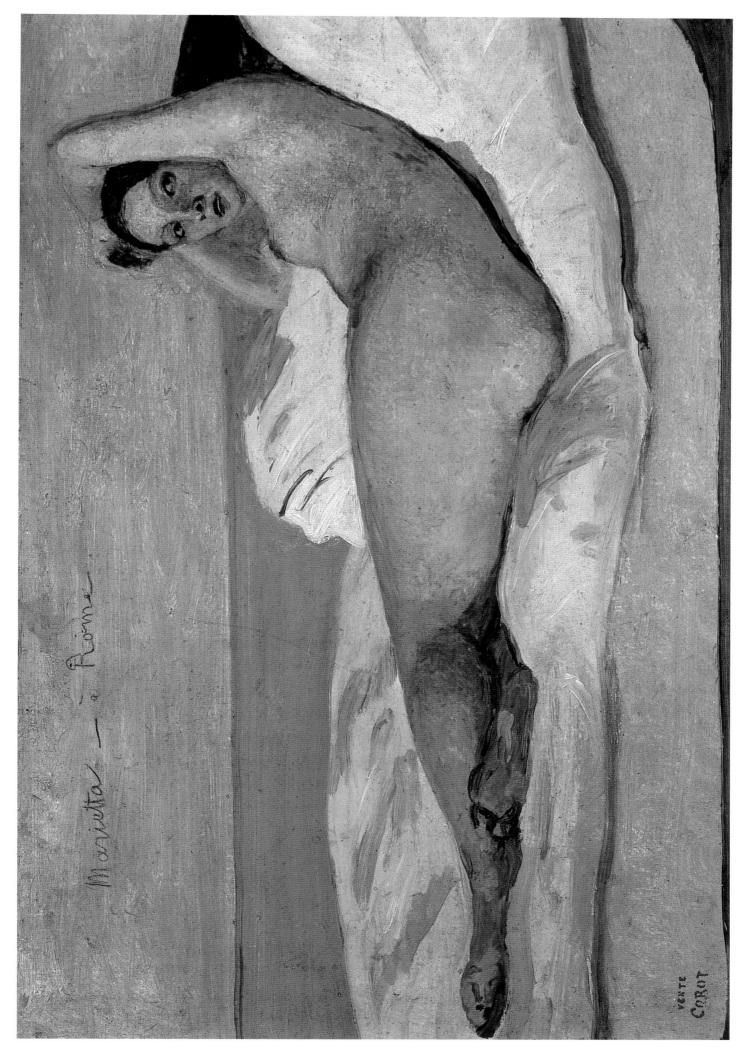

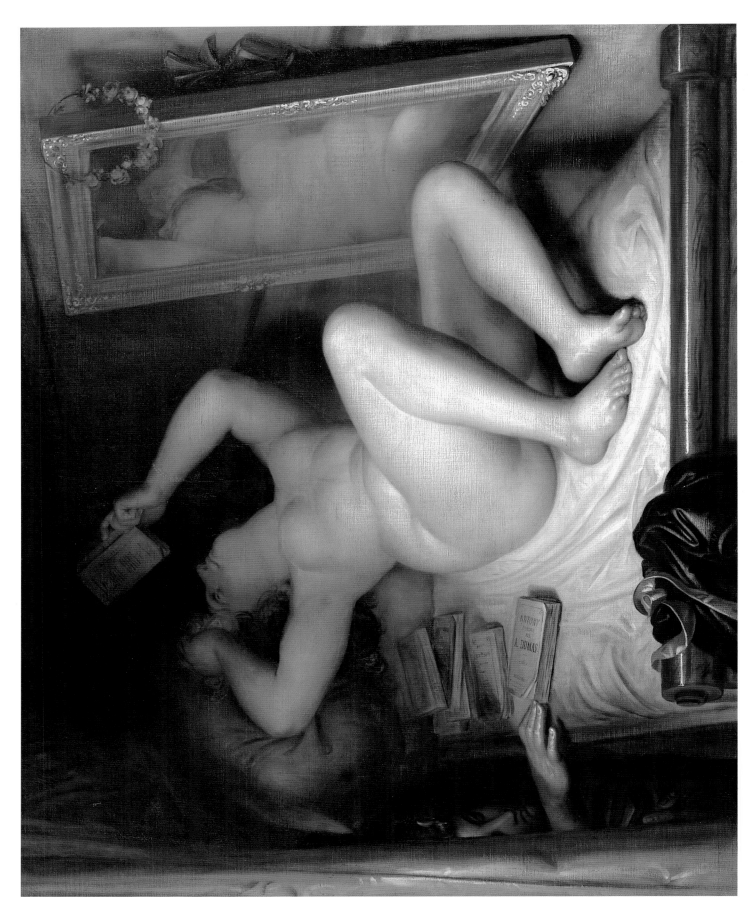

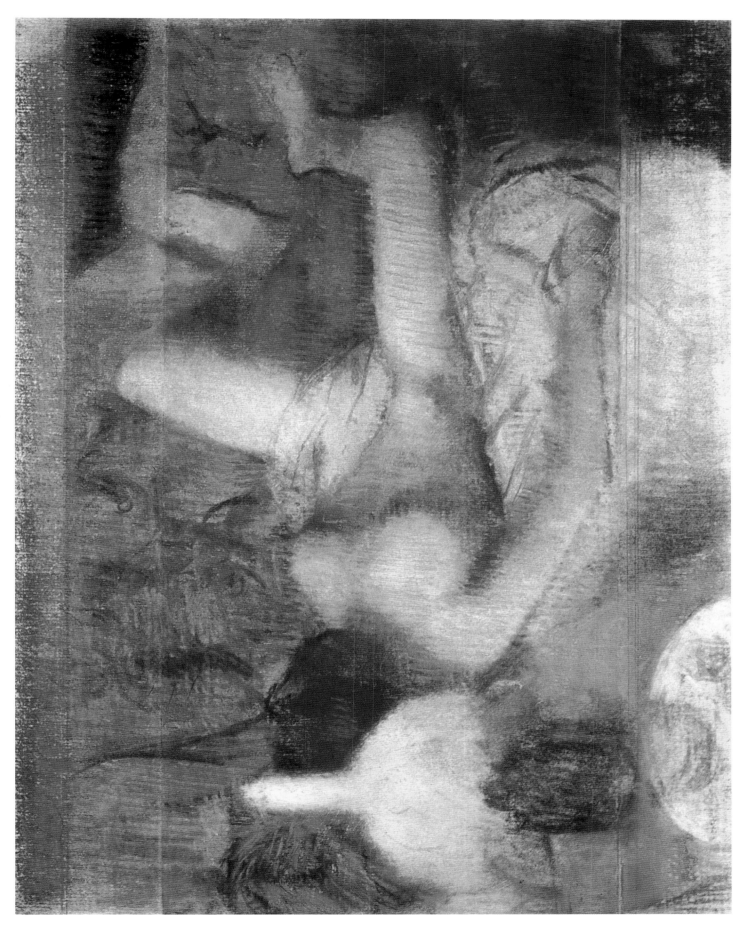

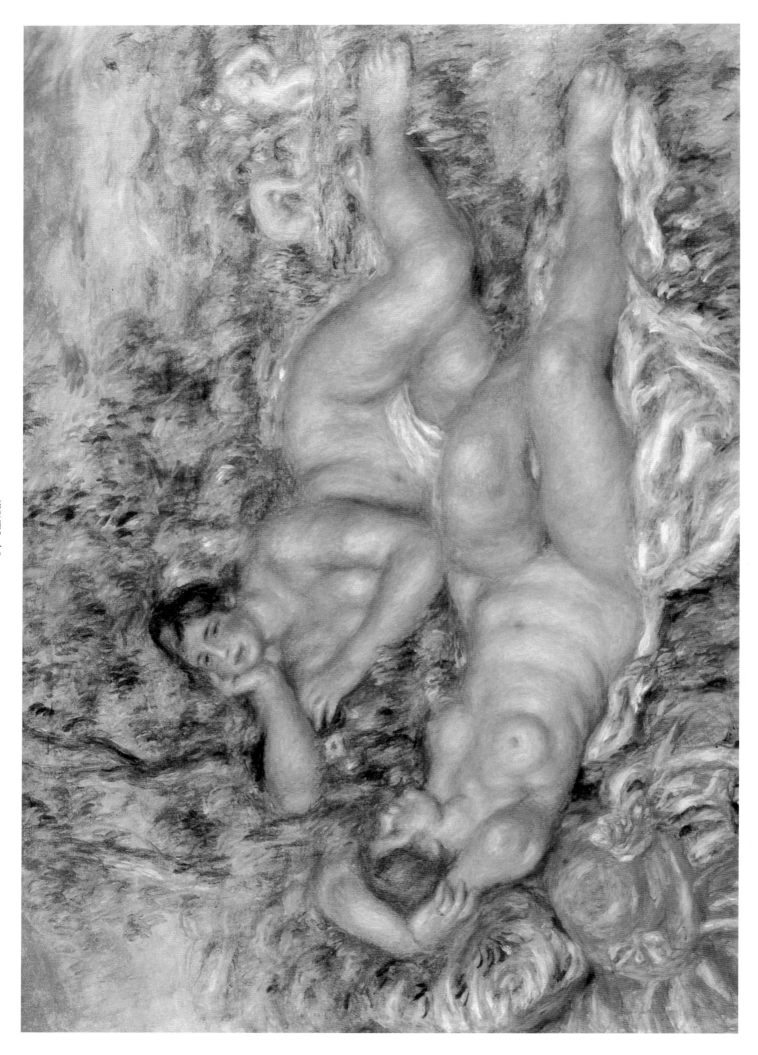

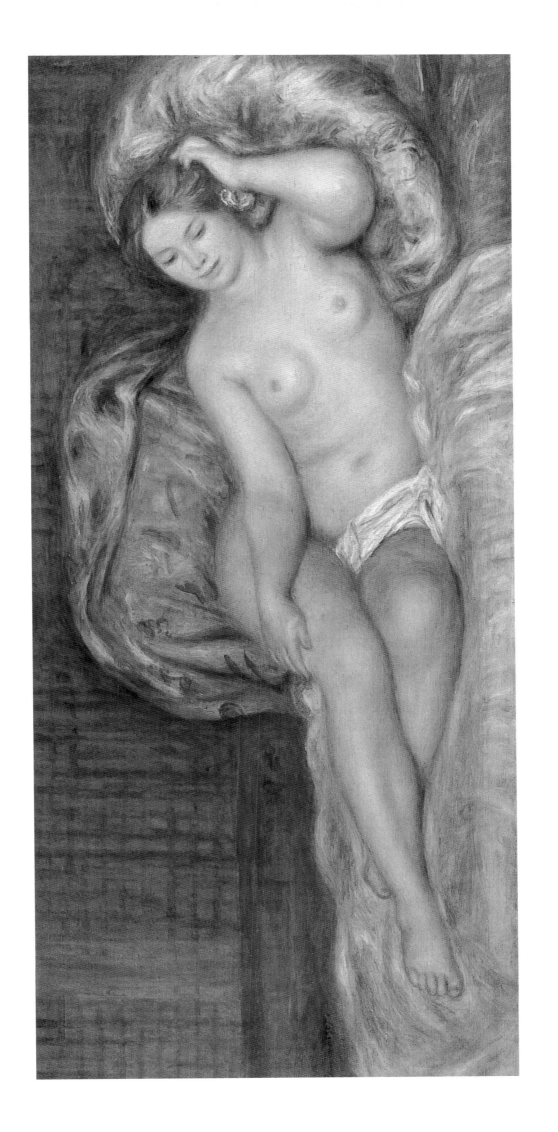

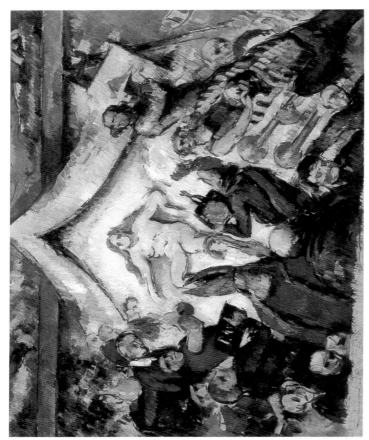

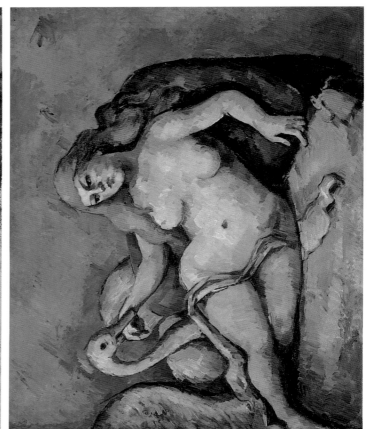

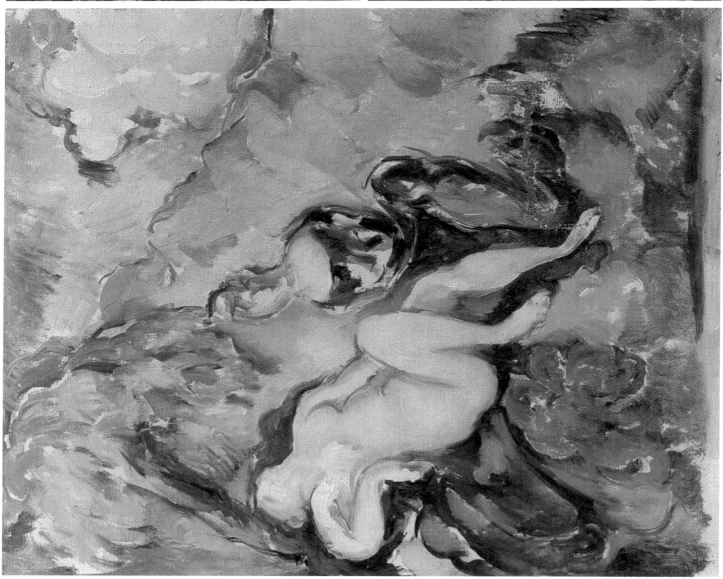

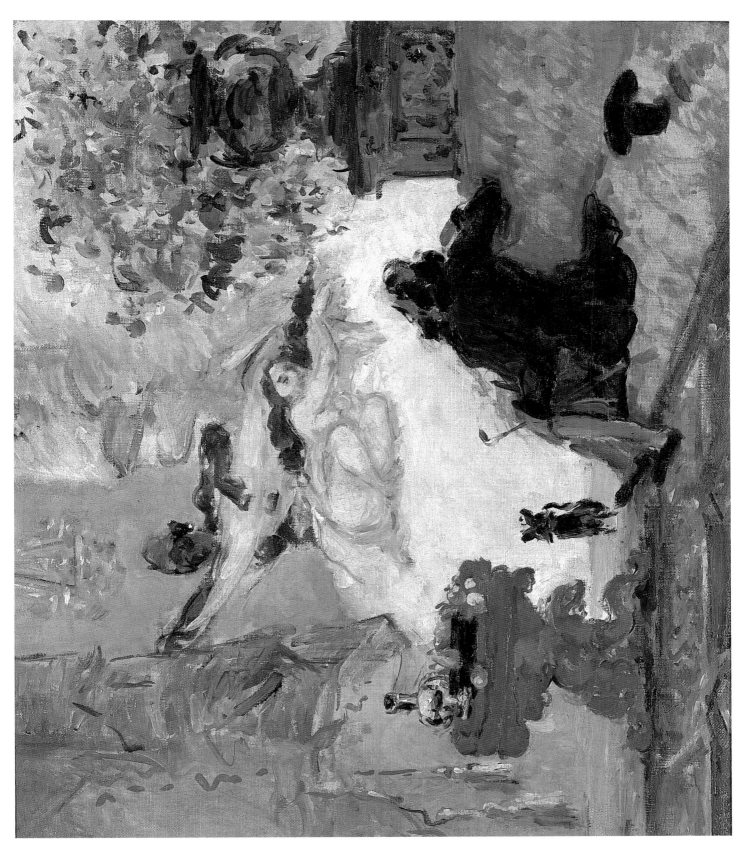

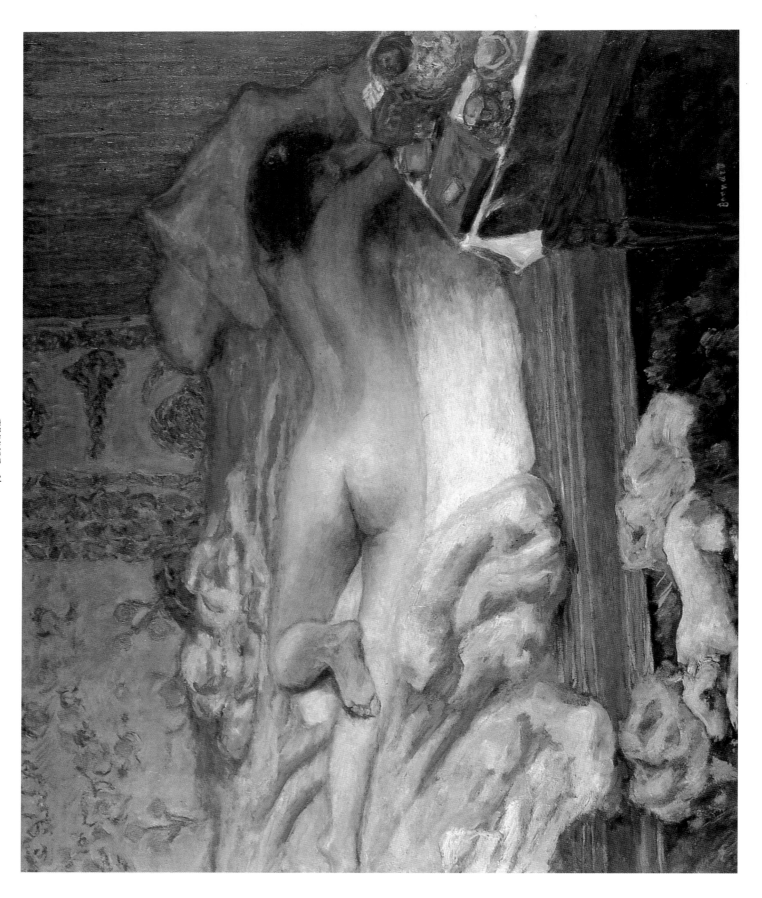

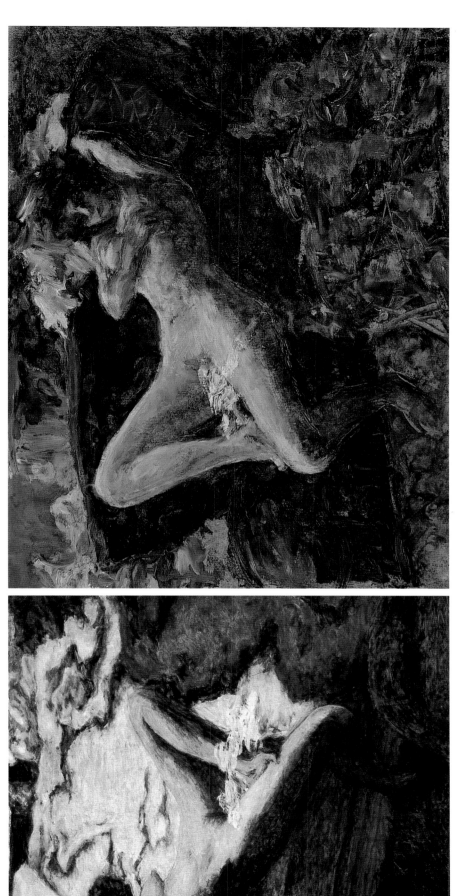

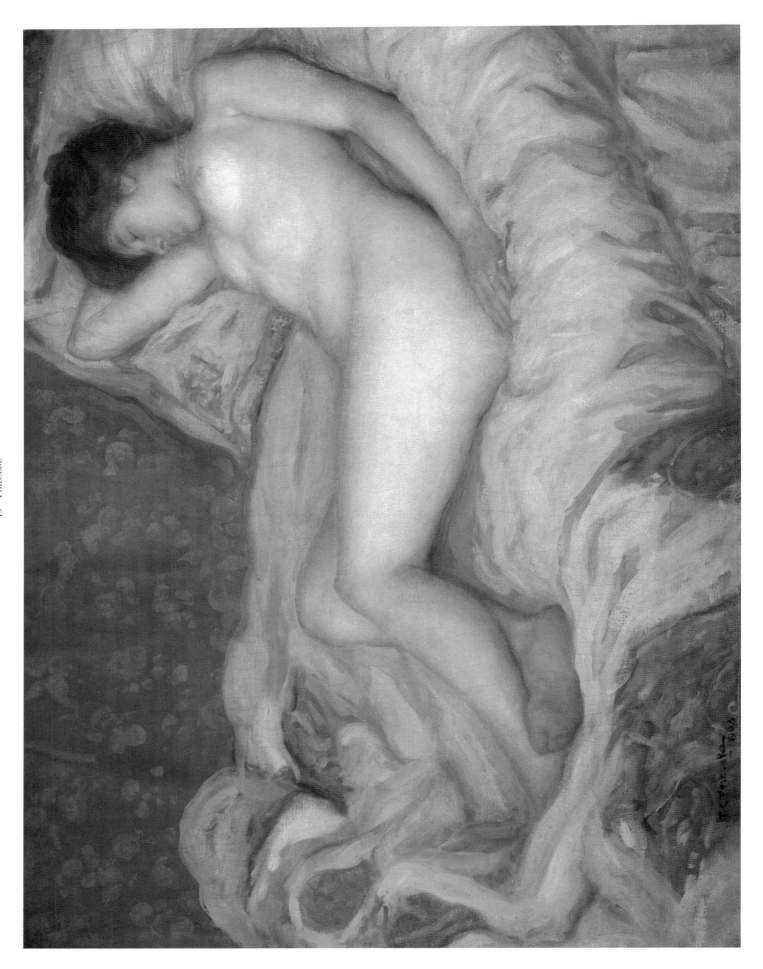

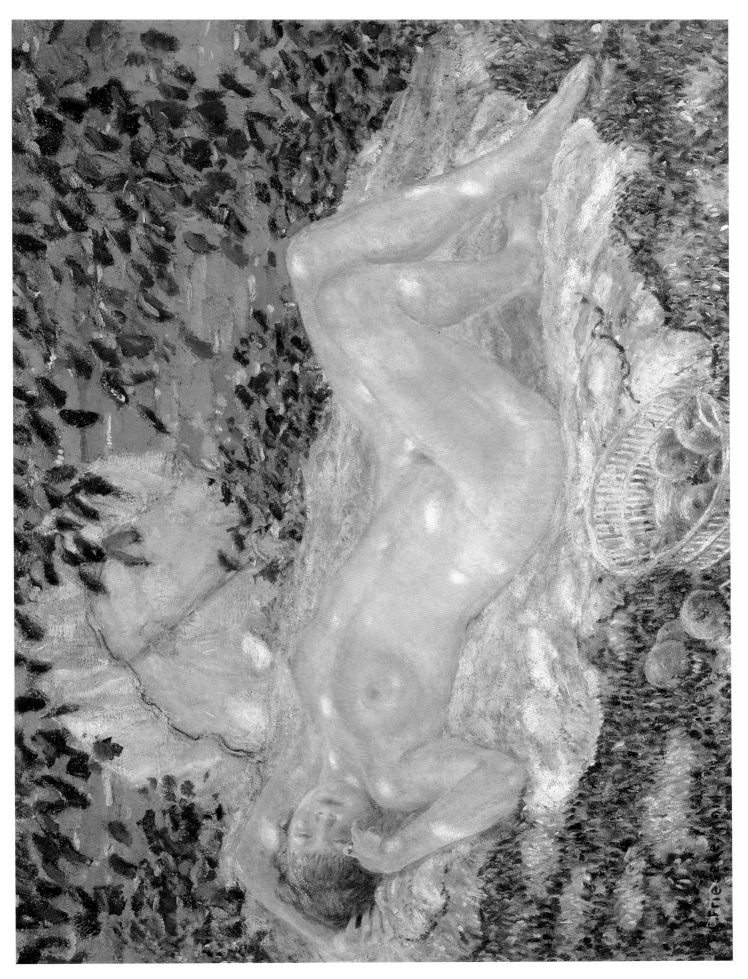

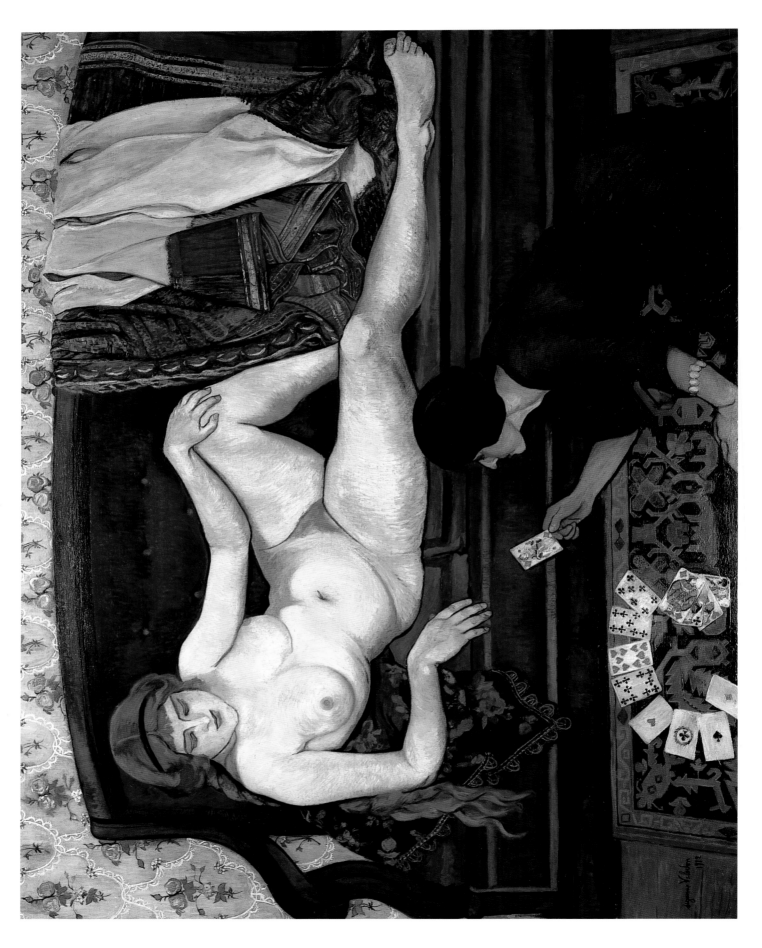

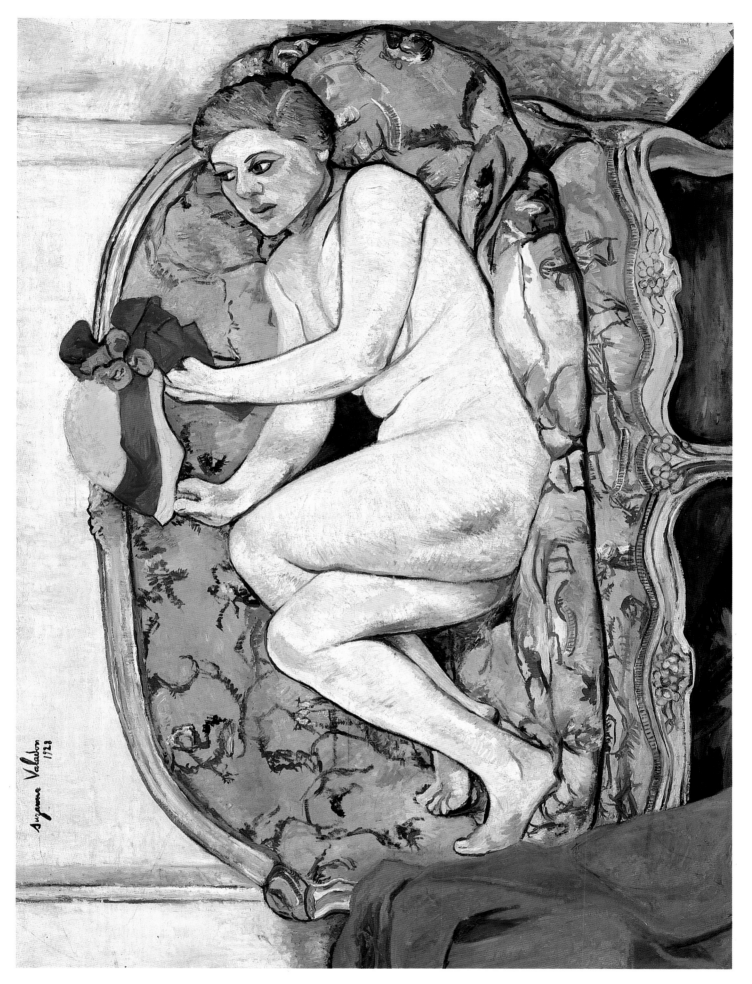

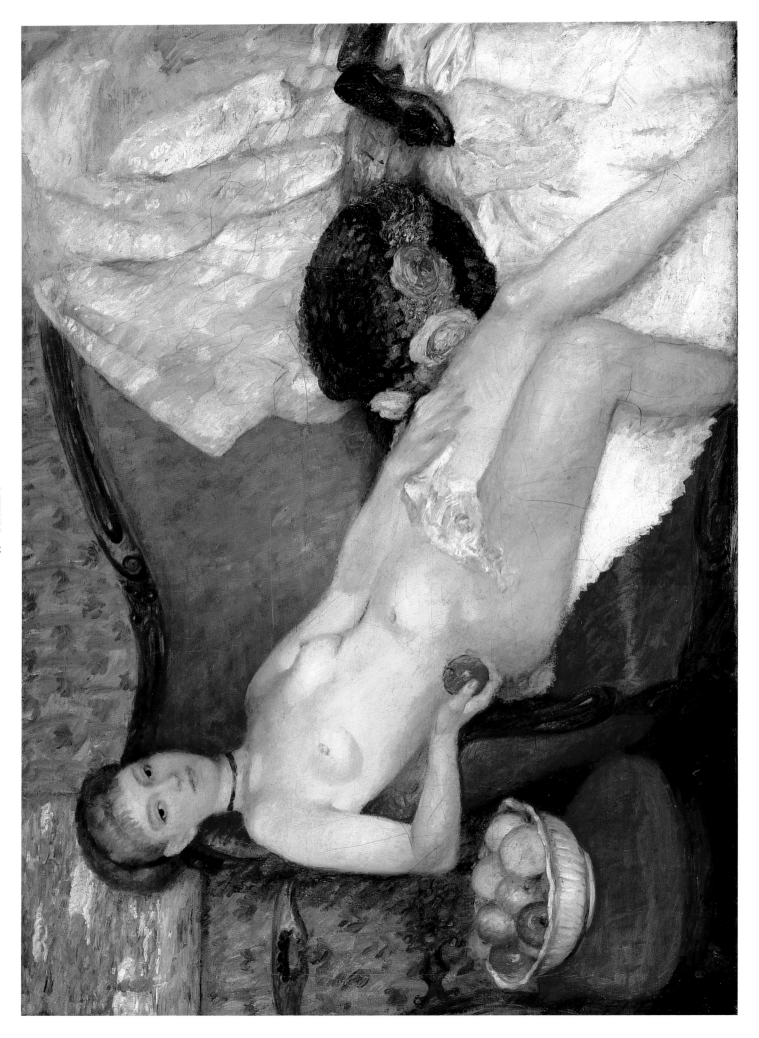

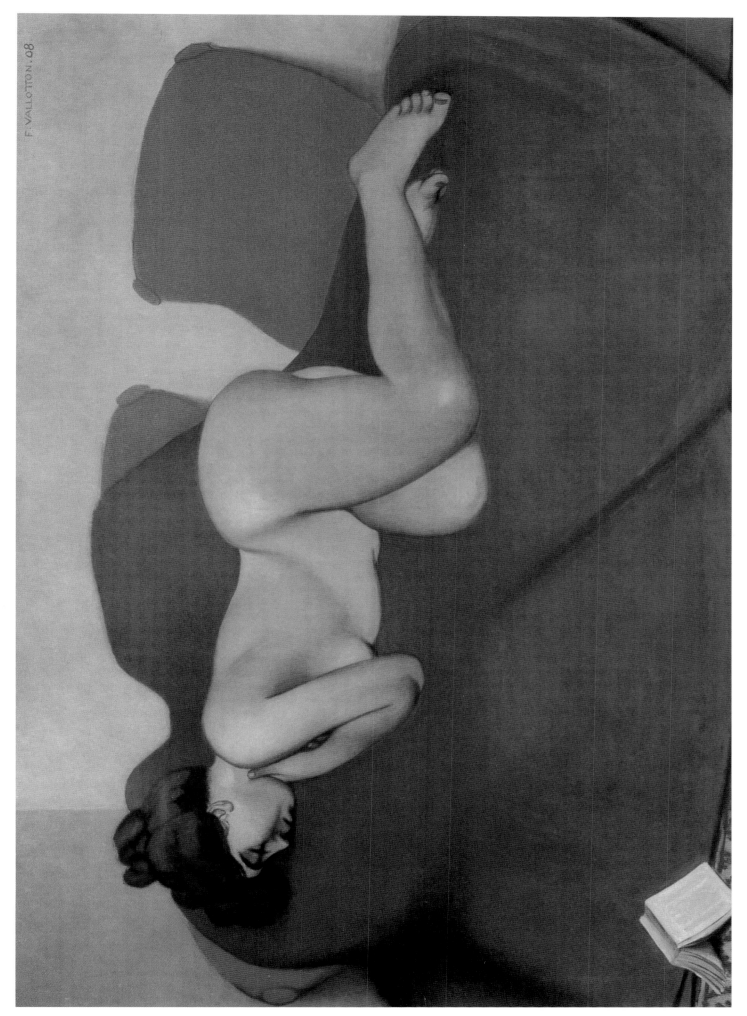

F. VALLOTTON. 08

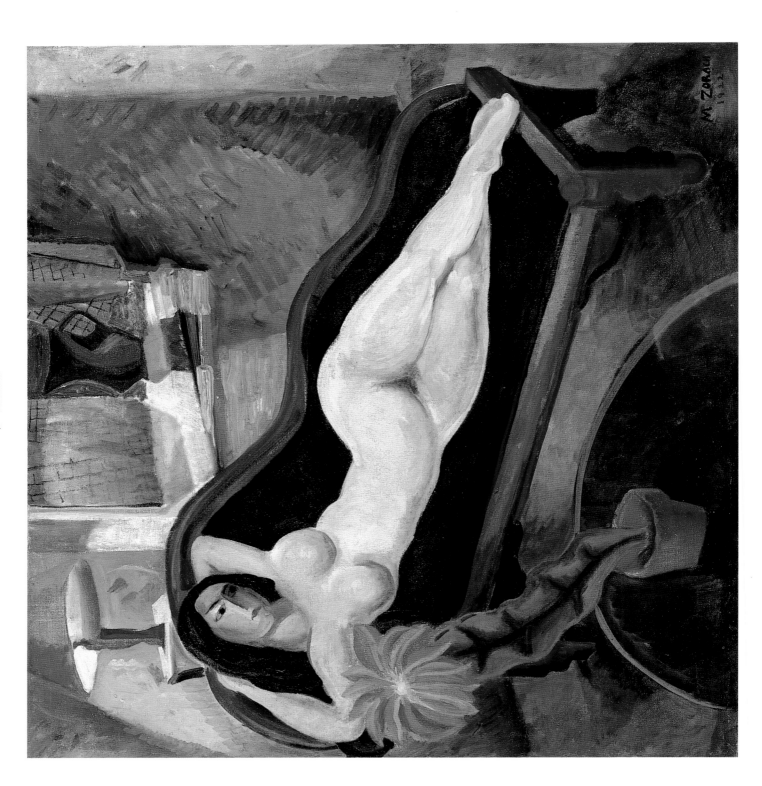

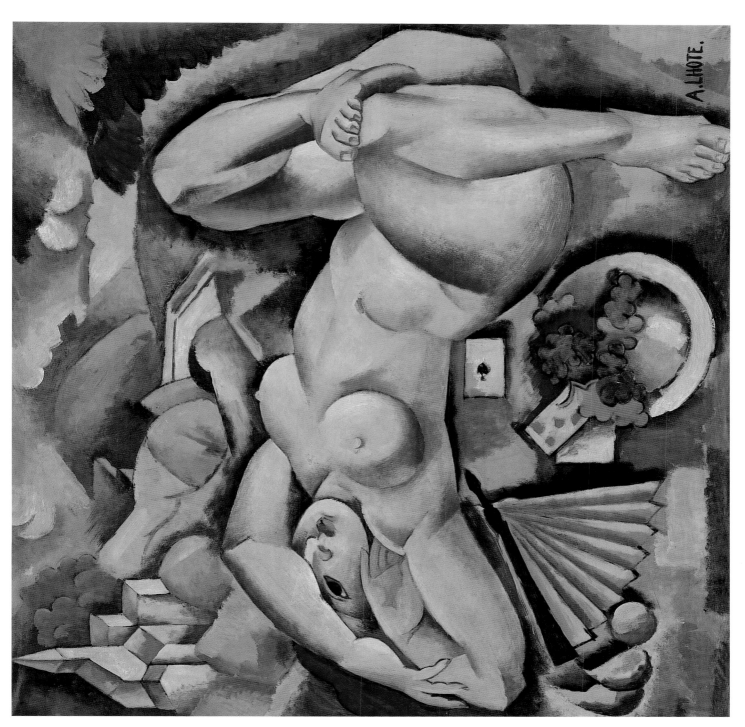

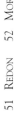

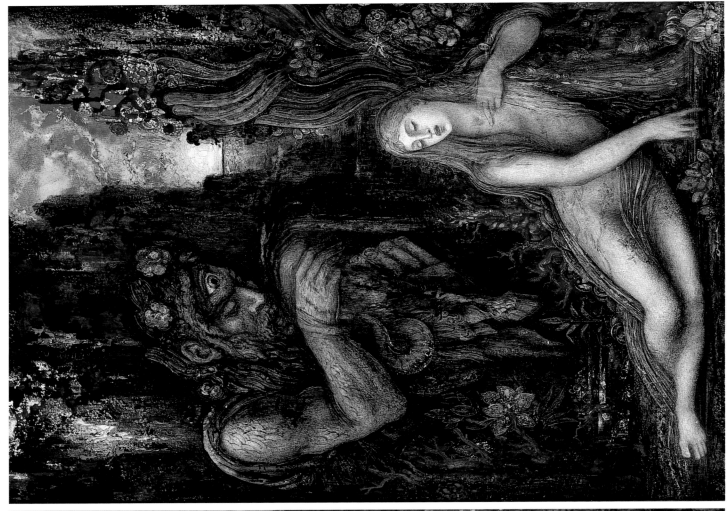

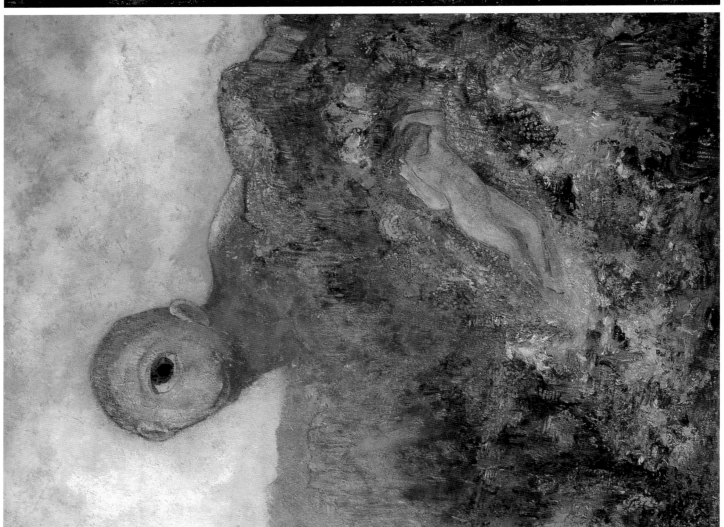

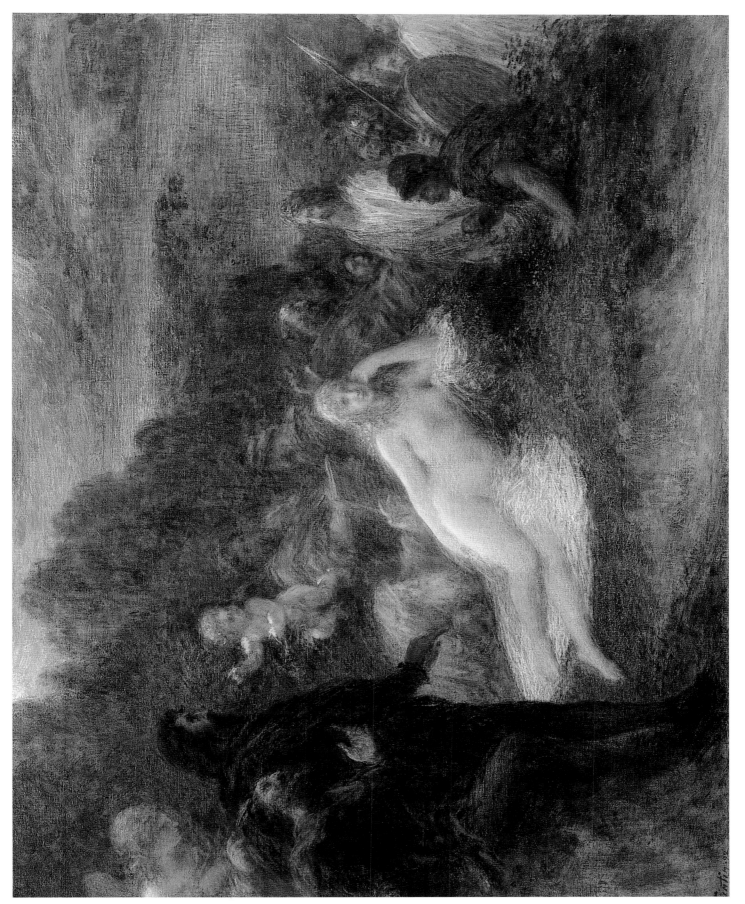

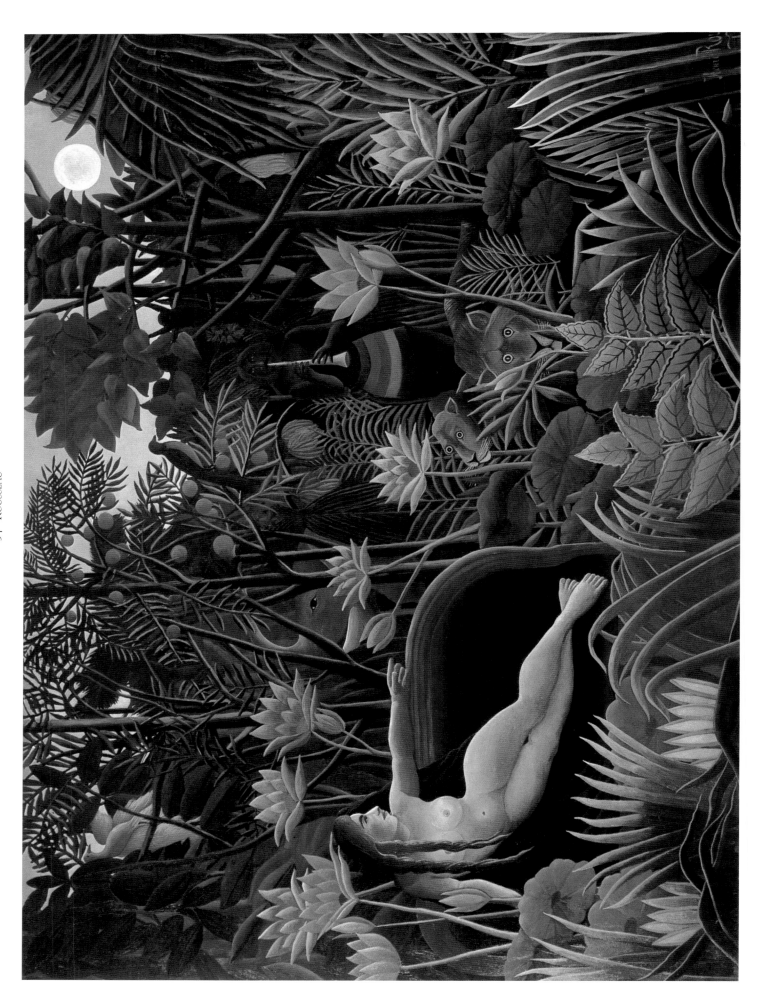

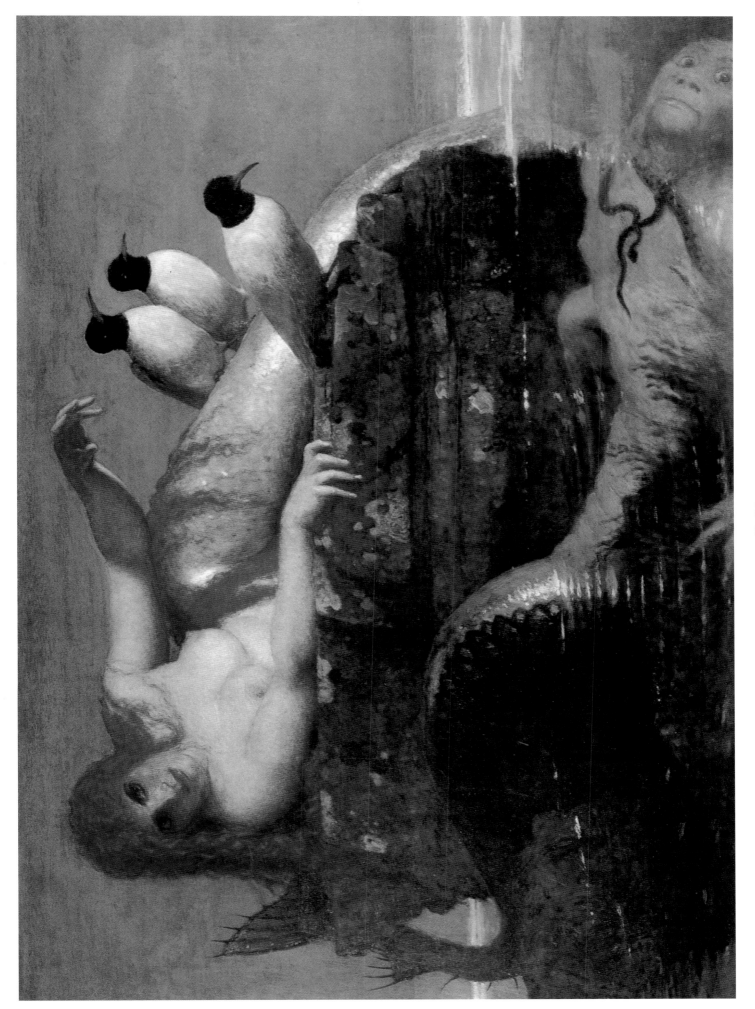

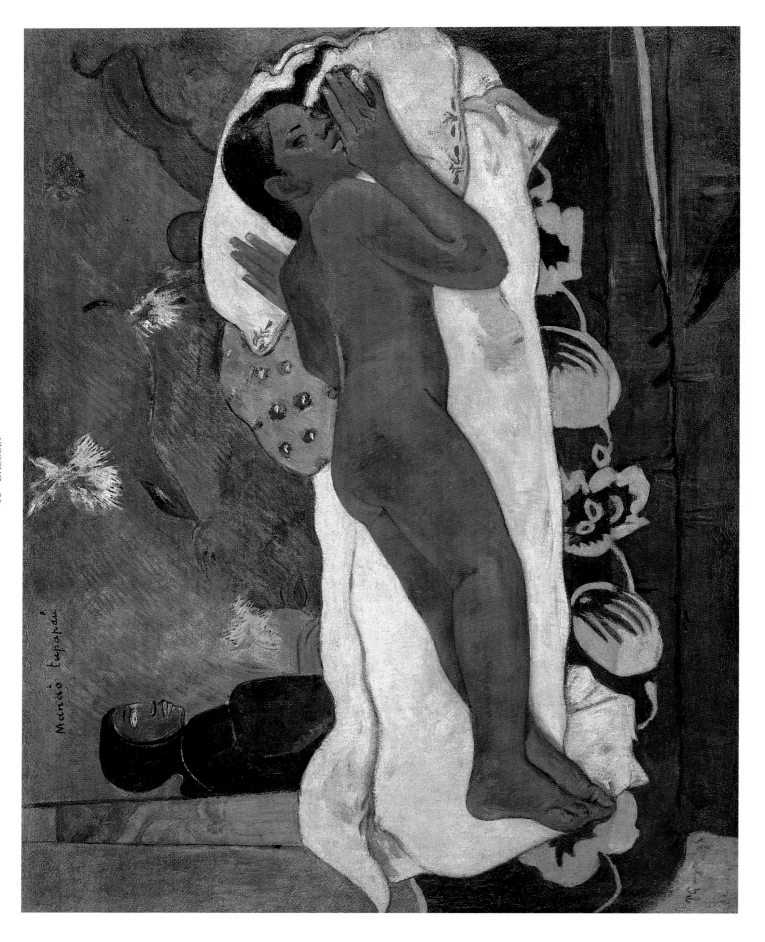

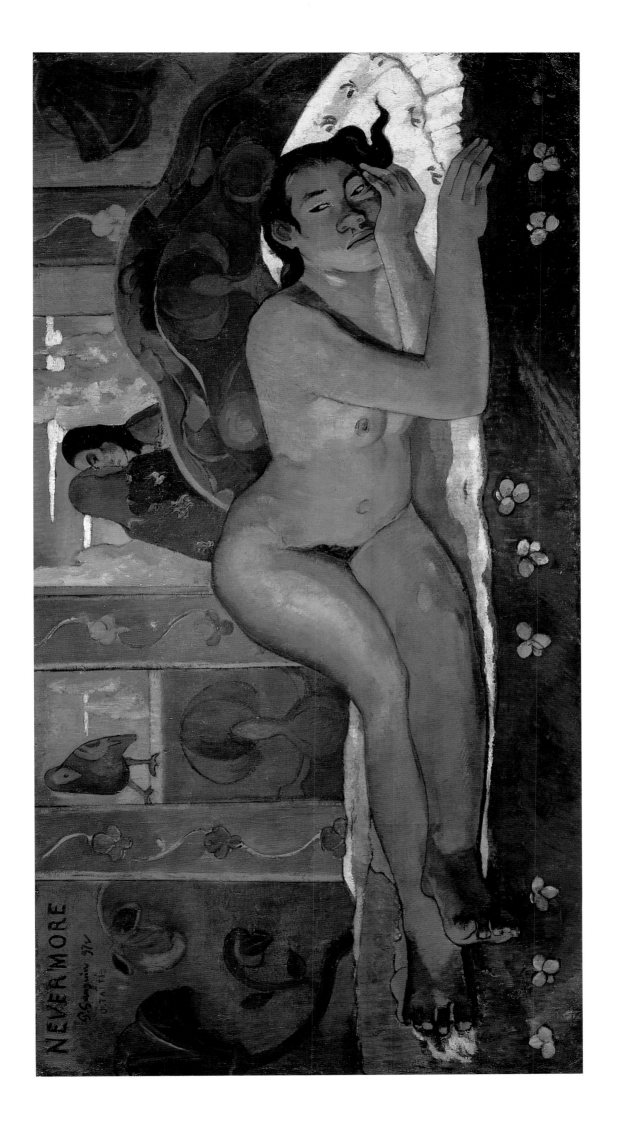

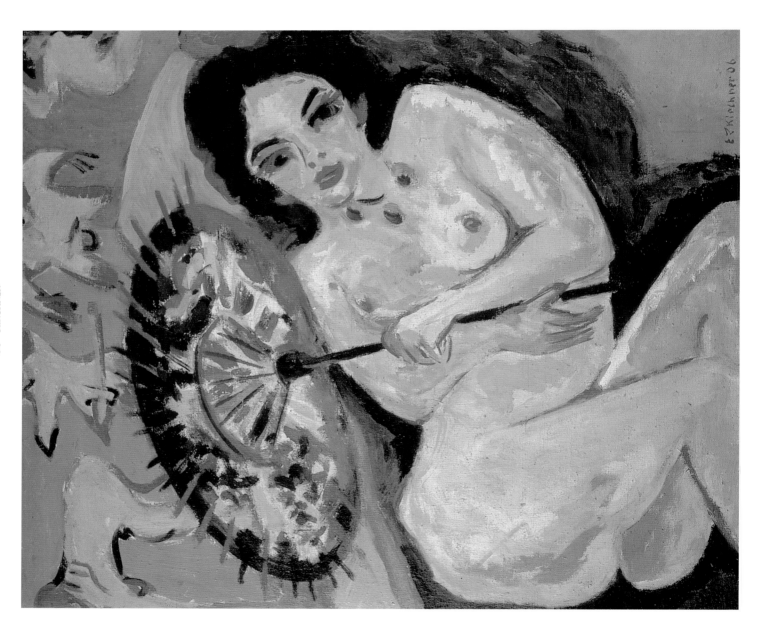

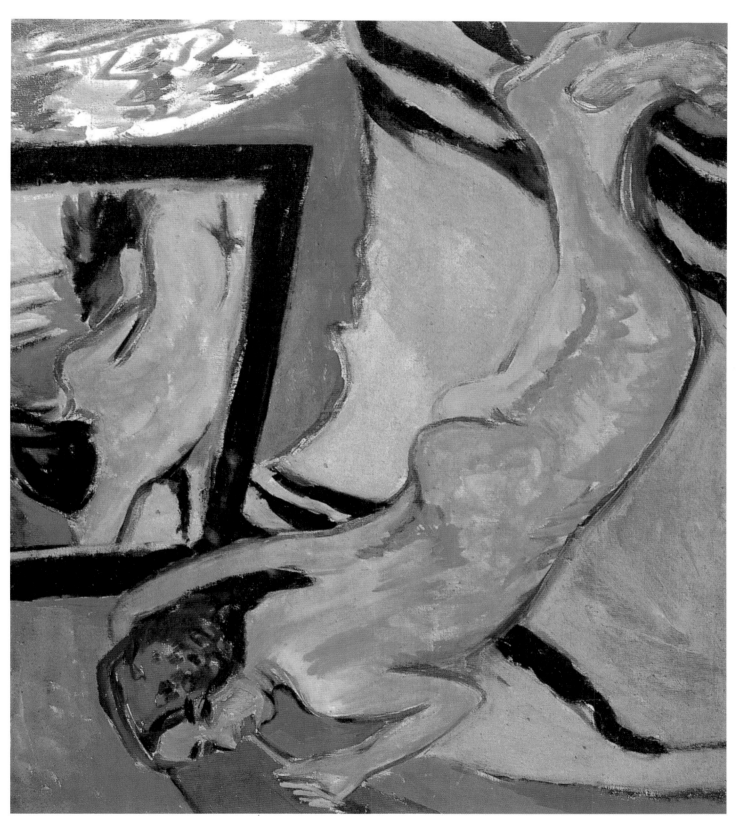

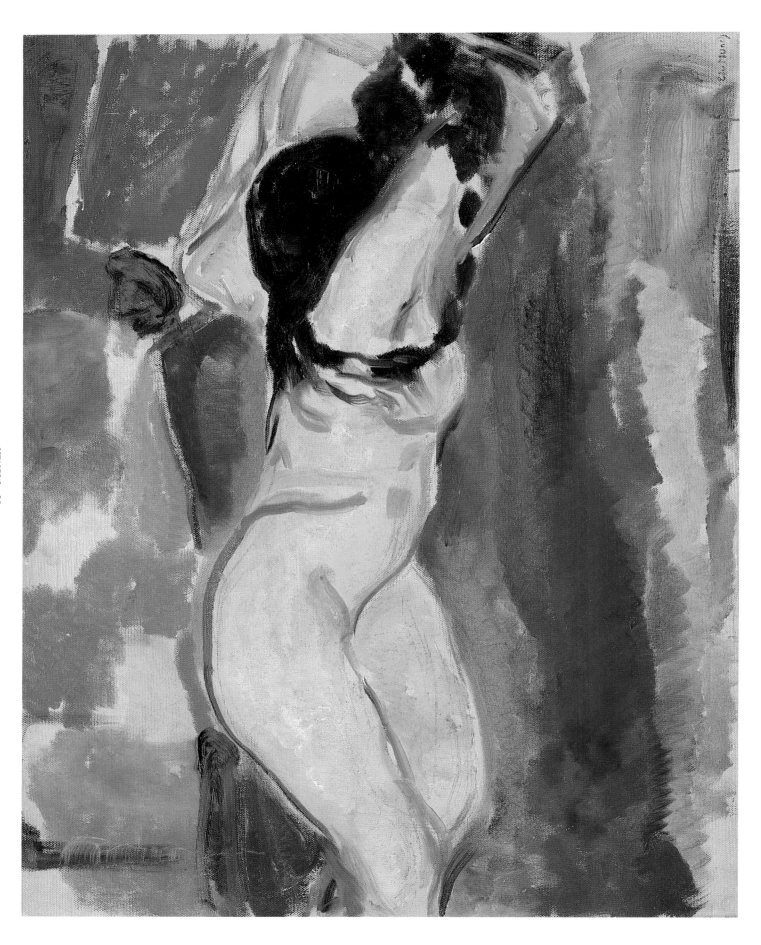

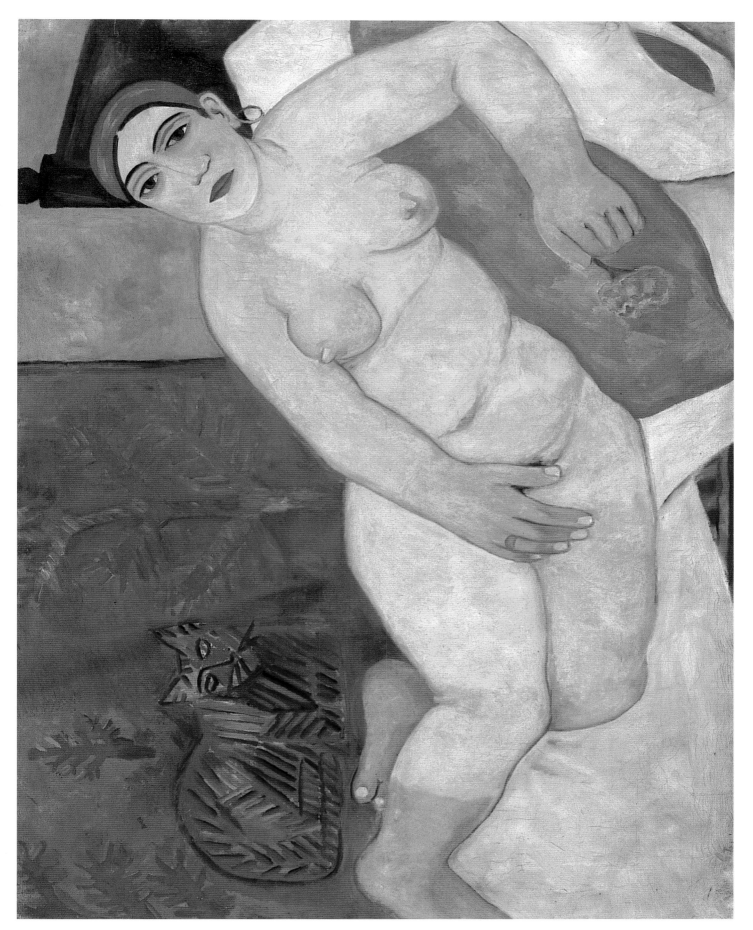

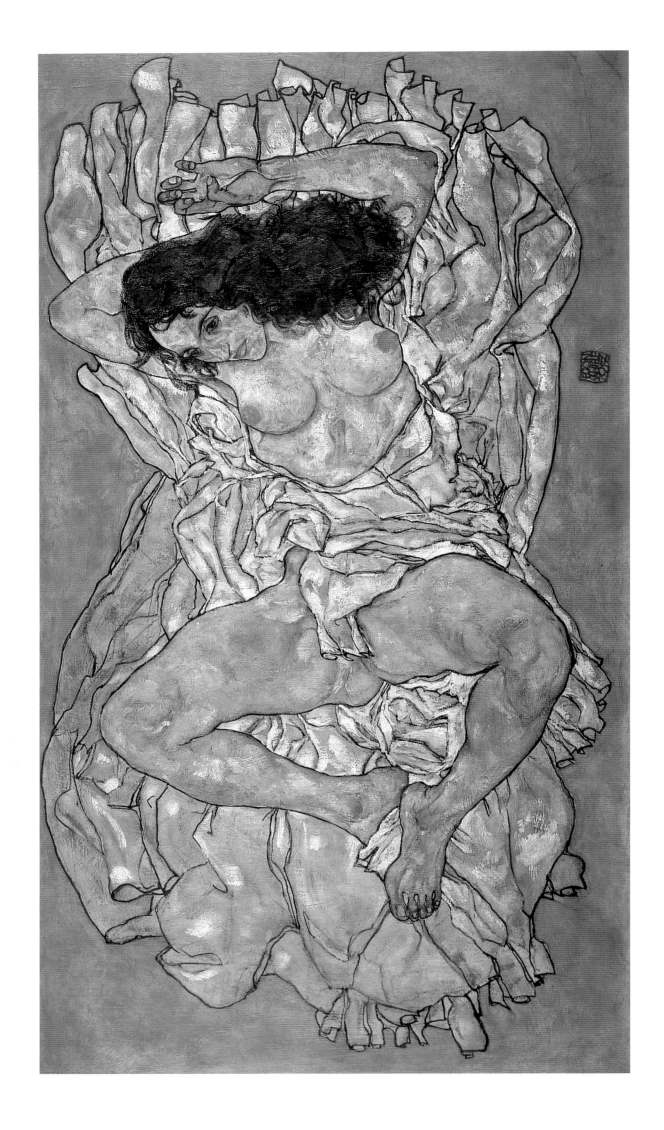

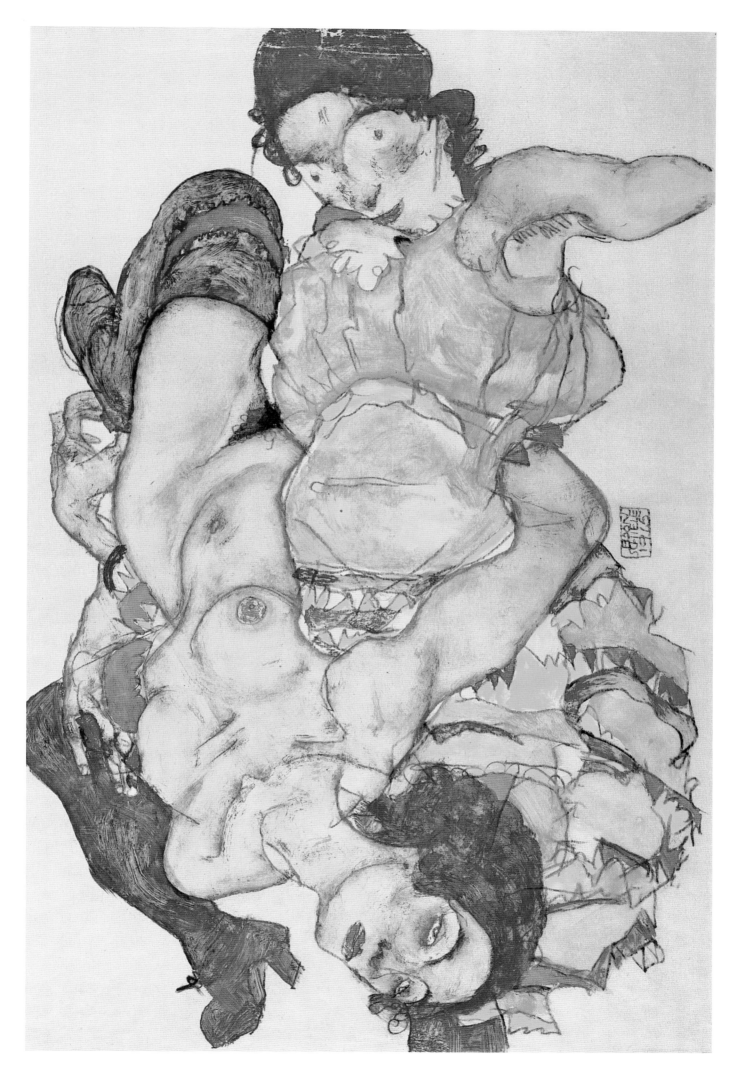

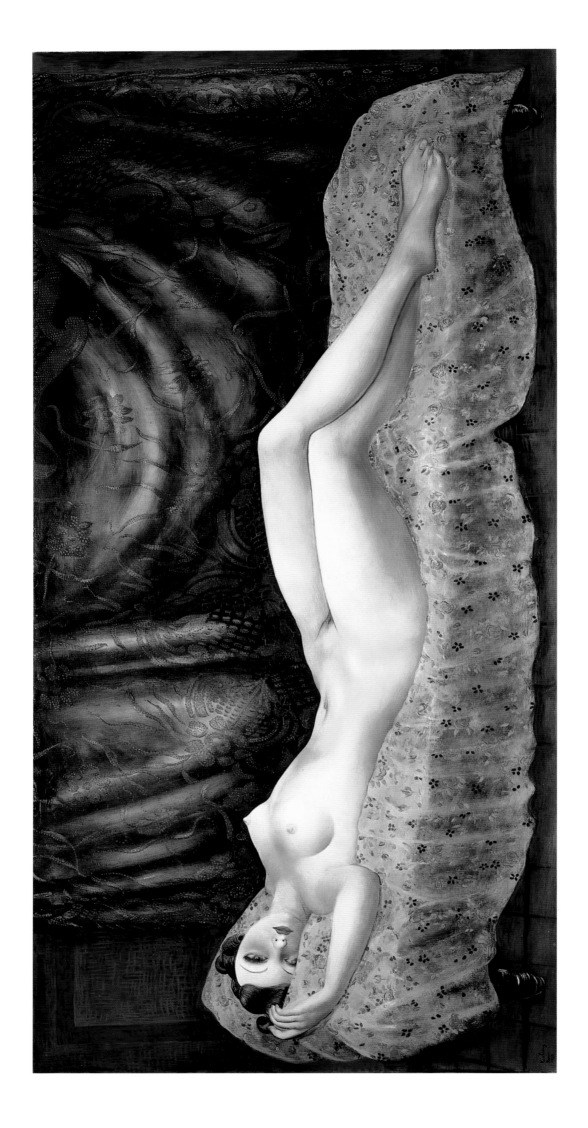

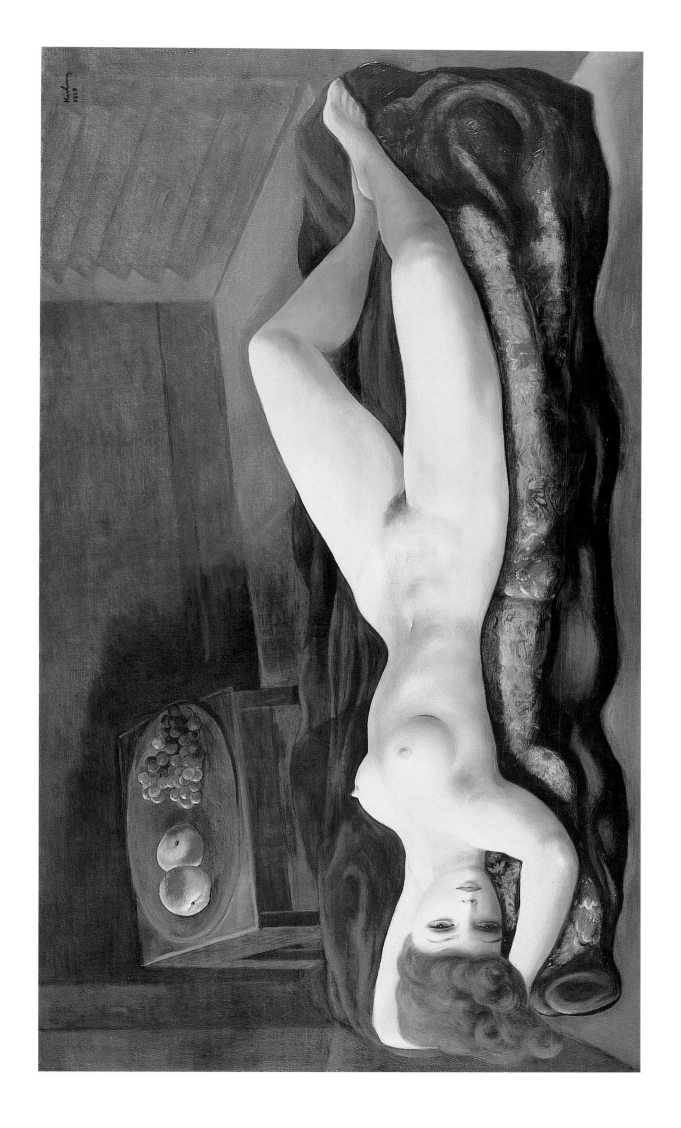

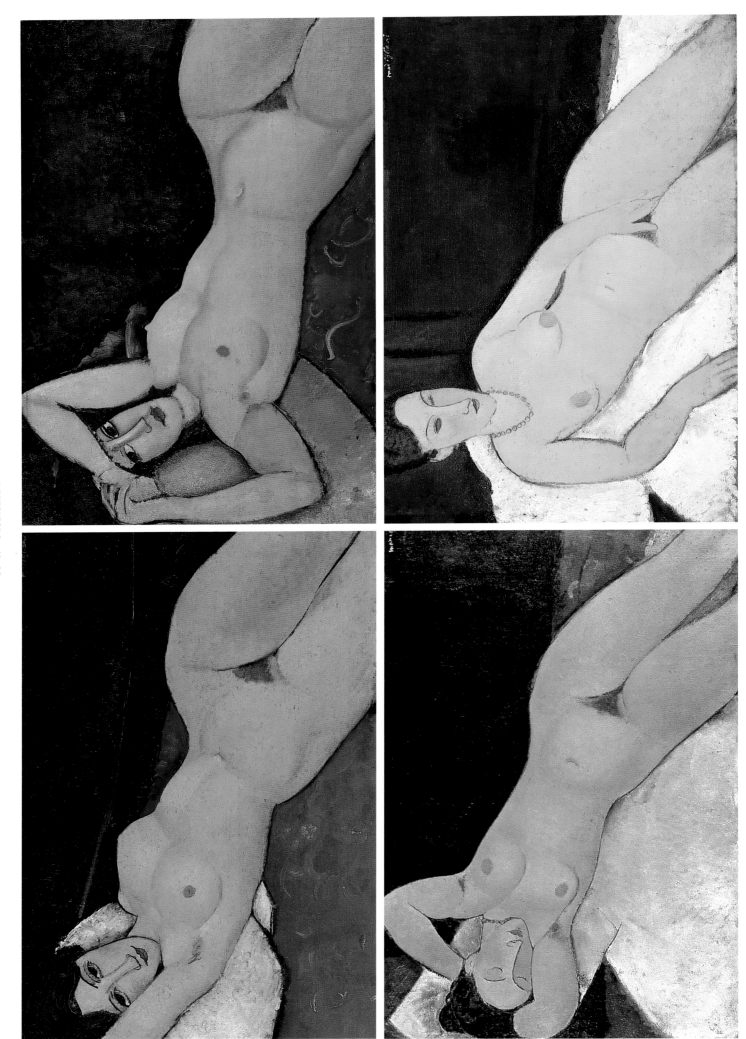

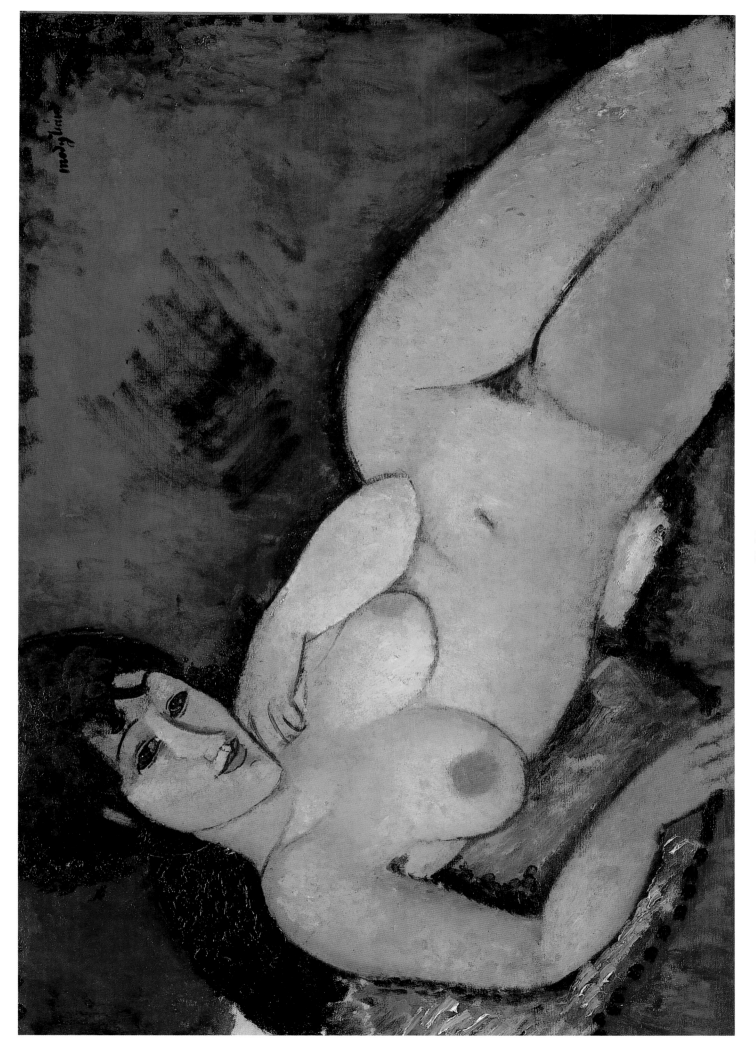

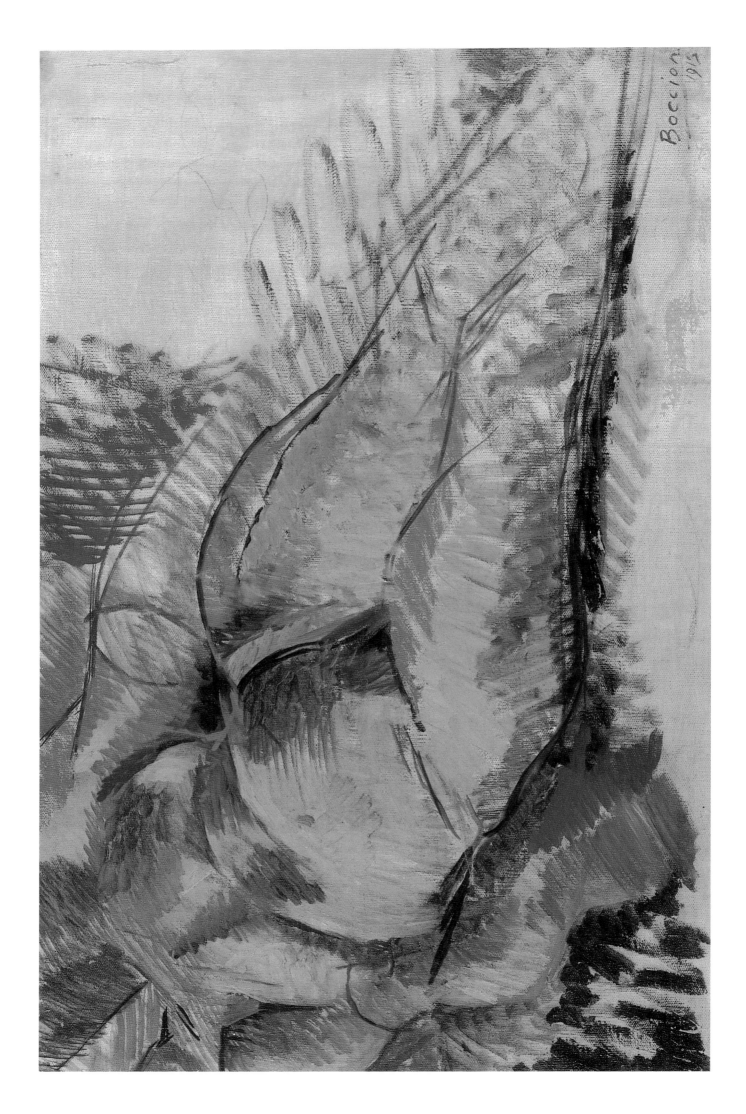

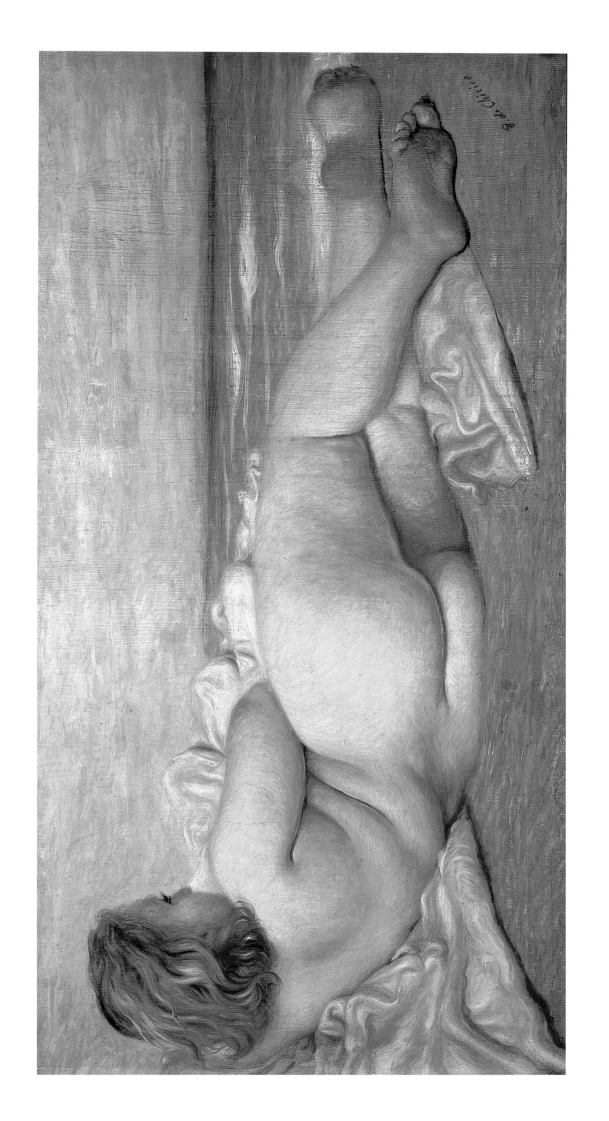

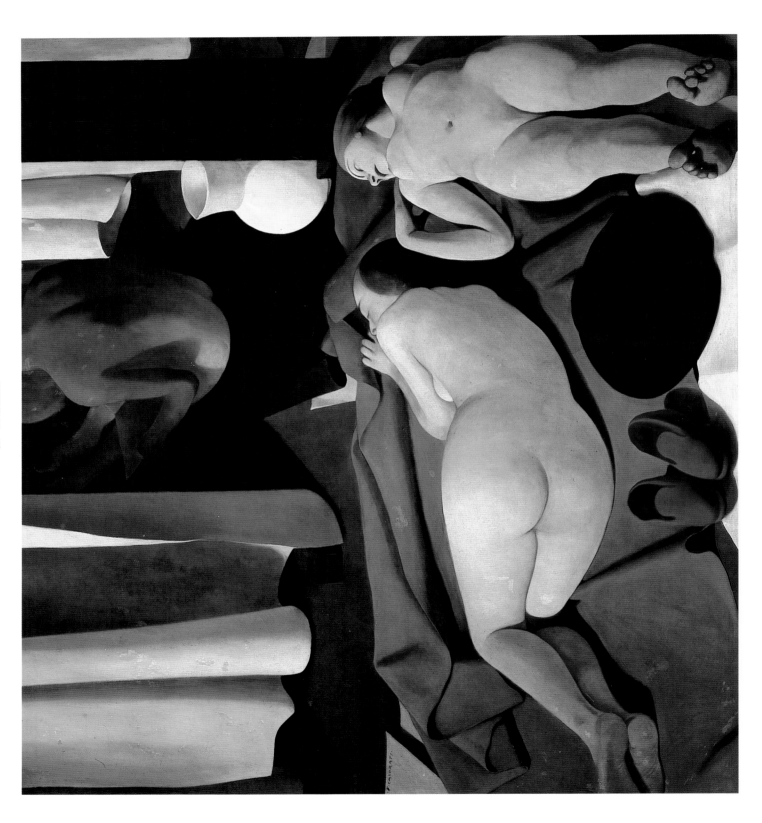

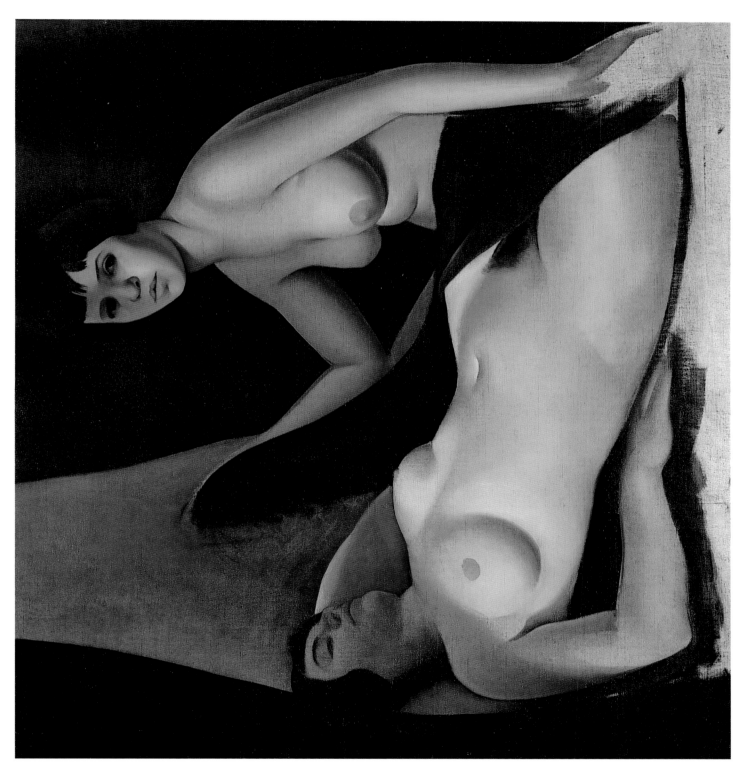

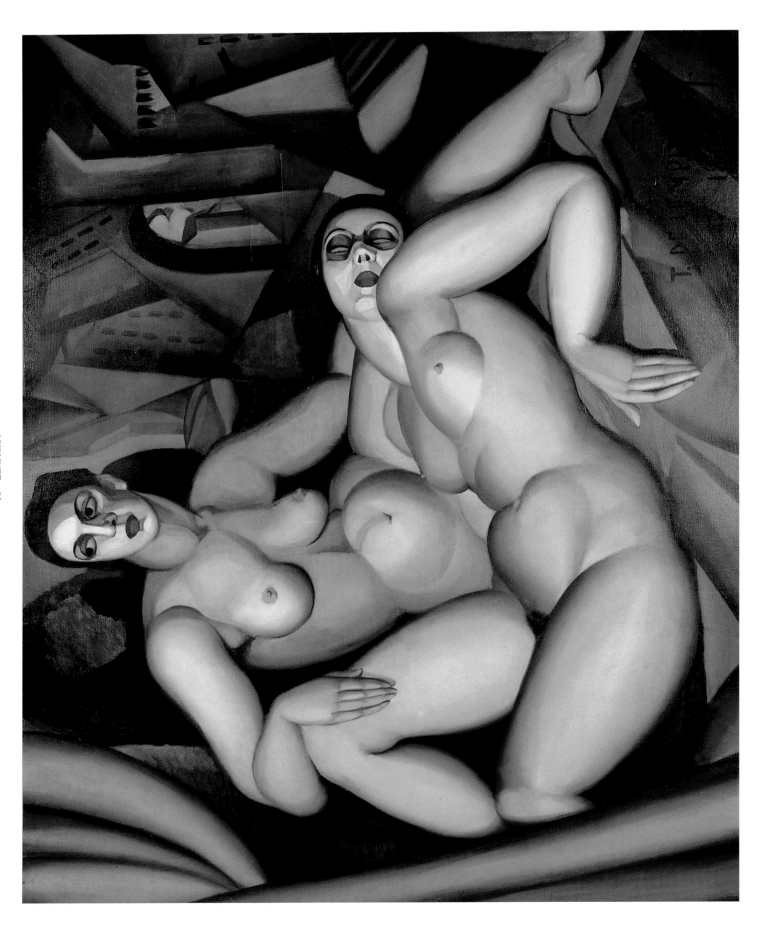

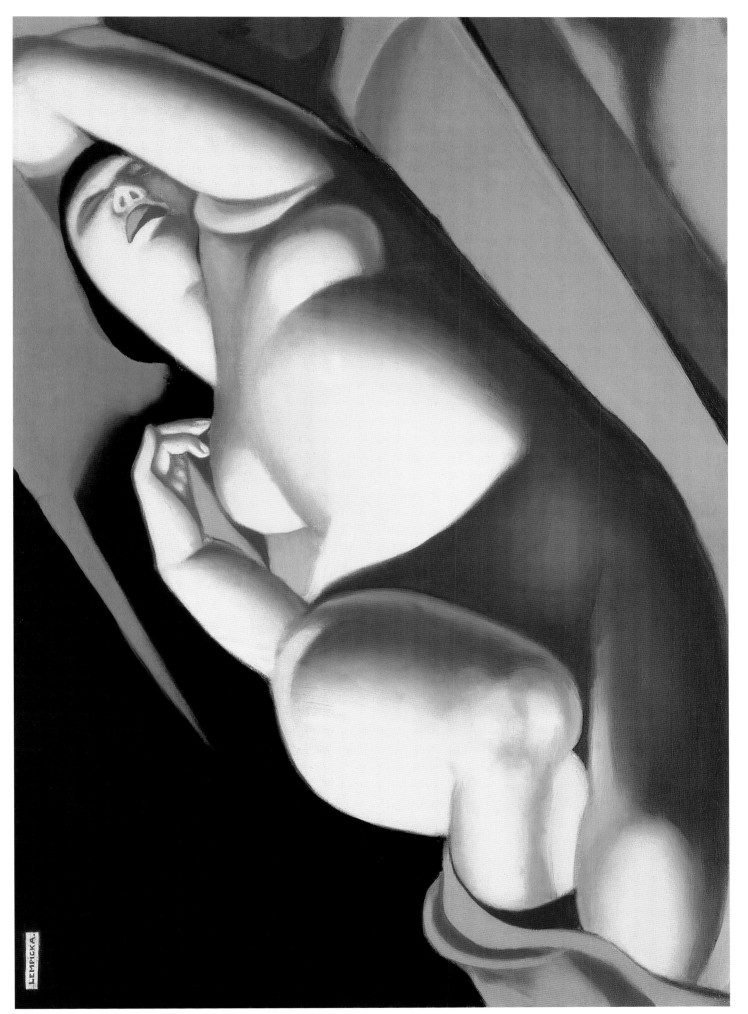

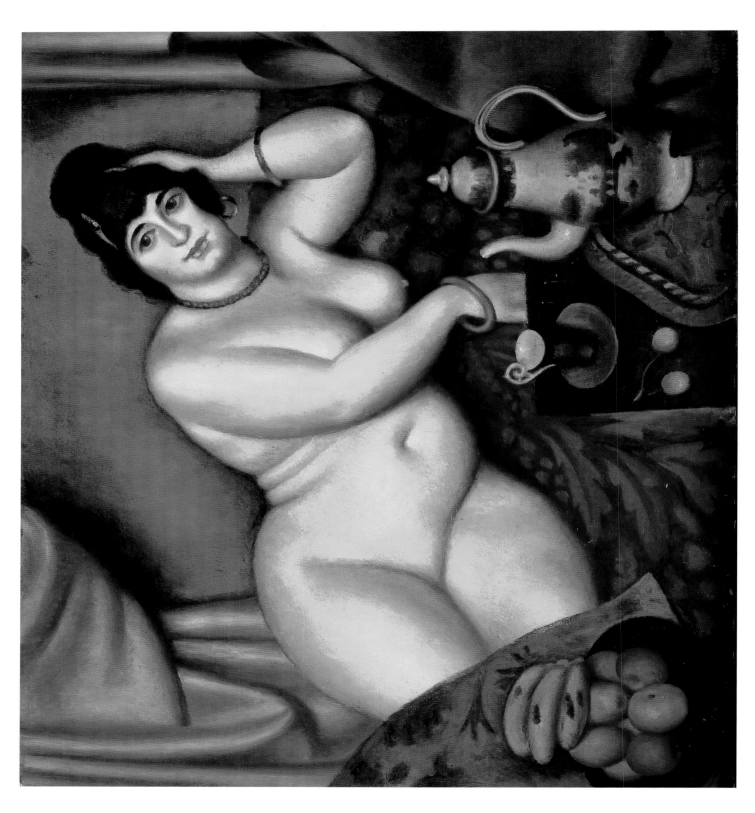

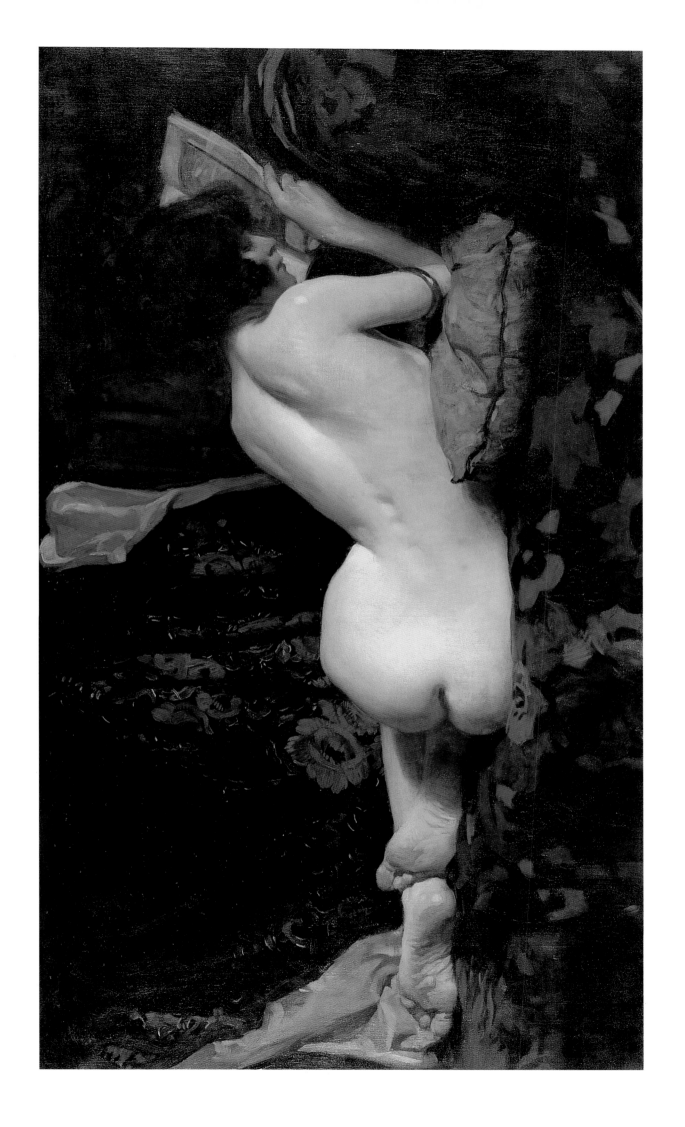

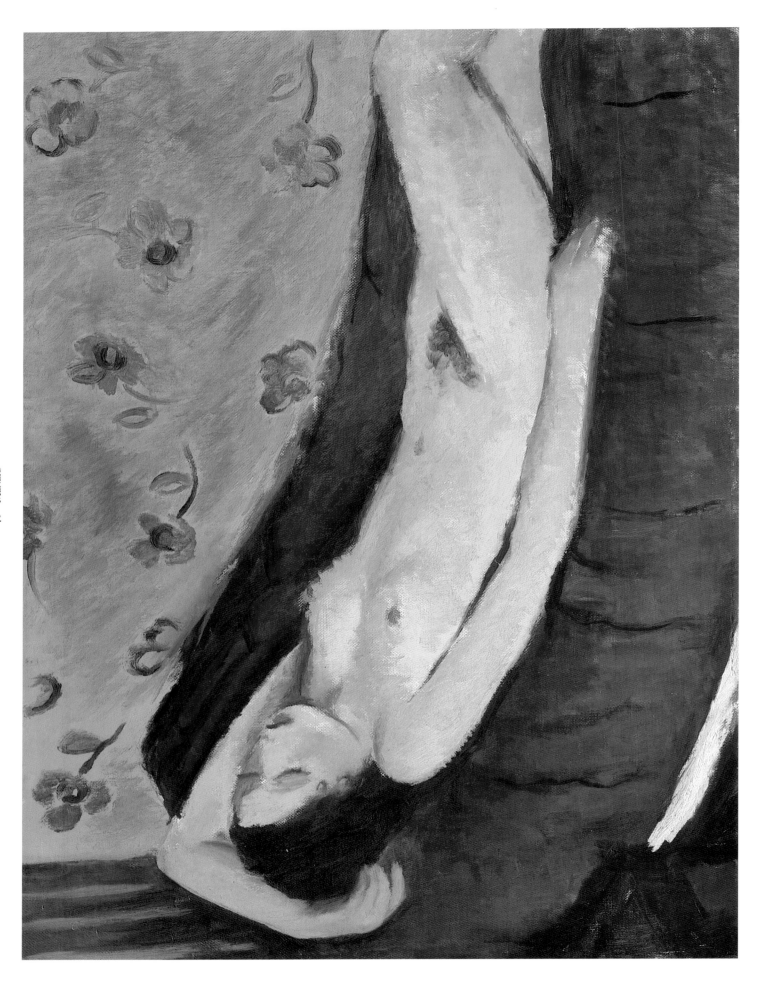

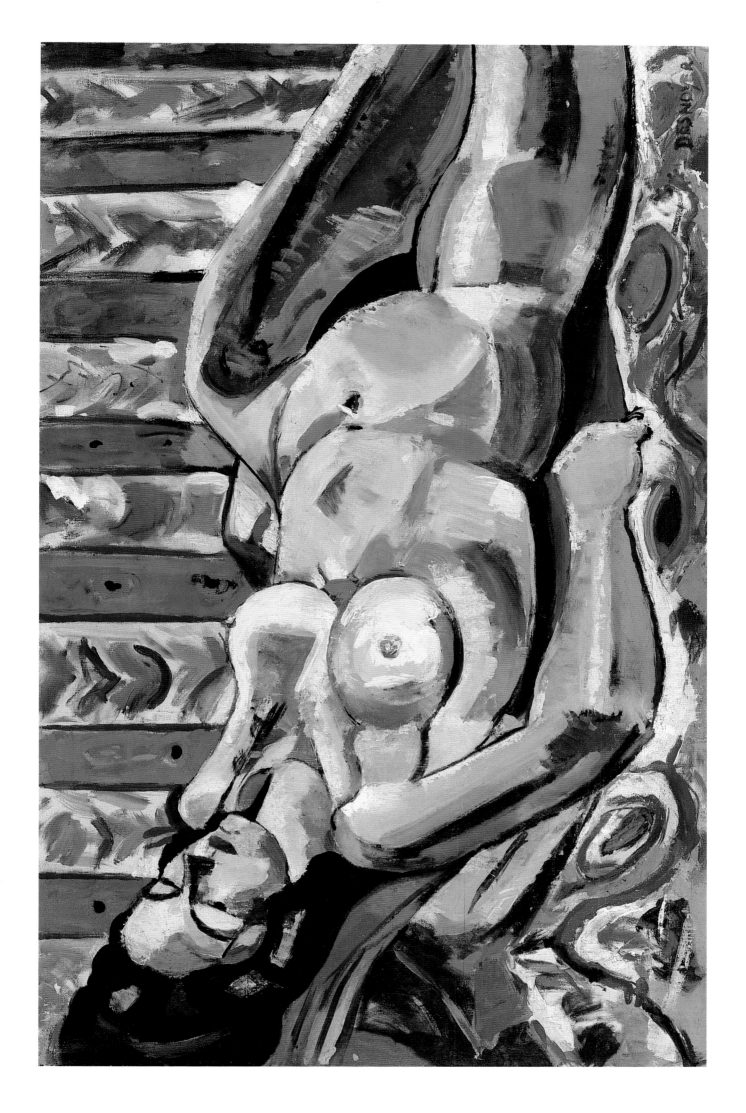

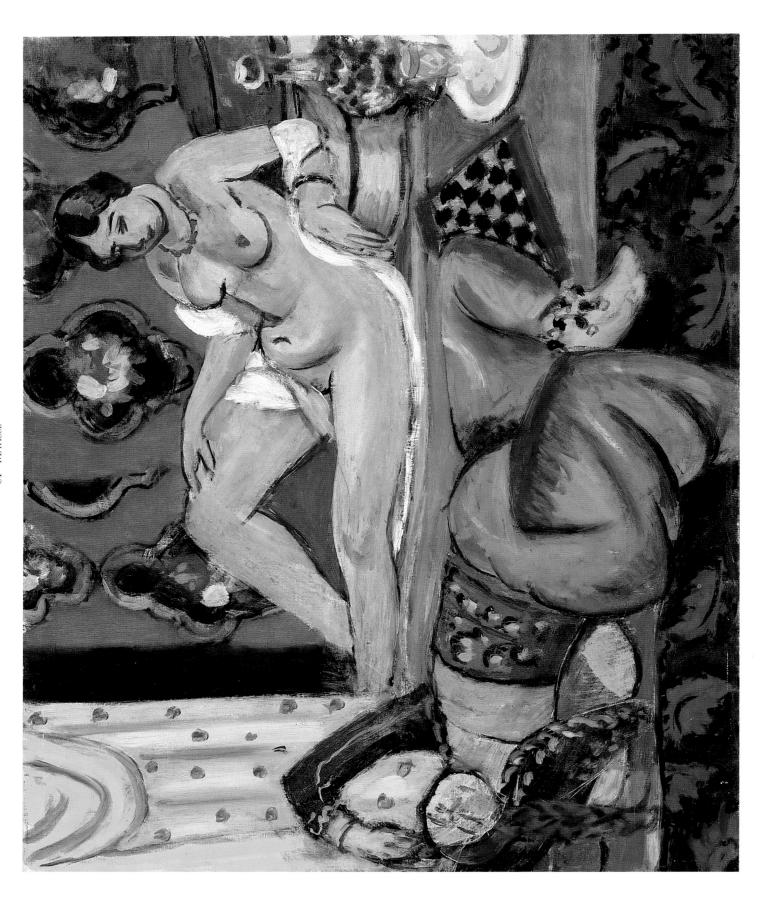

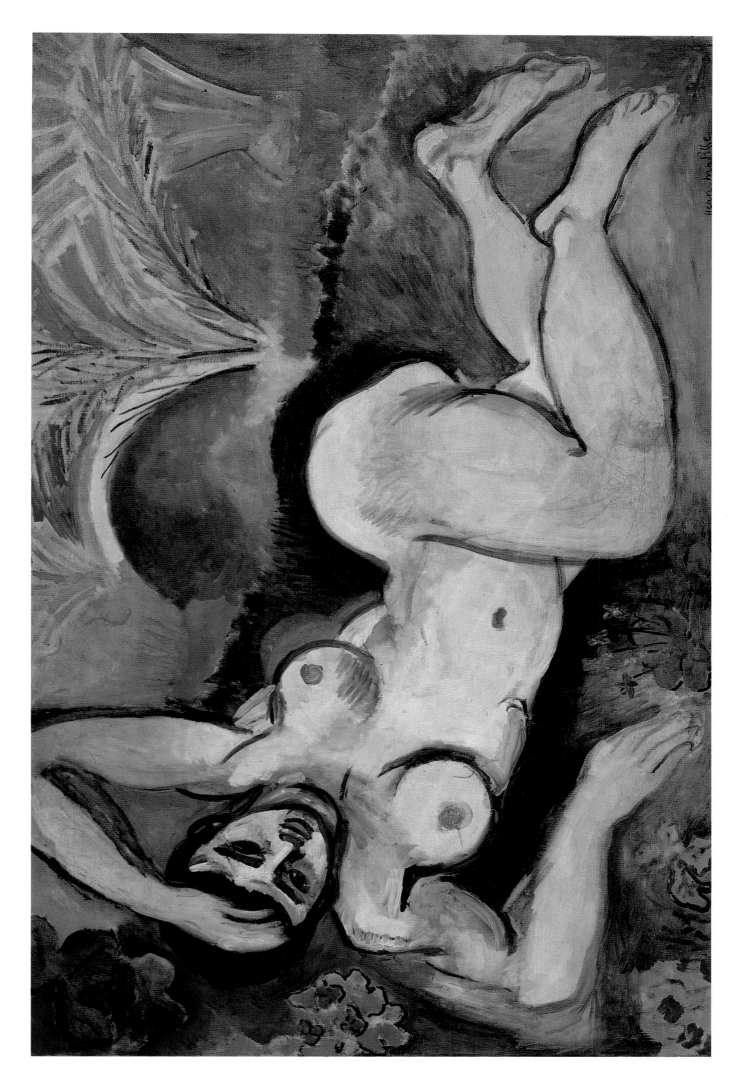

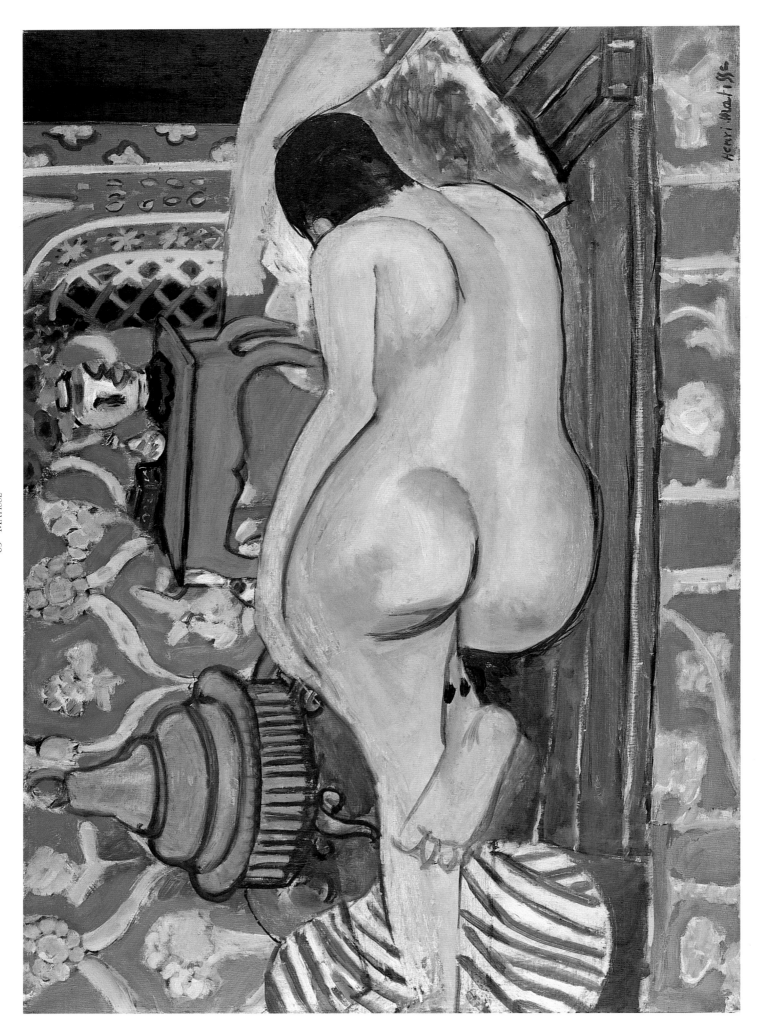

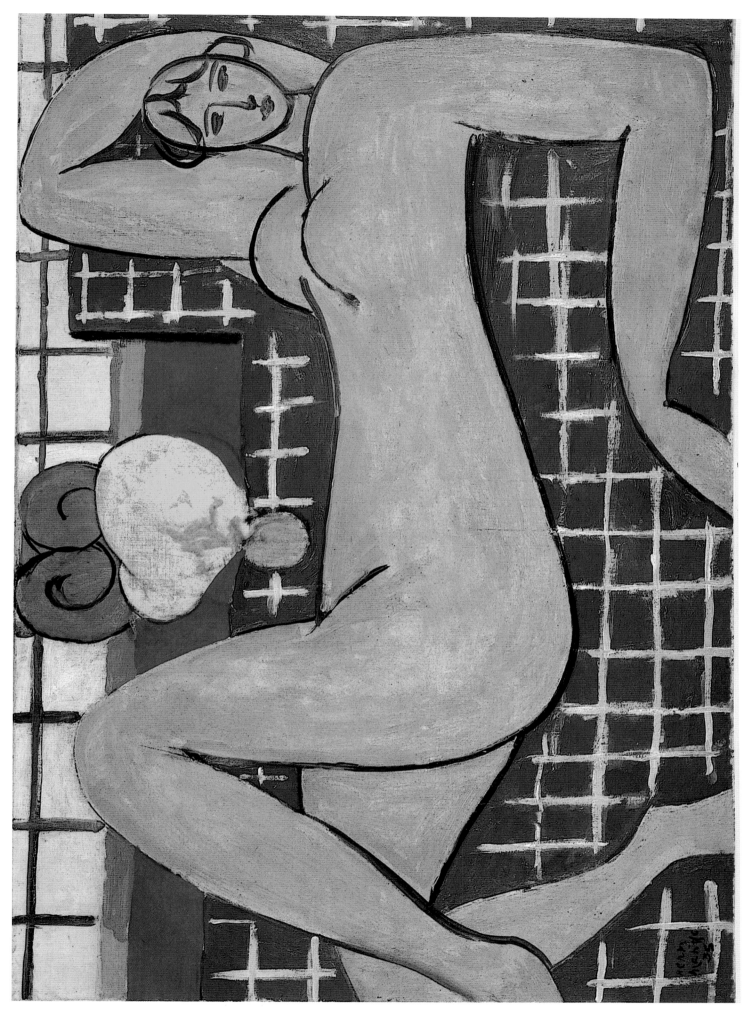

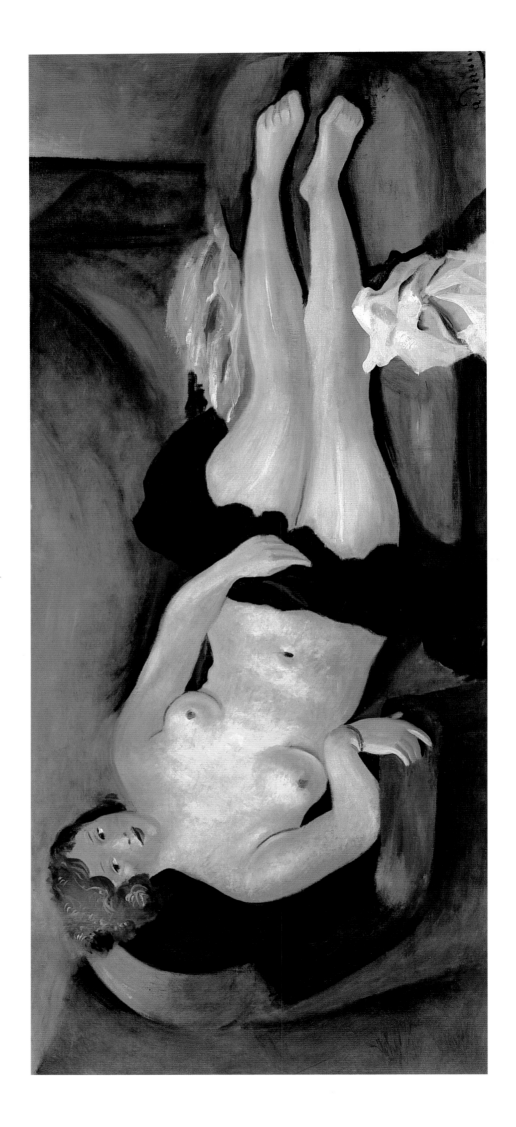

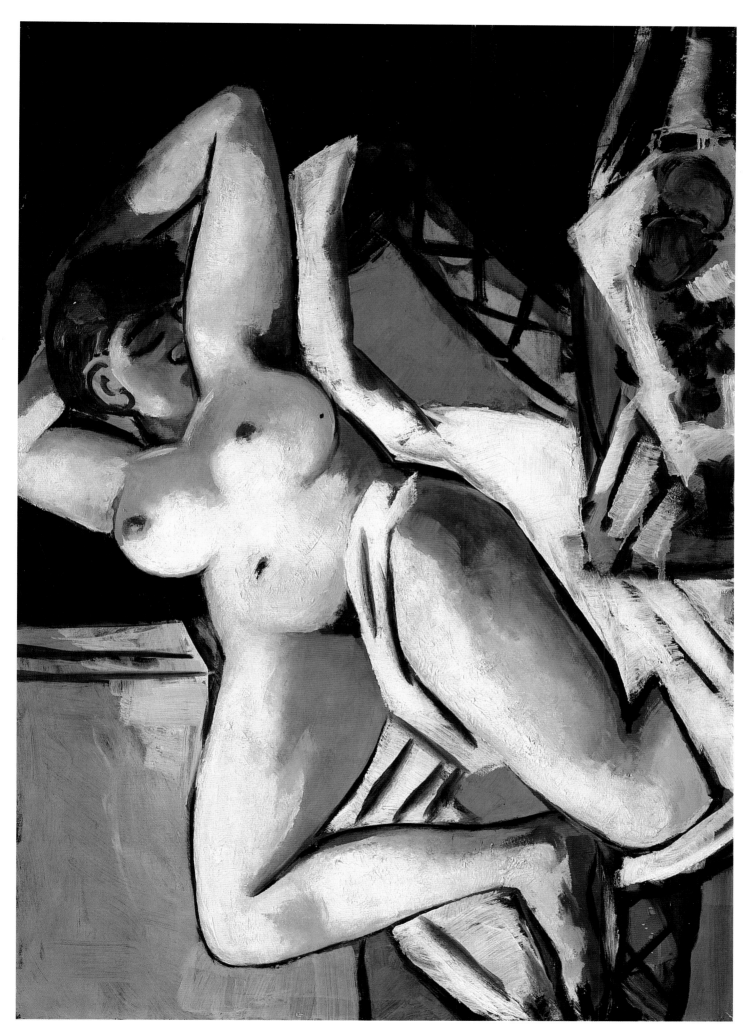

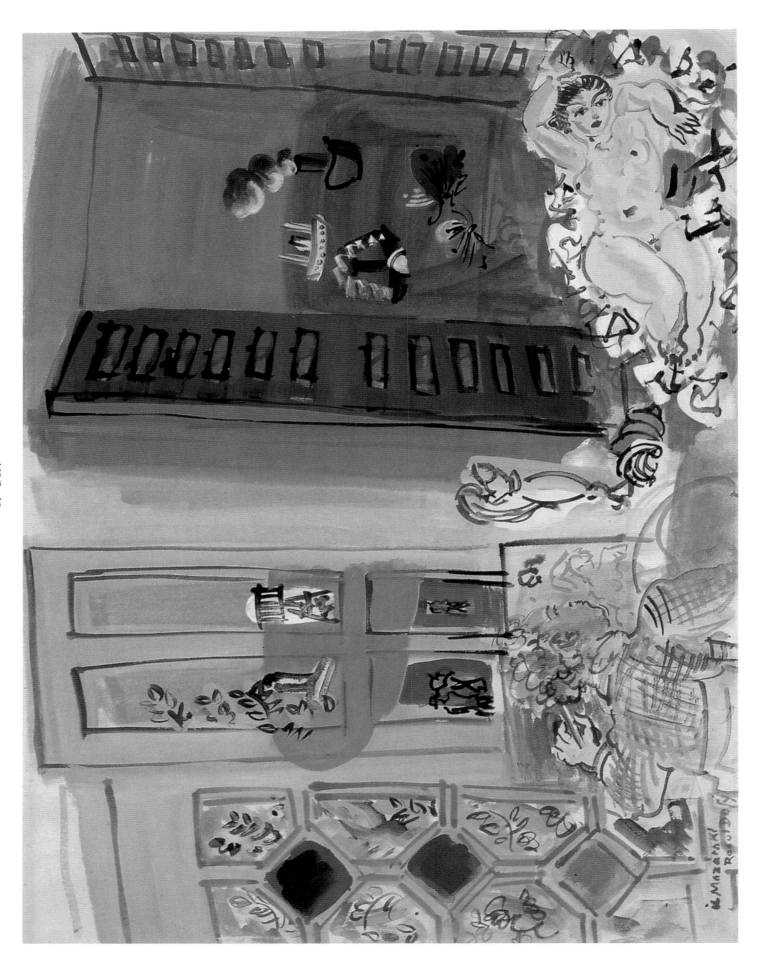

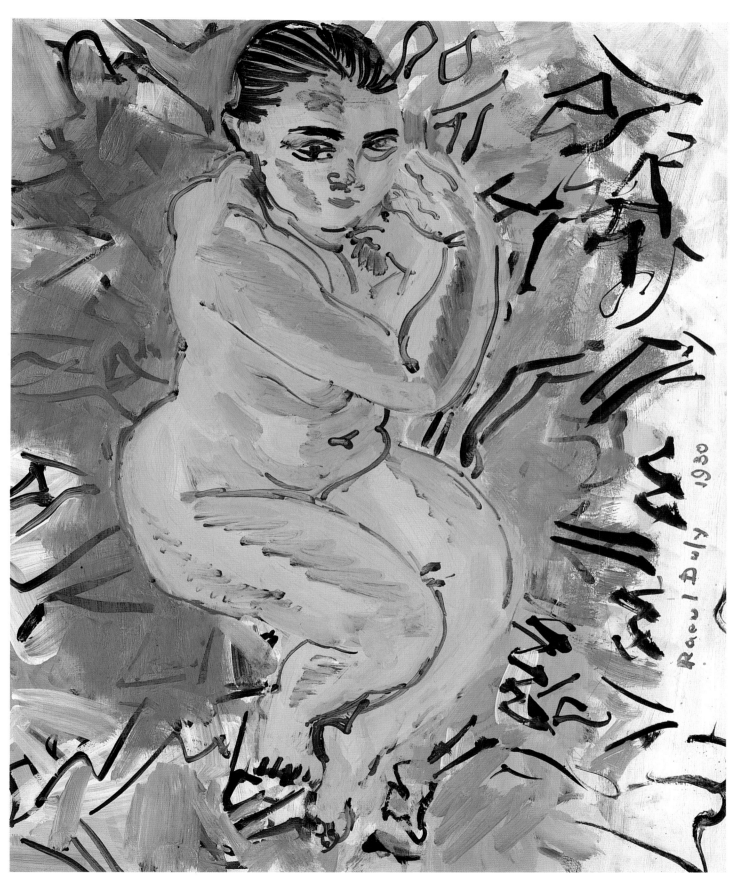

Raoul Dufy 1930

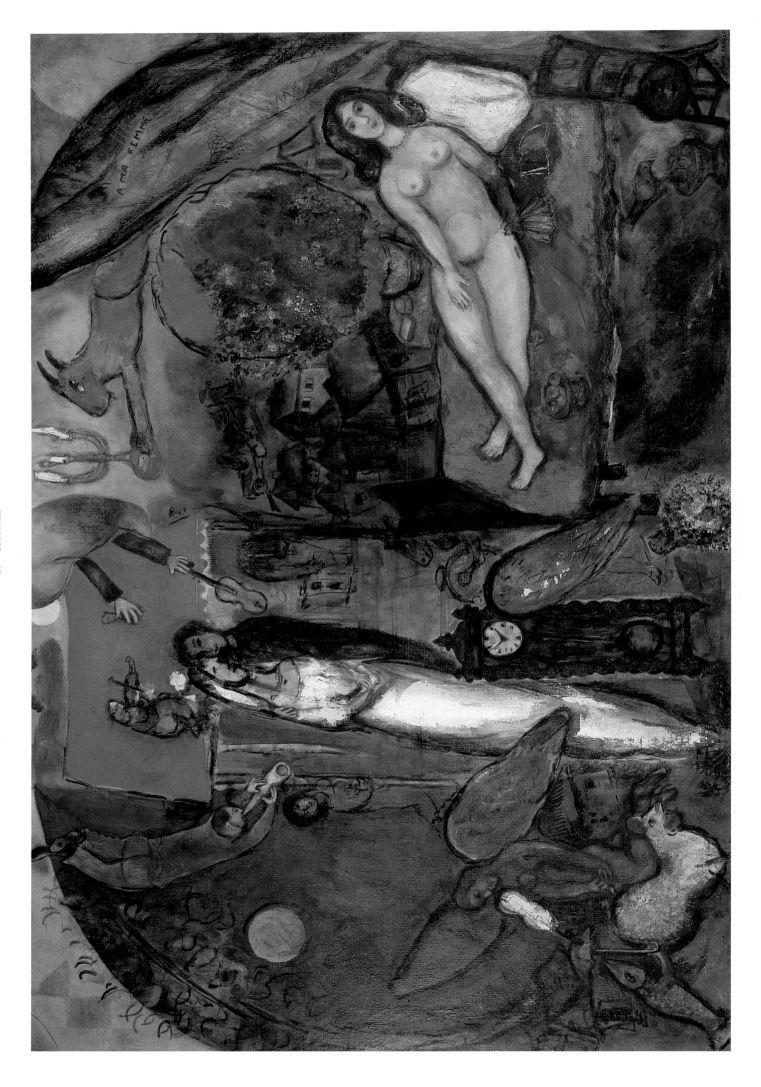

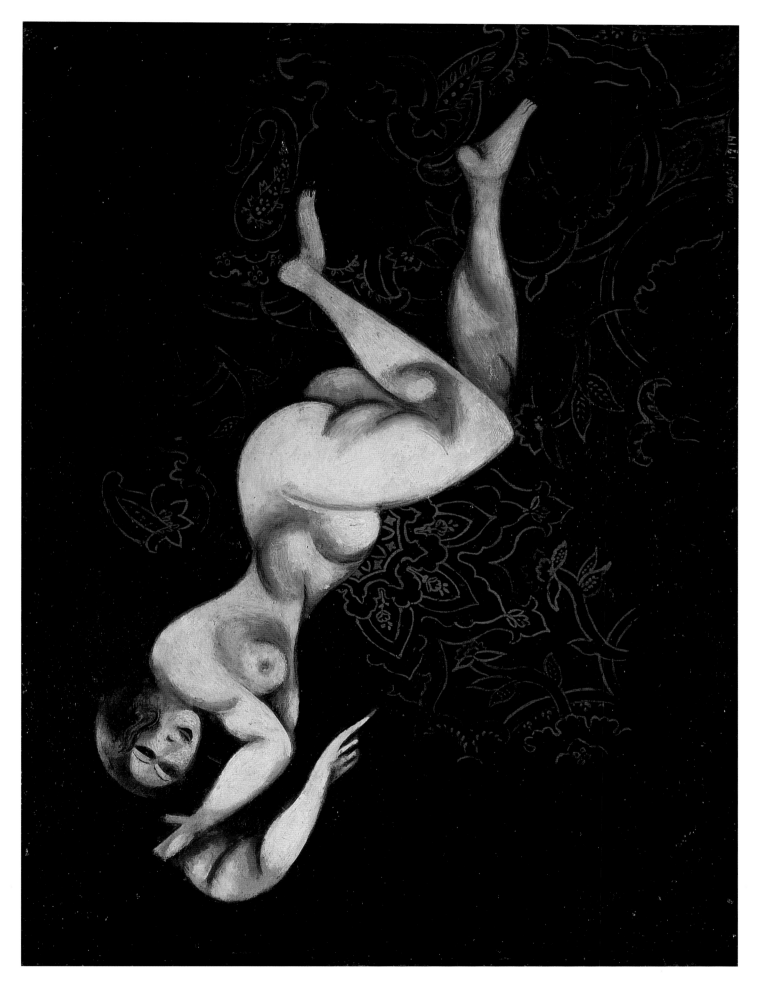

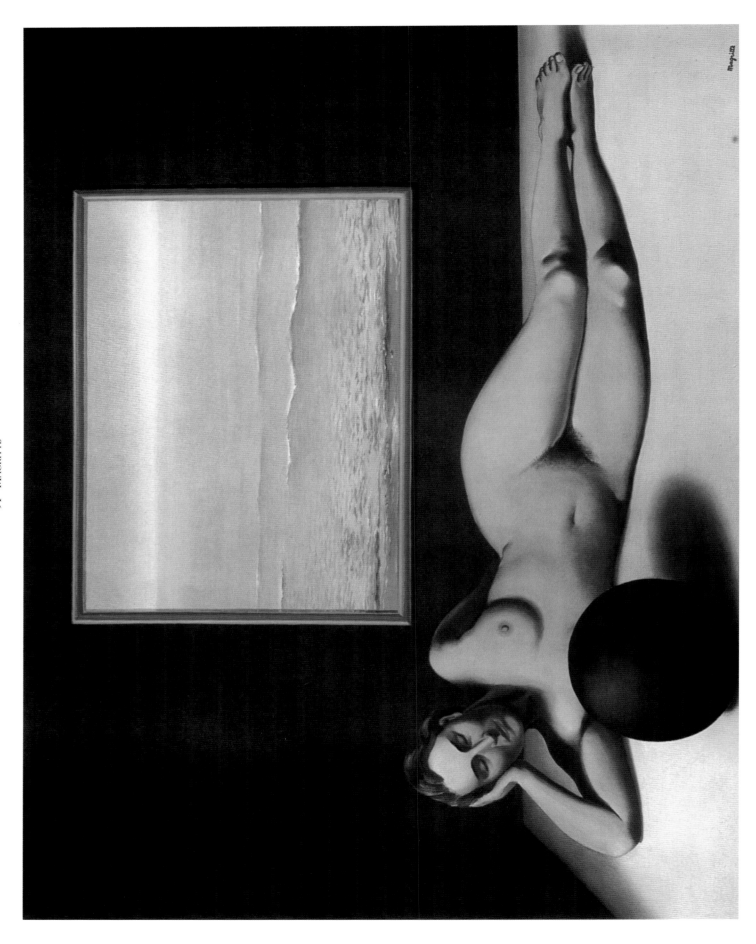

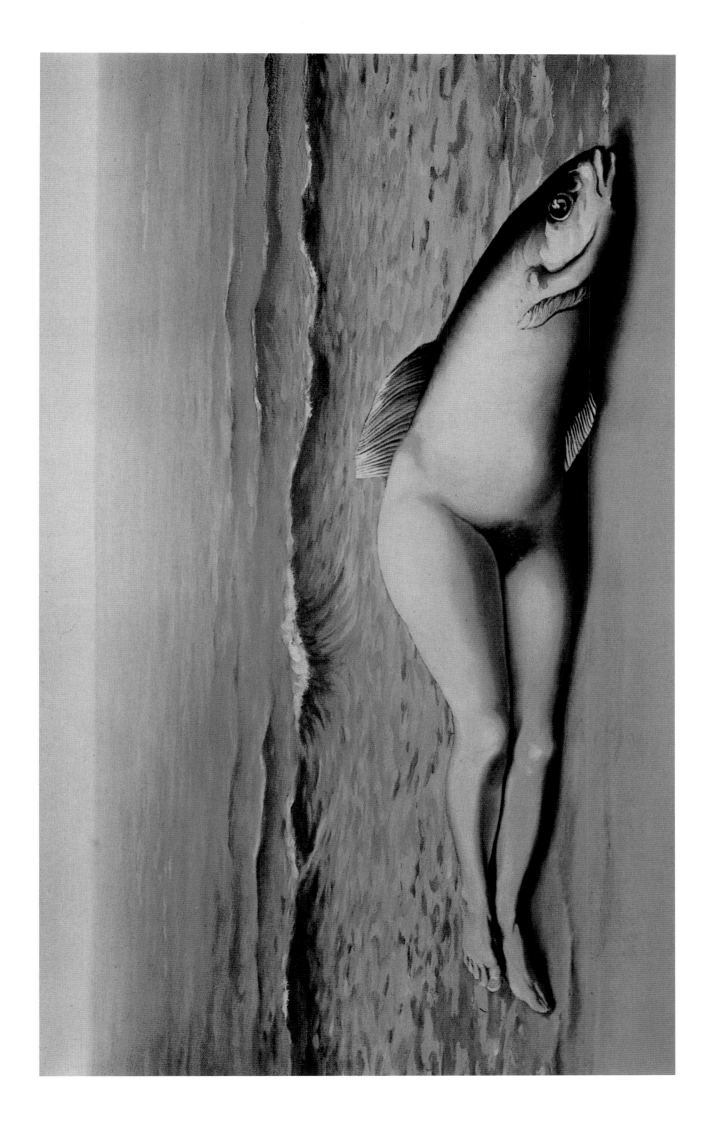

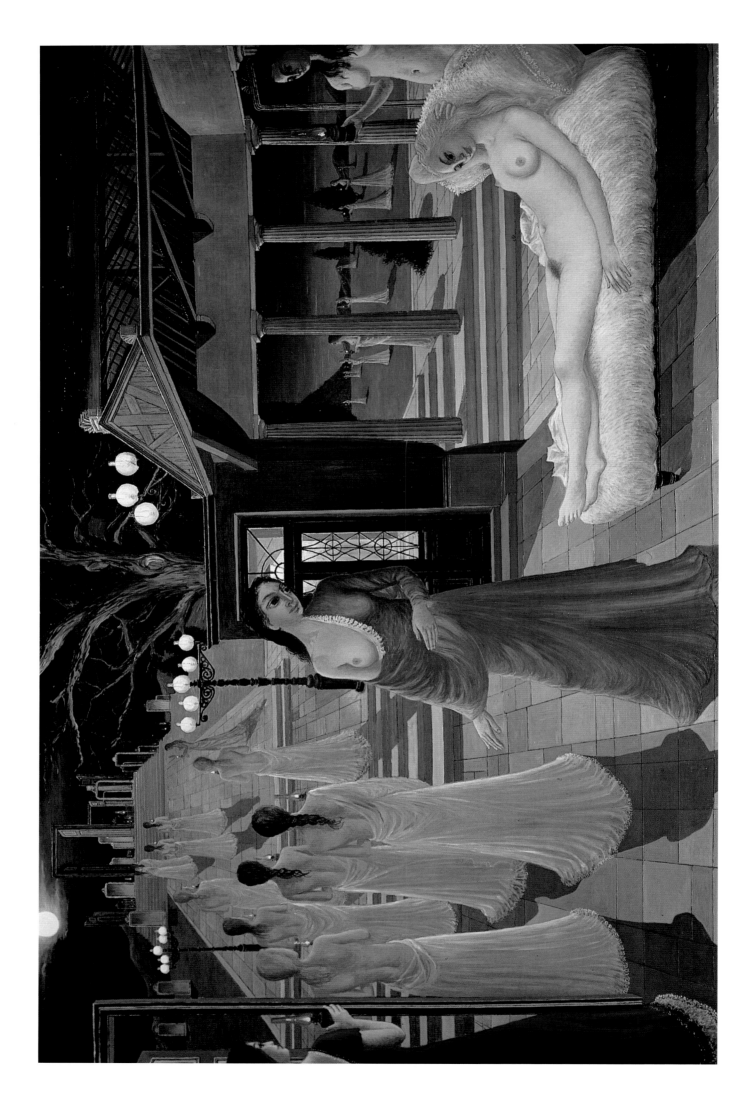

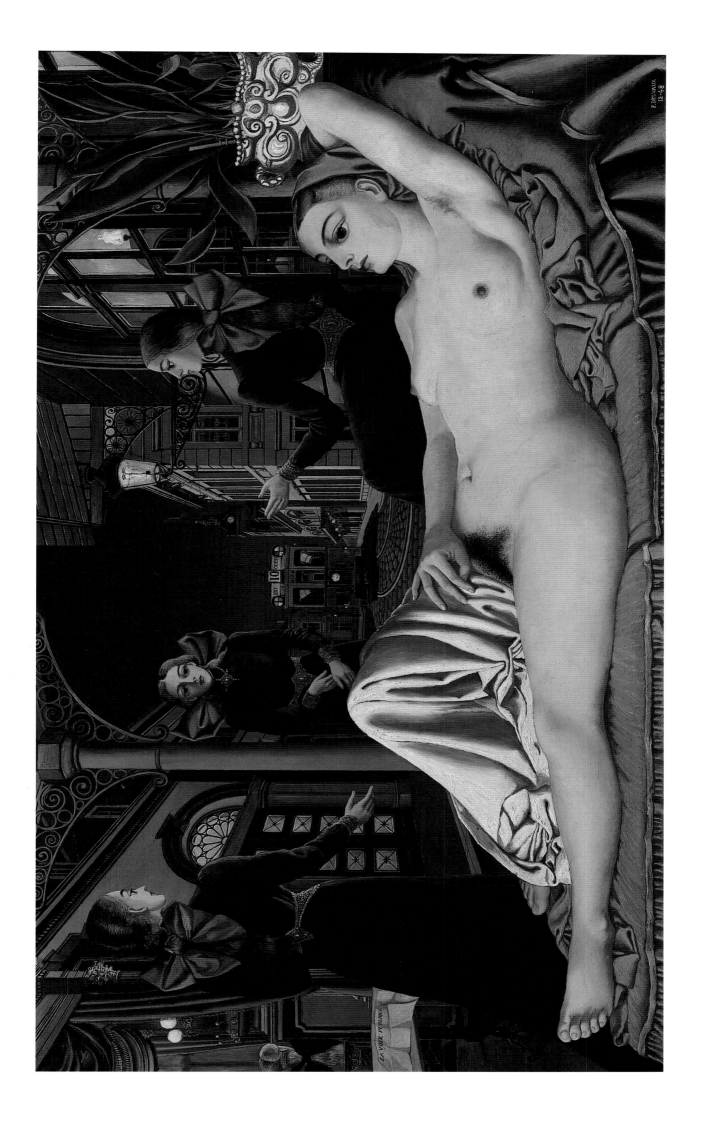

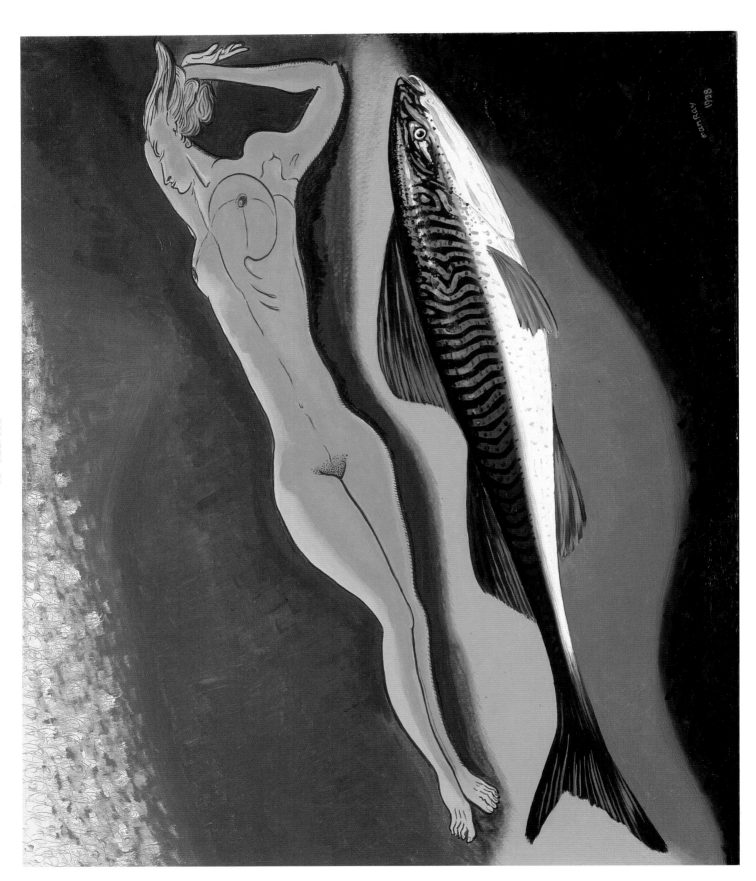

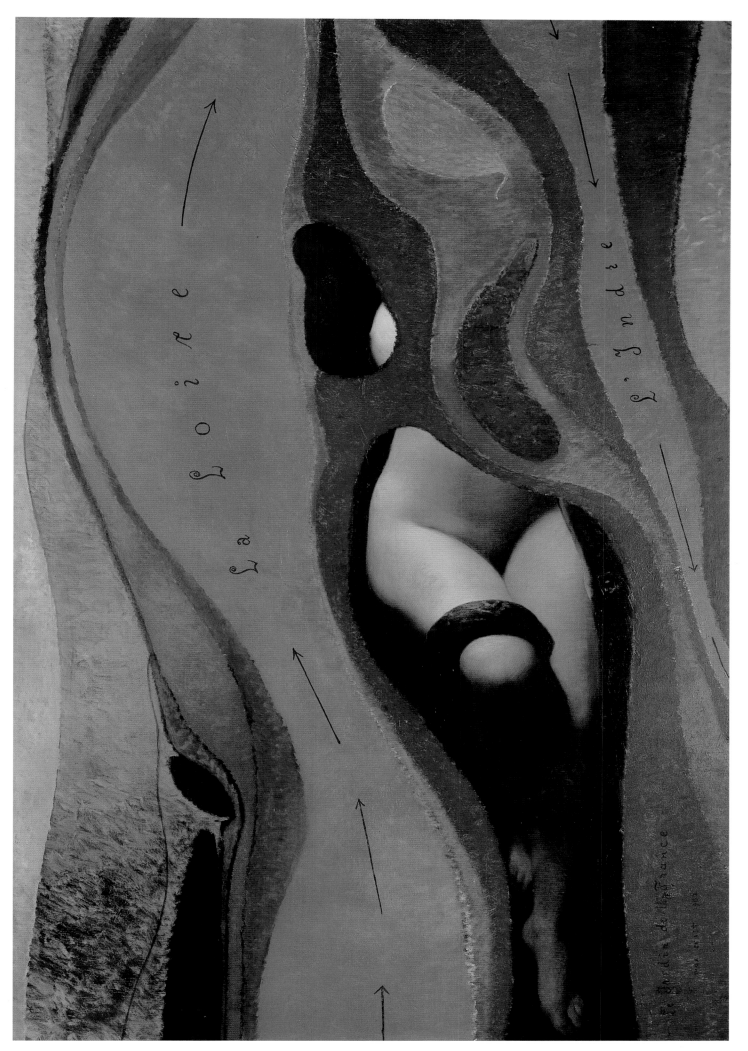

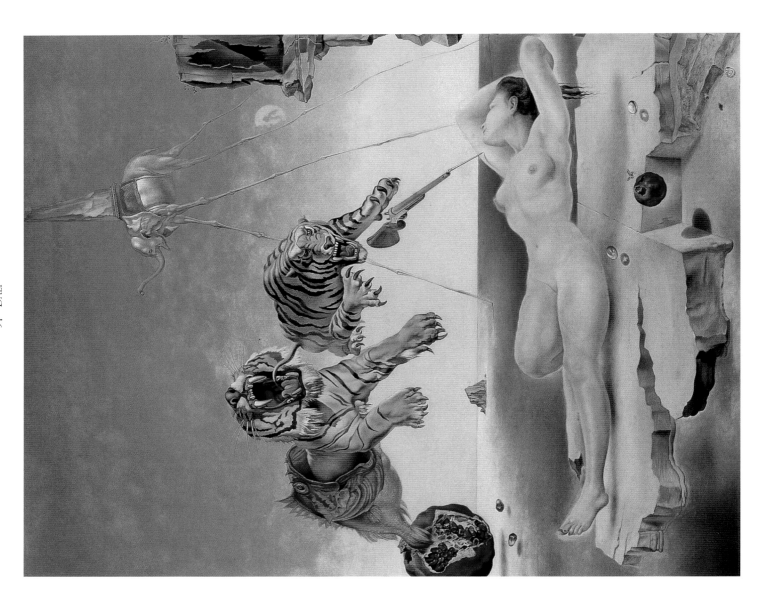

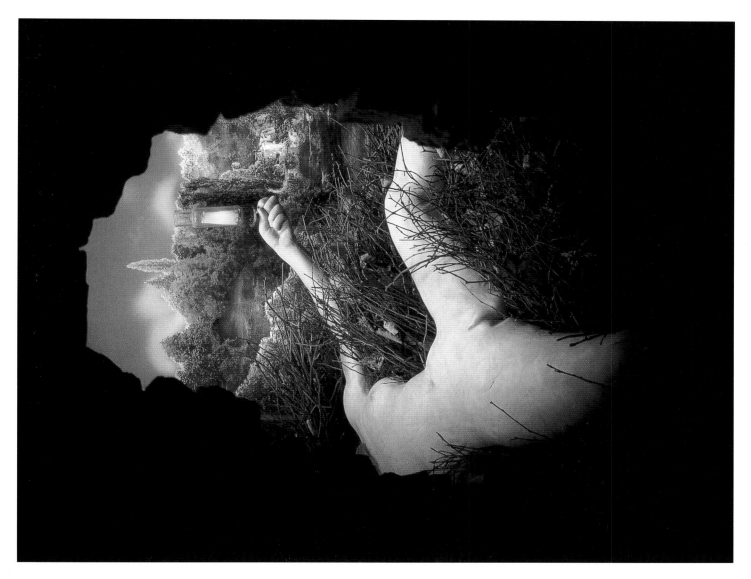

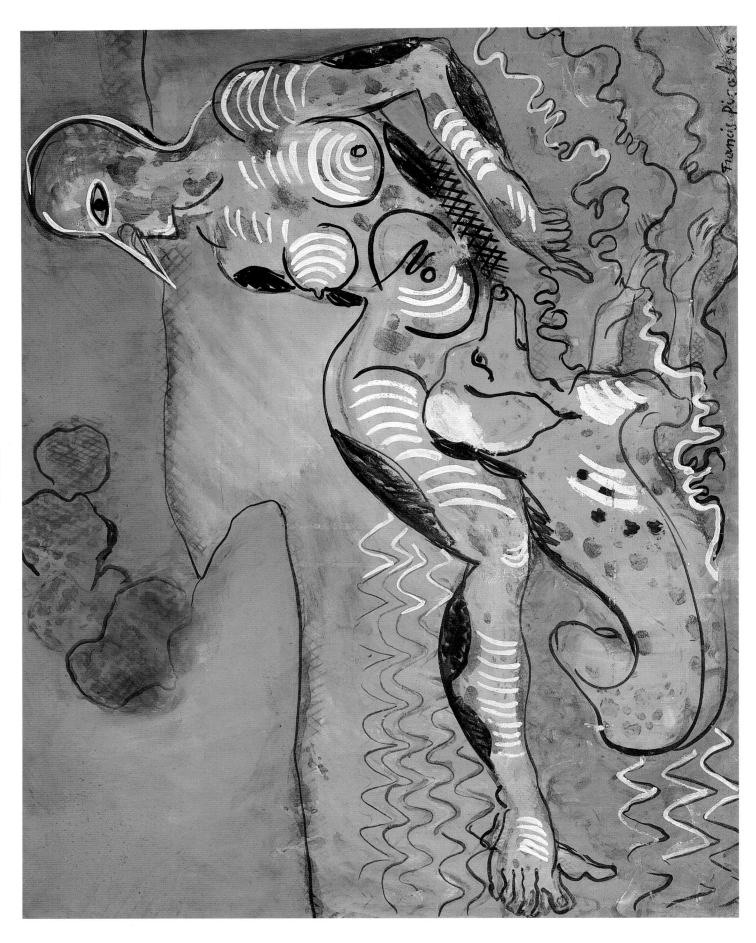

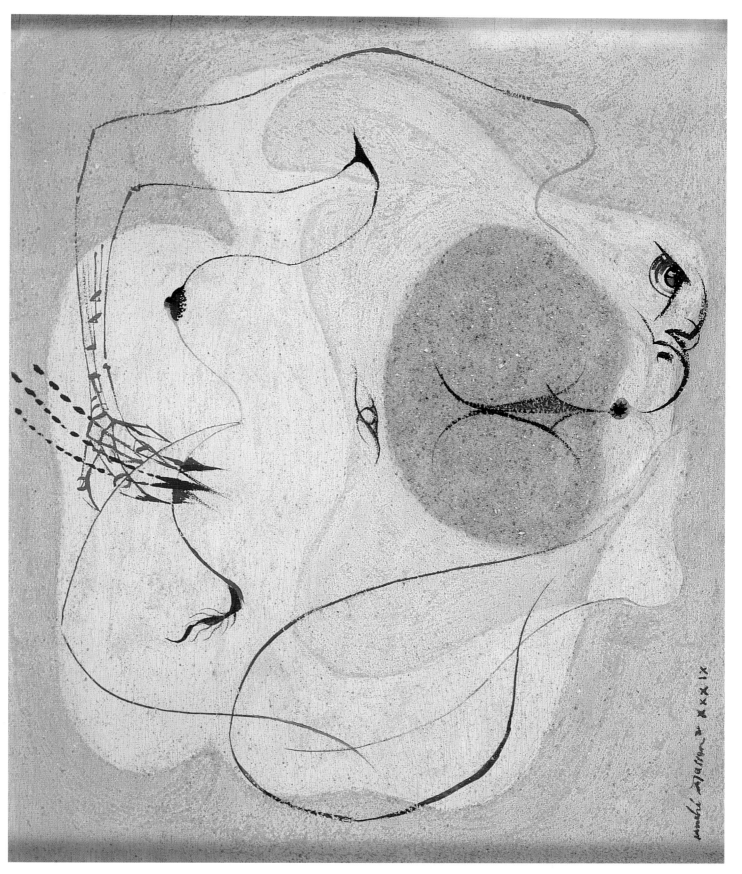

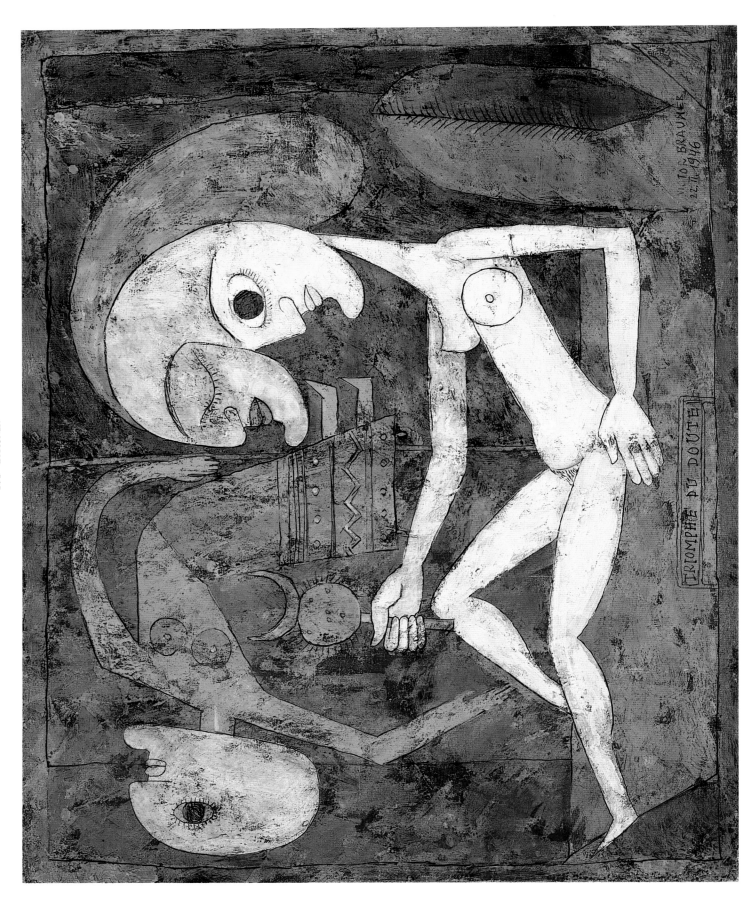

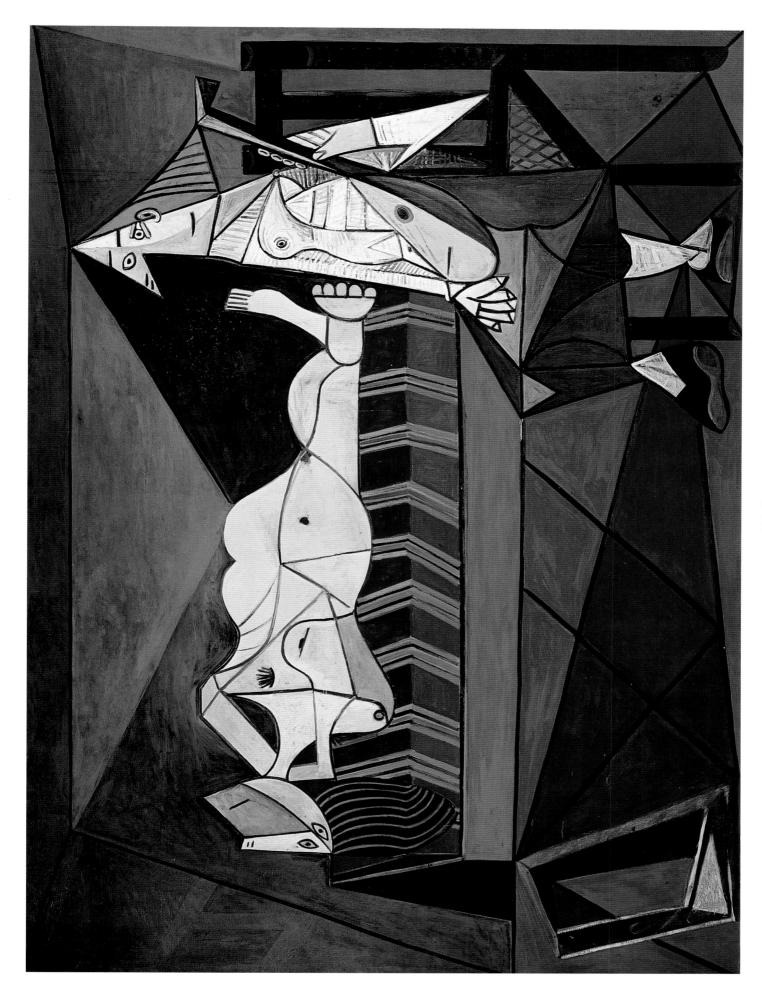

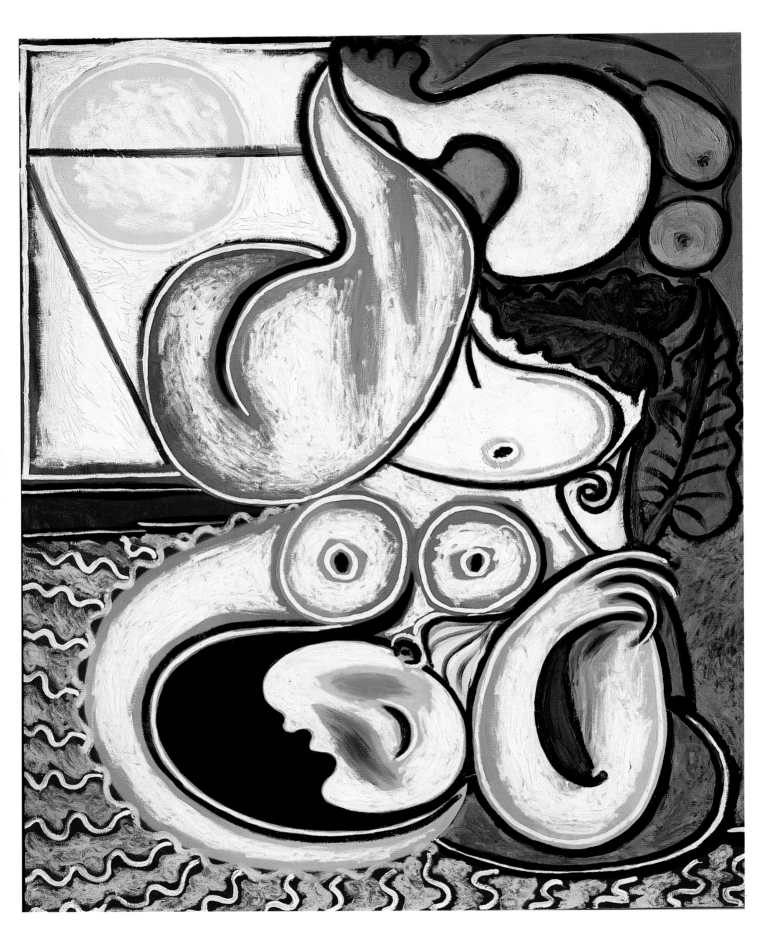

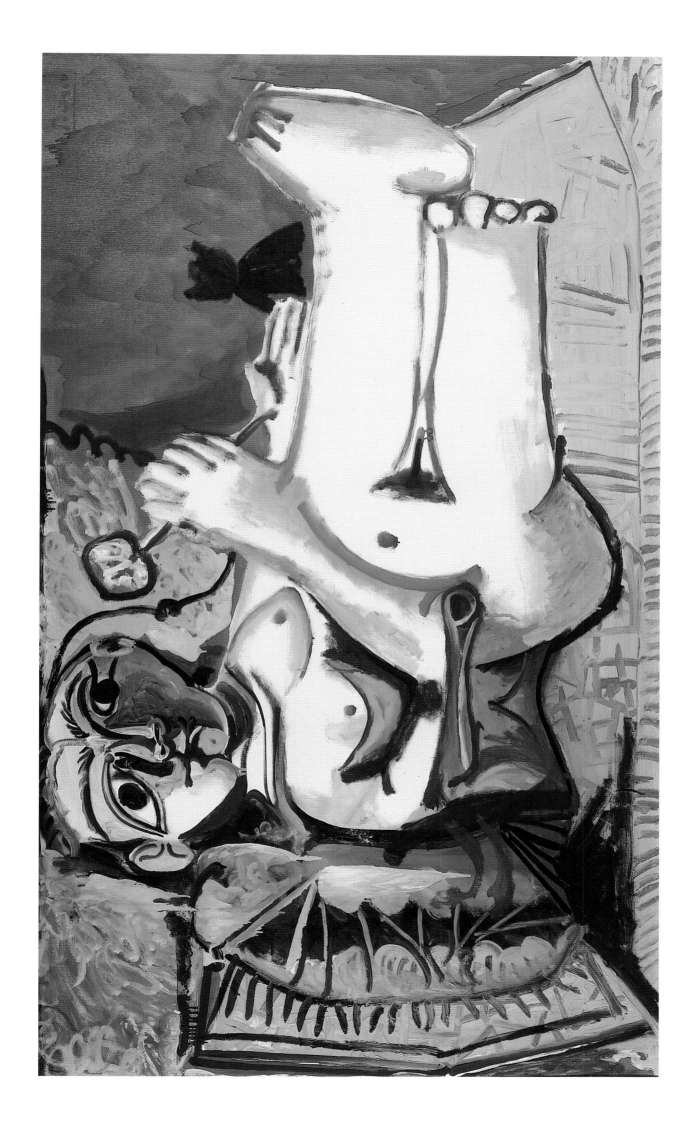

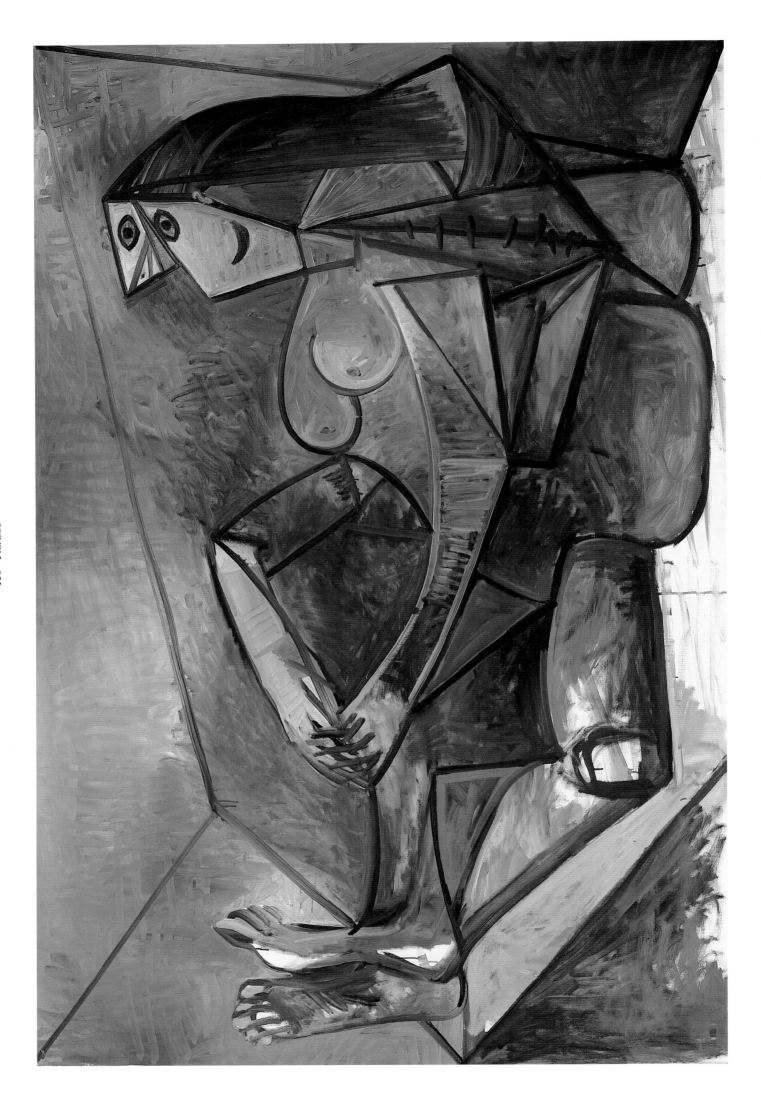

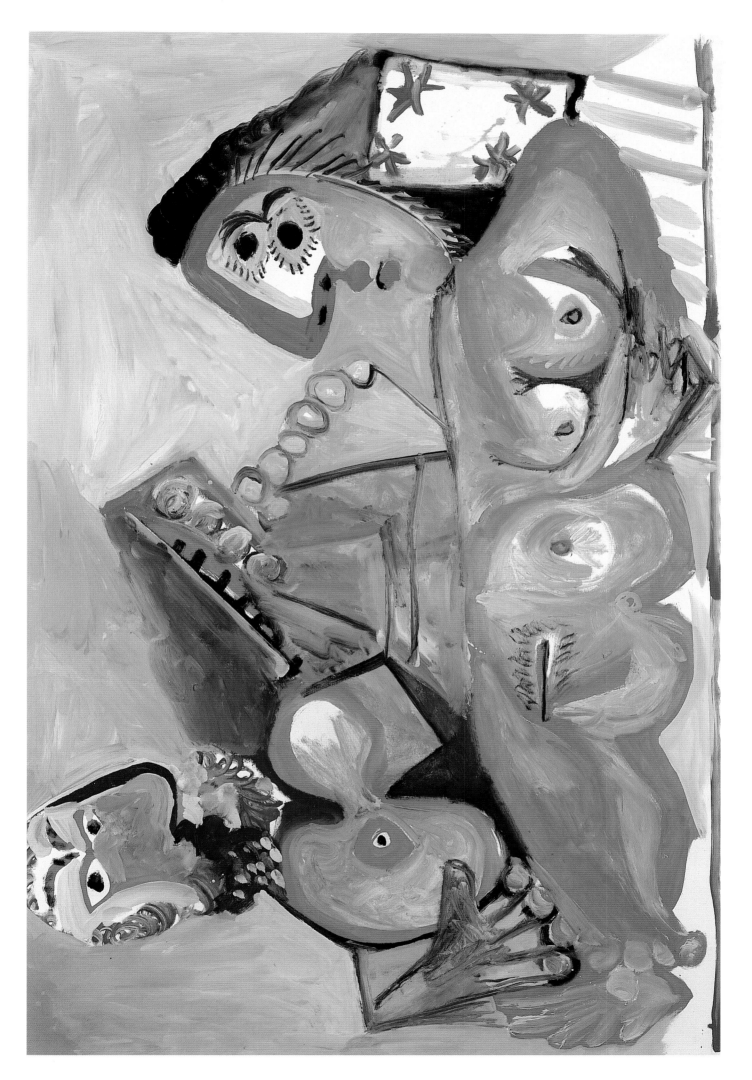

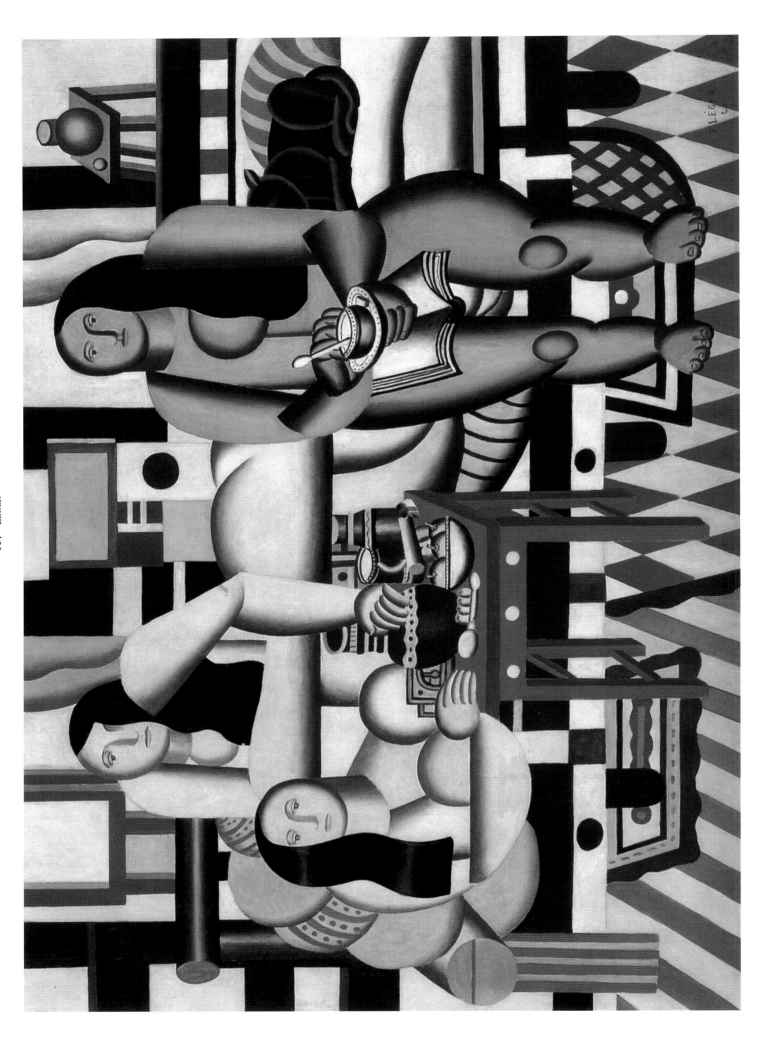

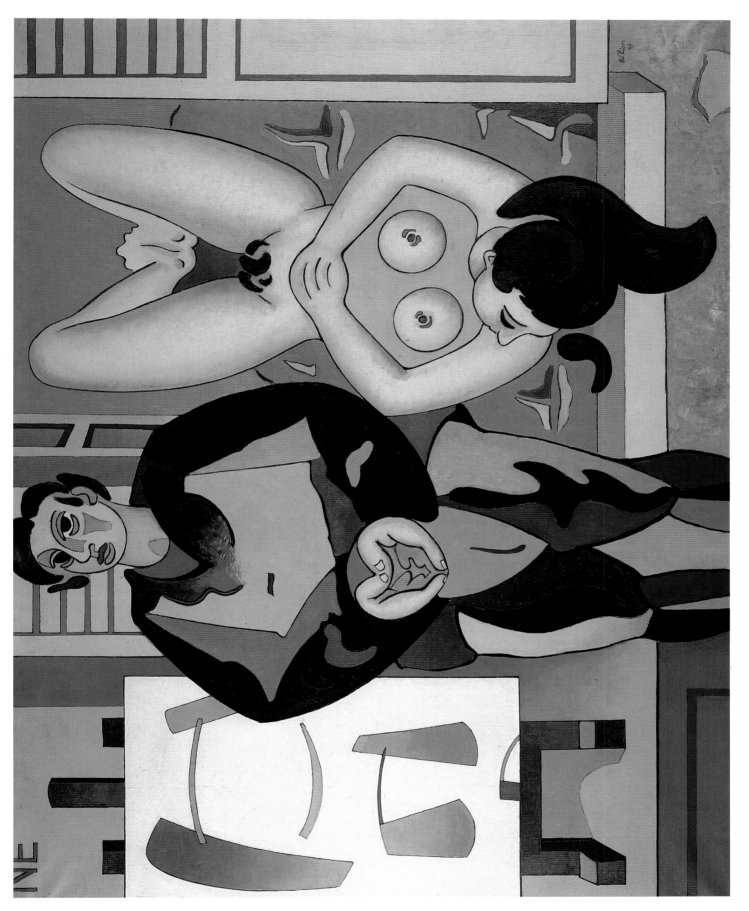

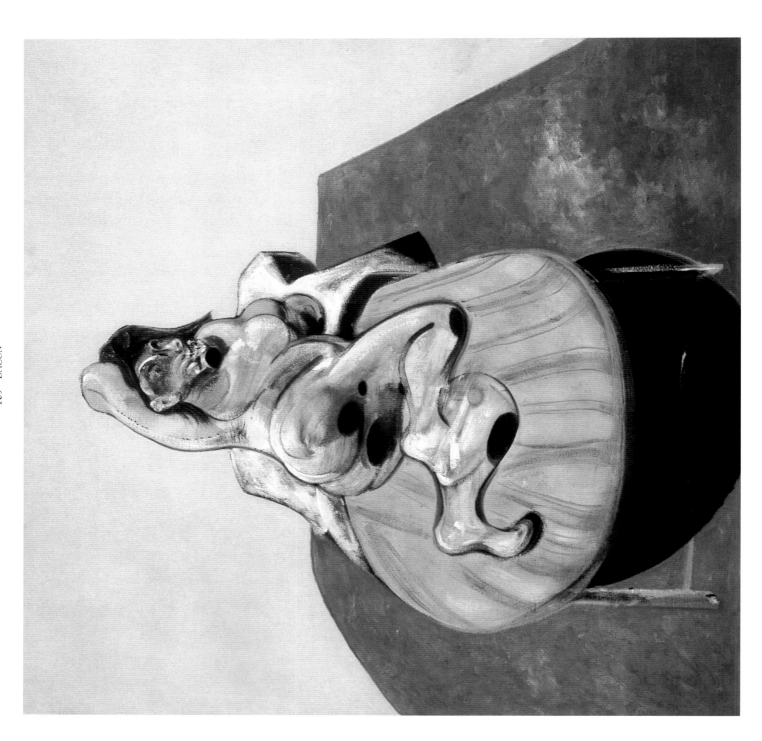

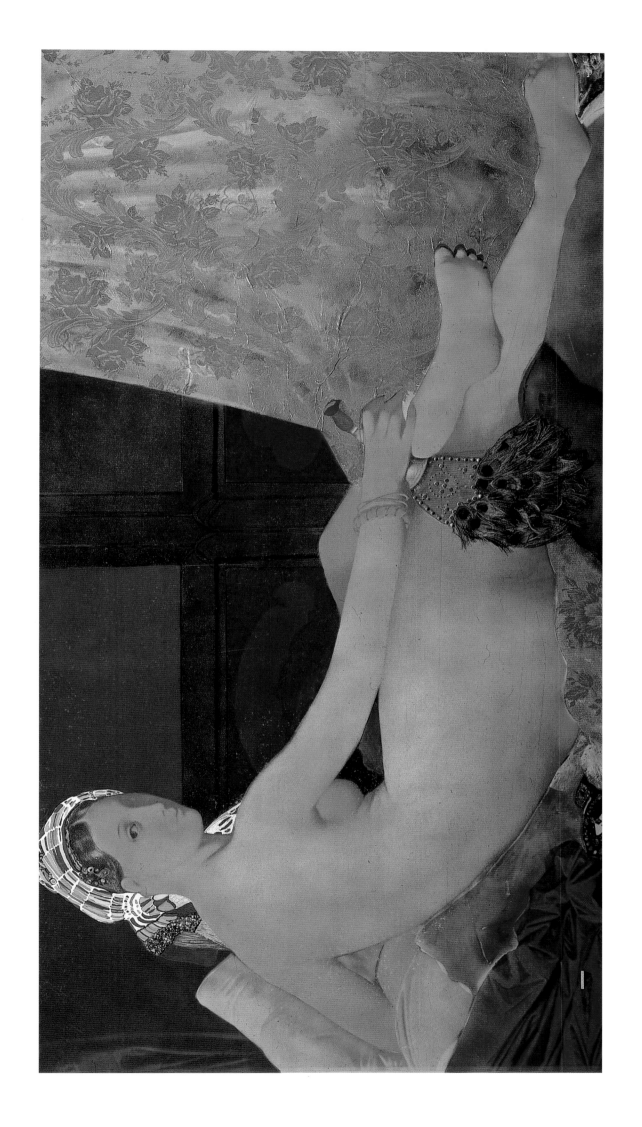

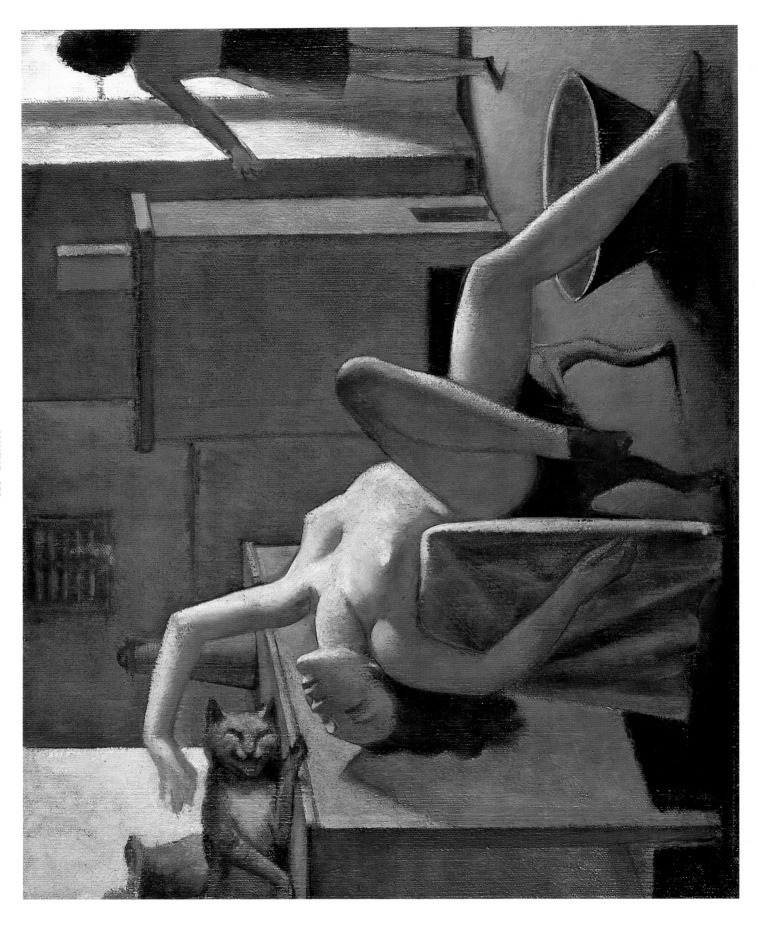

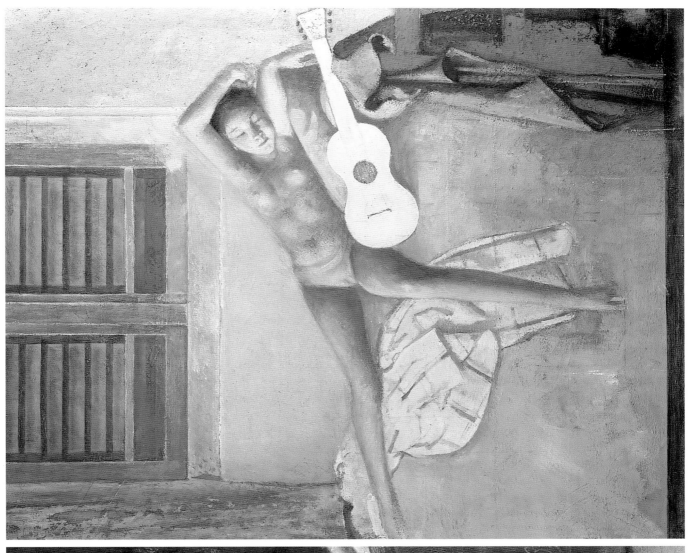

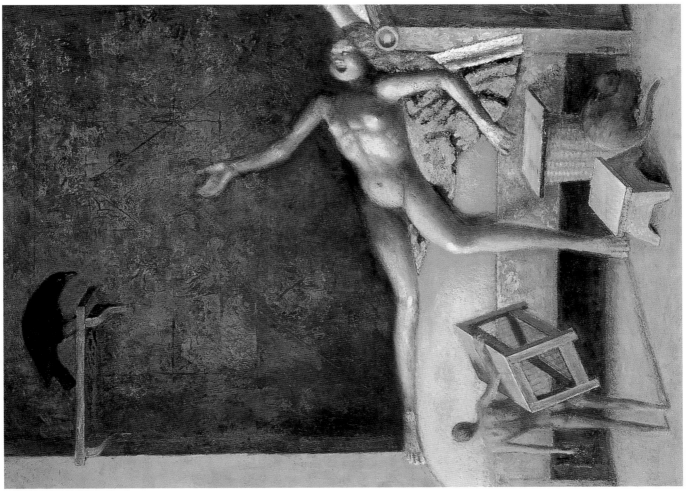

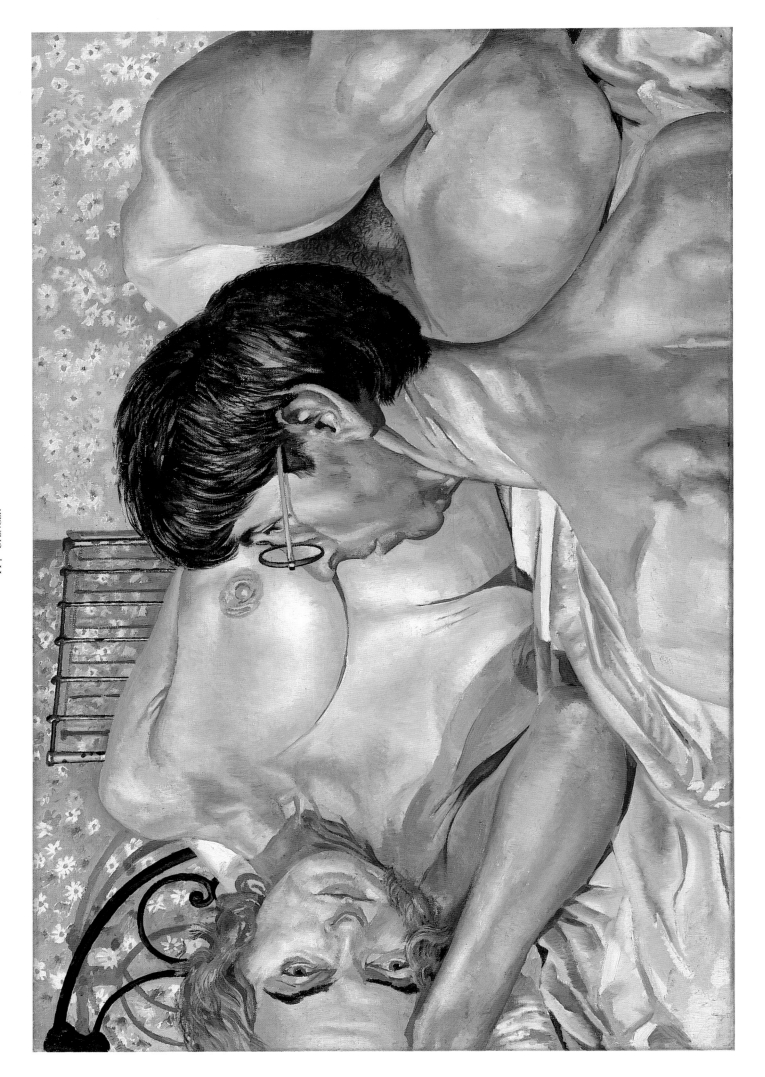

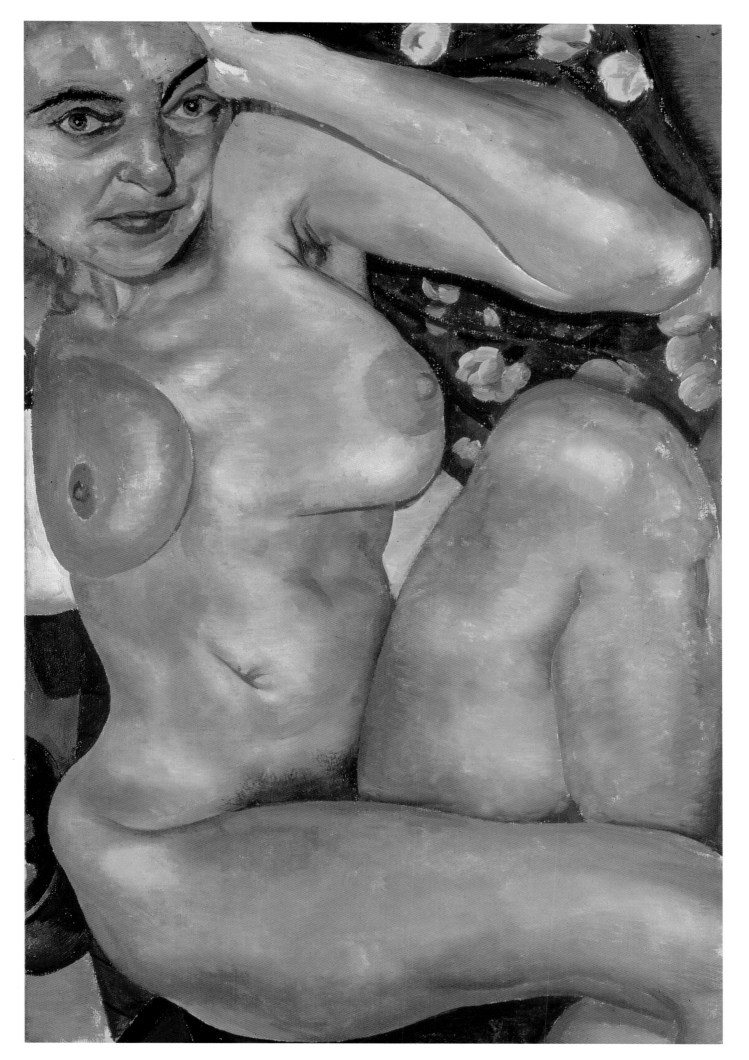

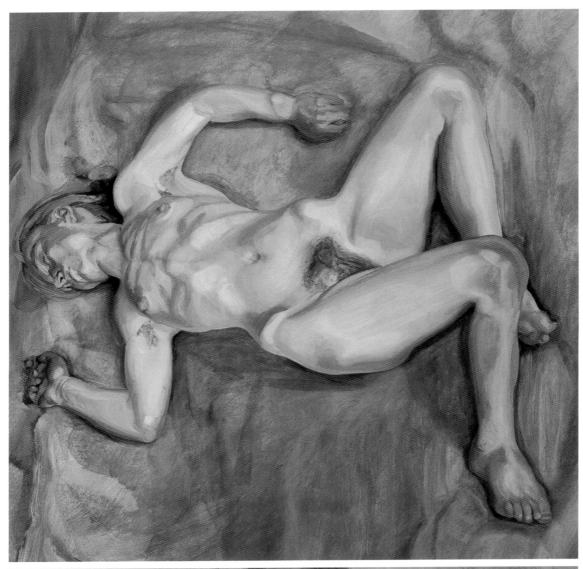

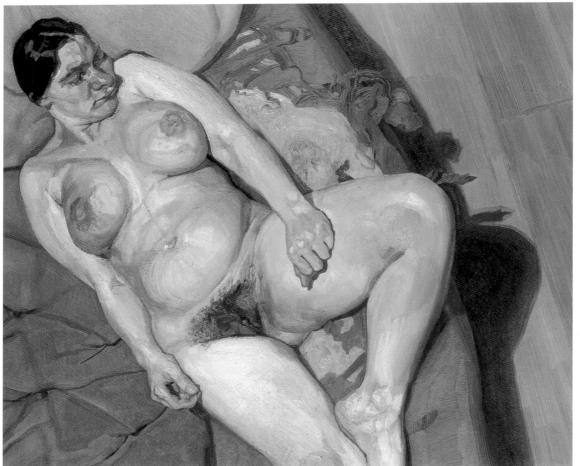

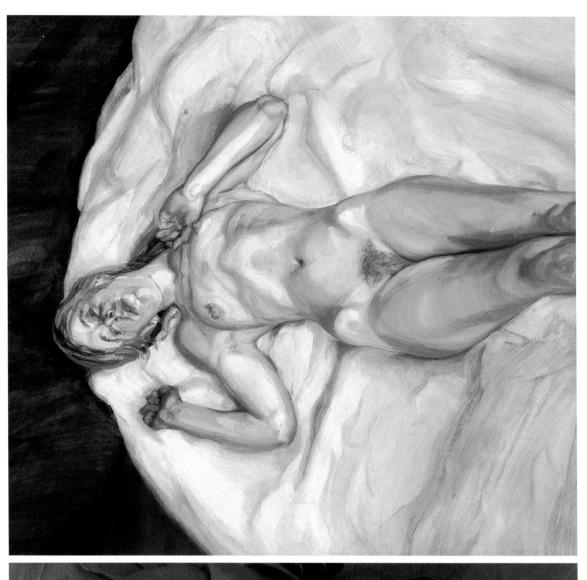

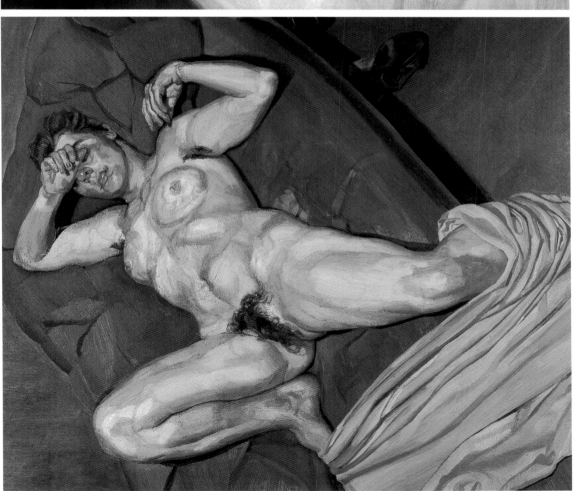

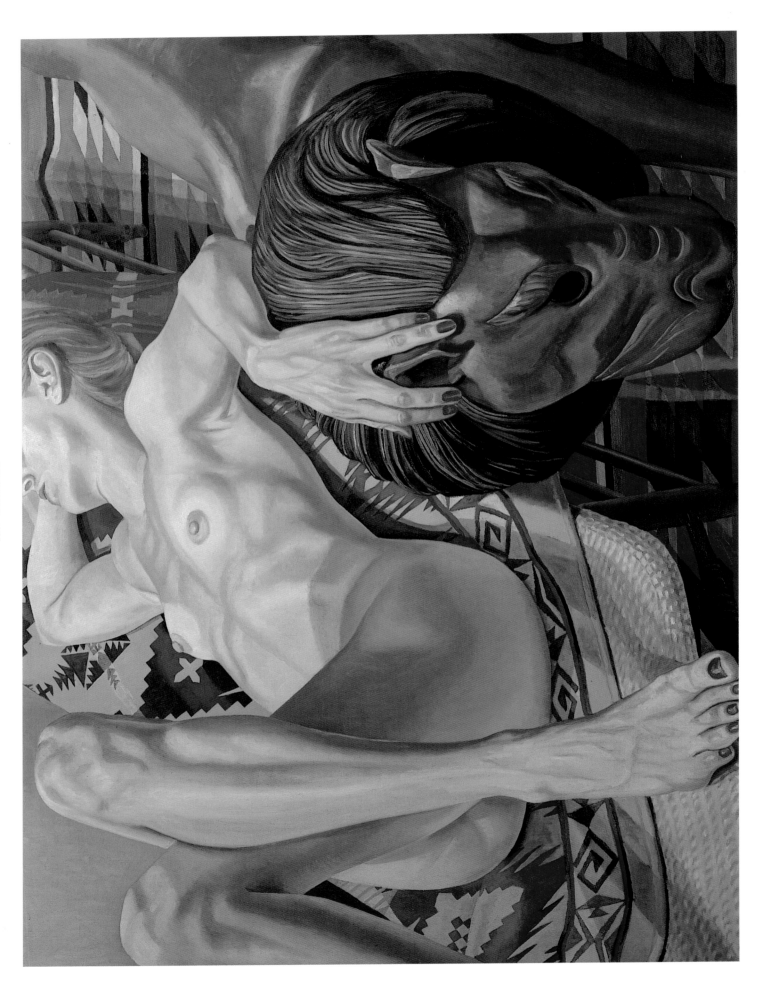

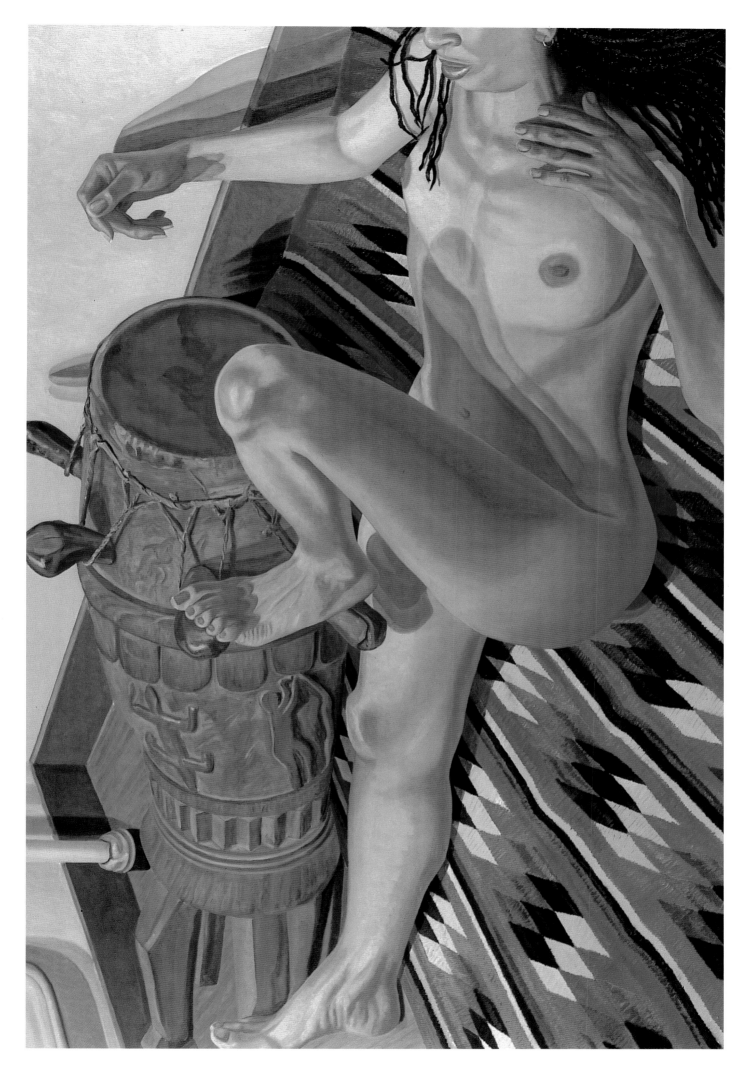

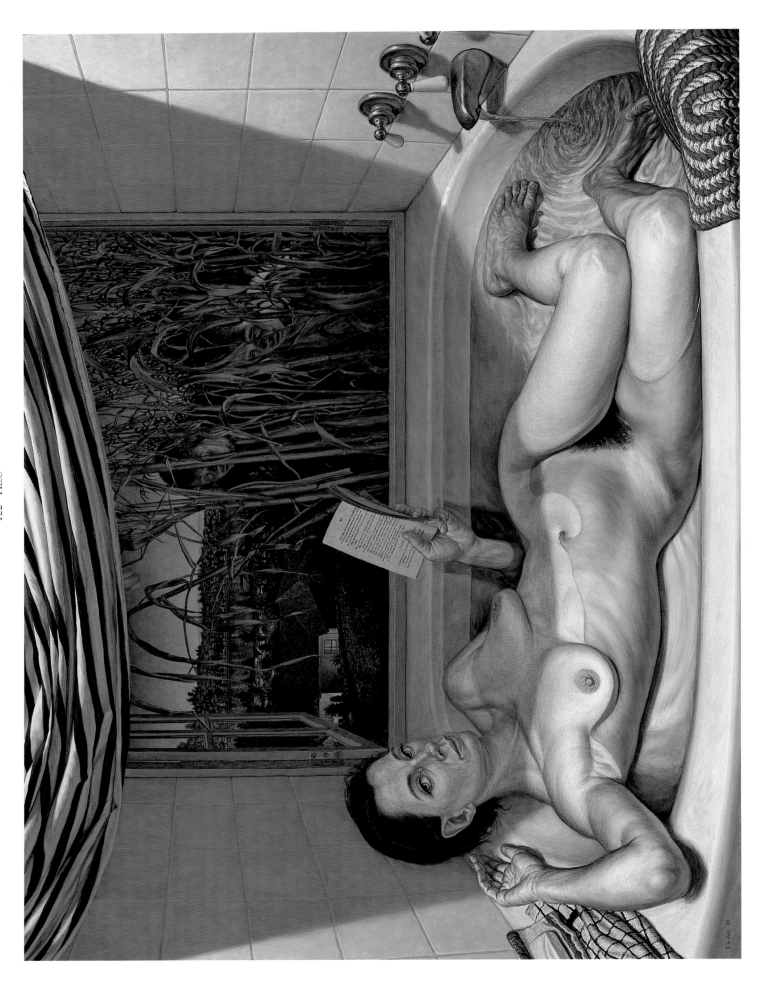

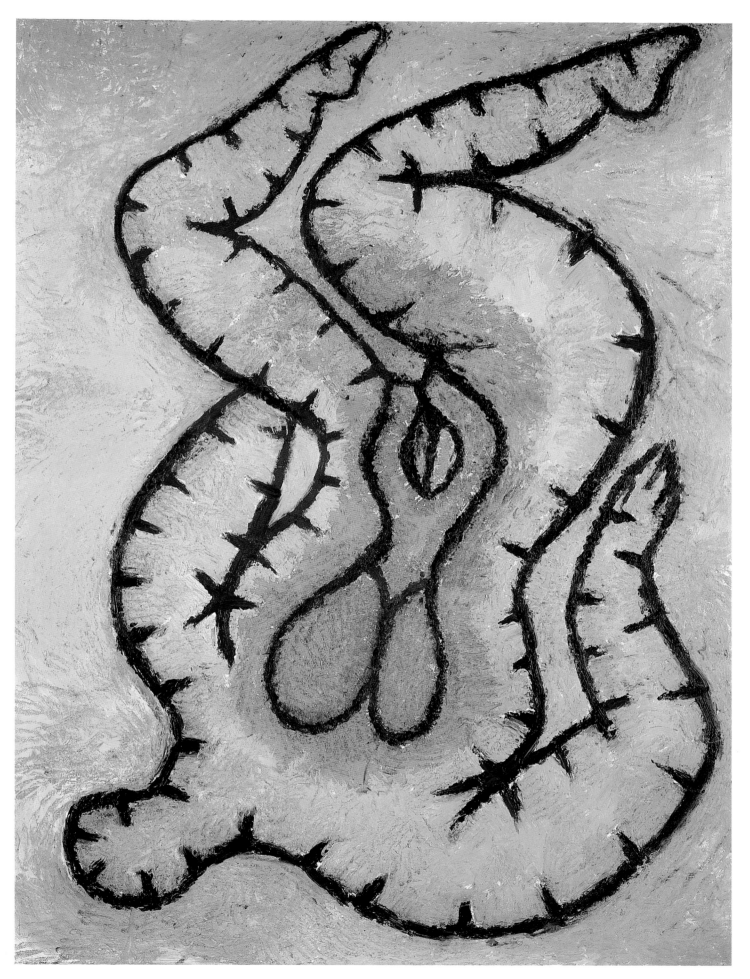

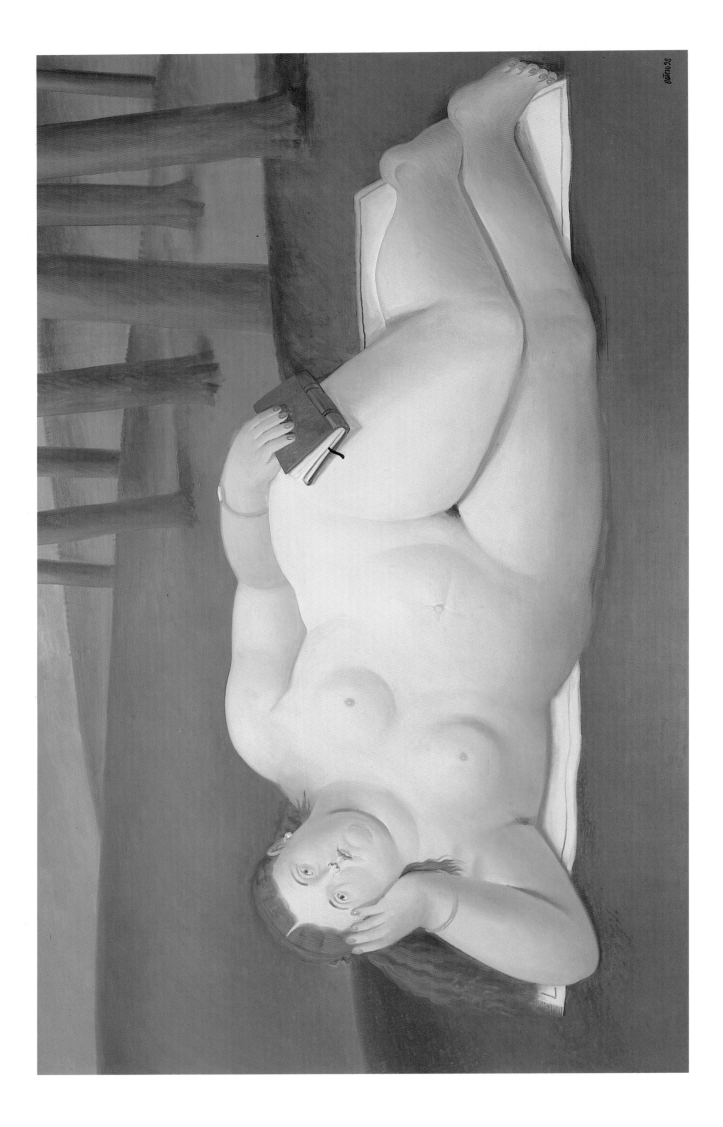

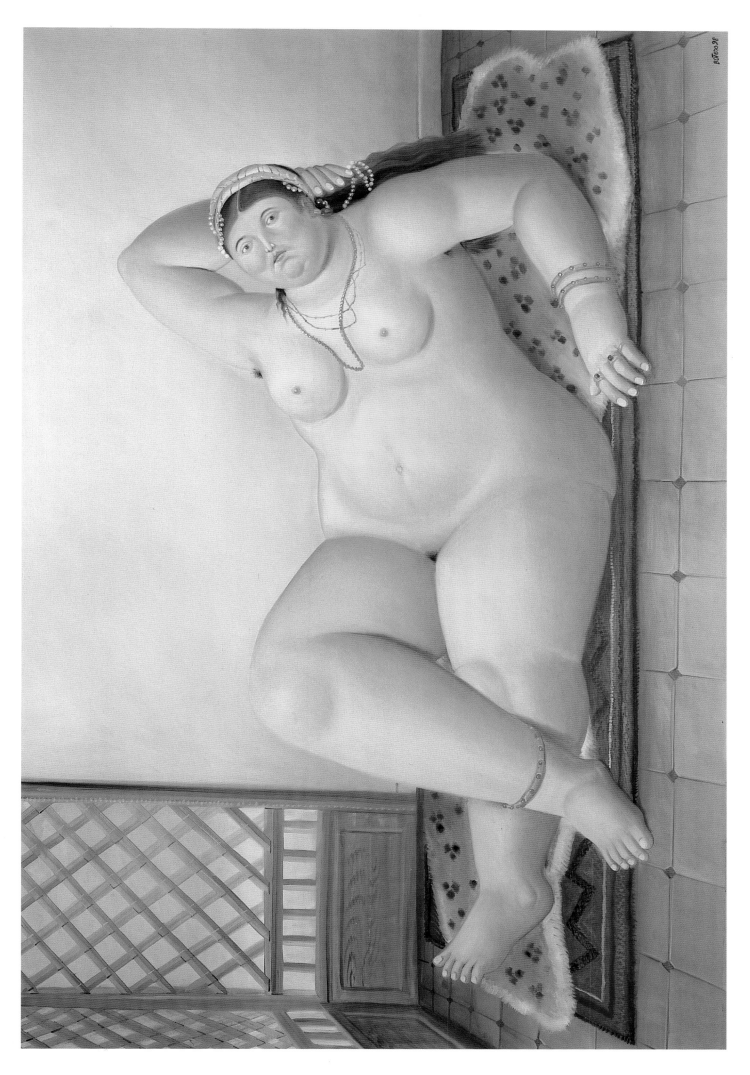

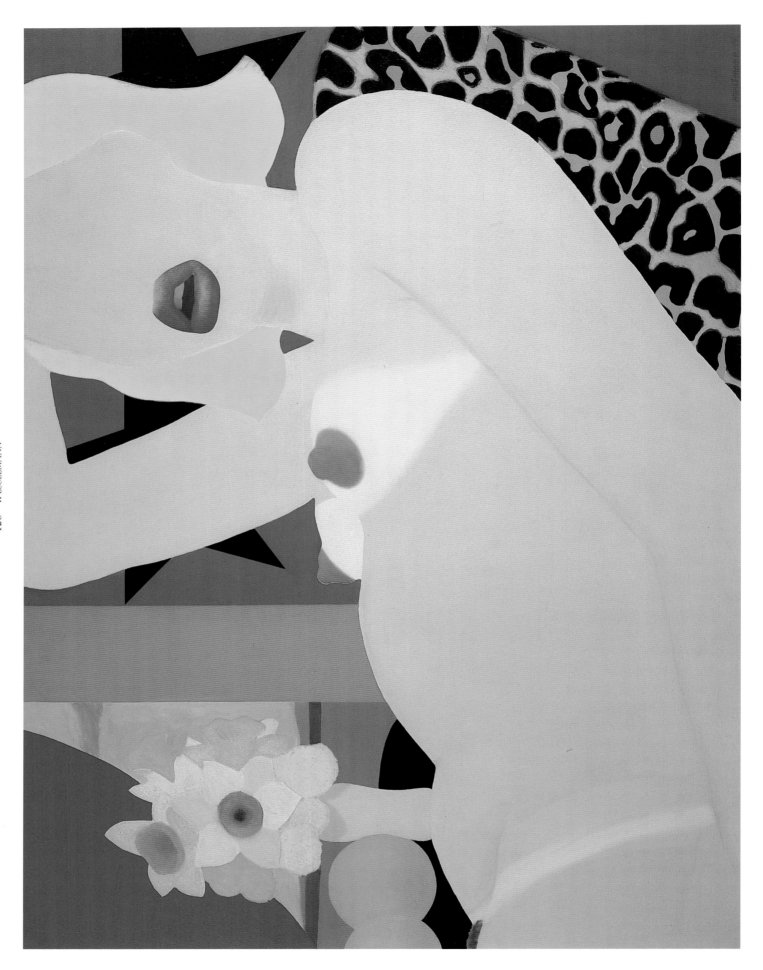

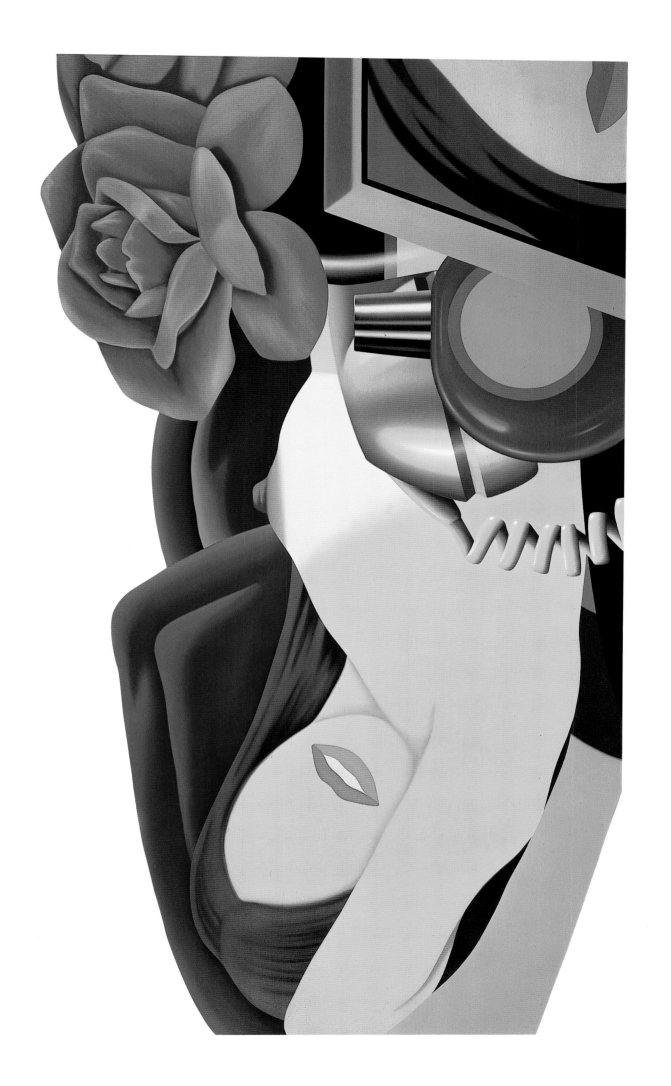

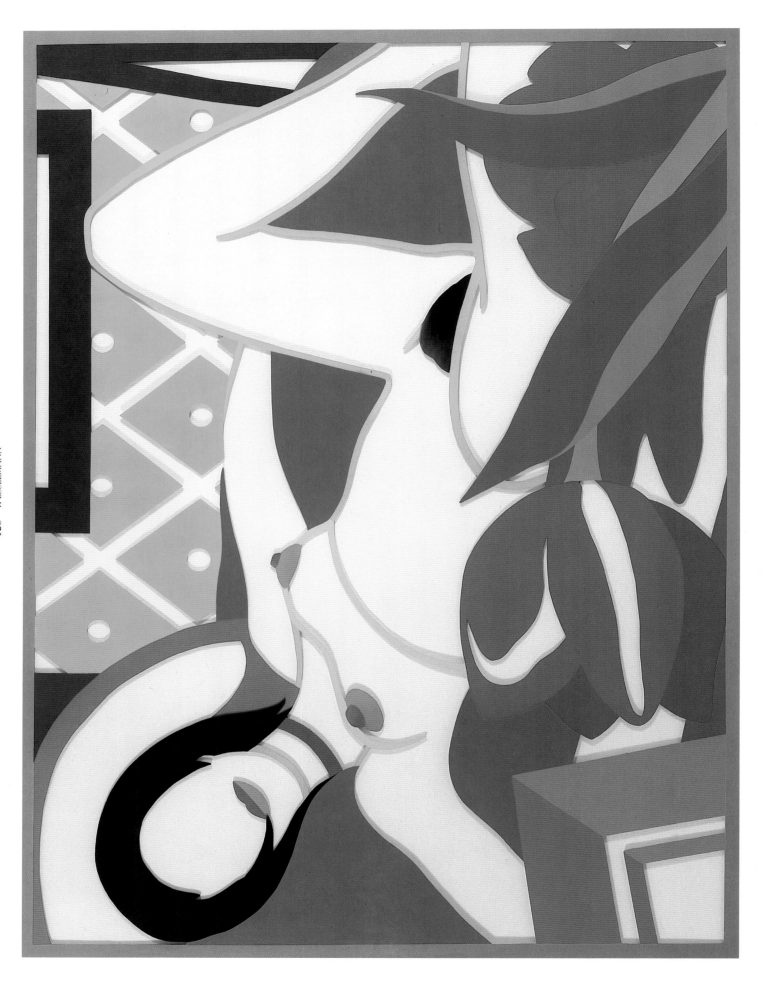

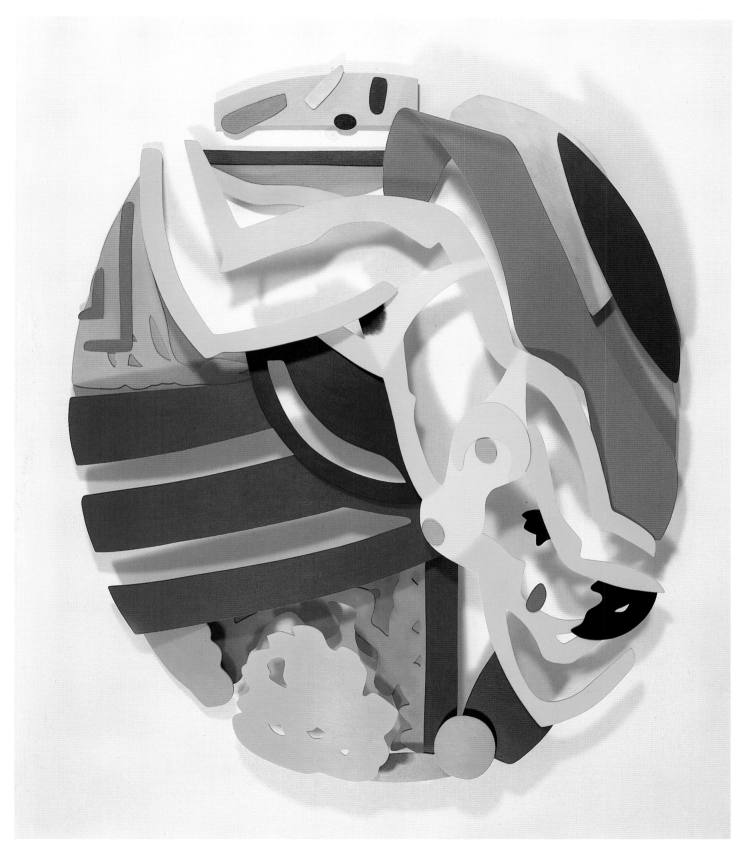

LIST OF ILLUSTRATIONS

Dimensions of works are given in centimetres and inches, height before width.
Grouped illustrations are numbered from left to right.

44. FREDERICK CARL FRIESEKE, *Autumn*, 1914. Museo d'Arte Moderna di Ca' Pesaro, Venice/Bridgeman Art Library.

45. SUZANNE VALADON, *The Future Unveiled*, 1912. Oil on canvas, 130 x 163 (51⅛ x 64⅛). Petit Palais, Musée d'Art Moderne, Geneva. © ADAGP, Paris and DACS, London 2002.

46. SUZANNE VALADON, *Reclining Nude on a Sofa*, 1928. Oil on canvas, 72 x 160 (28⅜ x 63). Private collection. Photo © Christie's Images Ltd 2002. © ADAGP, Paris and DACS, London 2002.

47. WILLIAM GLACKENS, *Nude with Apple*, 1910. Oil on canvas, 103.2 x 106 (40⅝ x 57½). Brooklyn Museum of Art, New York, Dick S. Ramsay Fund 56.70. © Estate of the artist, represented by Kraushaar Galleries, New York.

48. FÉLIX VALLOTTON, *The Sleep*, 1908. Oil on canvas, 114.5 x 162.5 (45⅛ x 64). Musée d'Art et d'Histoire, Geneva.

49. MARGUERITE ZORACH, *Nude Reclining*, 1922. Oil on canvas, 74 x 76.8 (29⅛ x 30¼). The National Museum of Women in the Arts, Washington, D.C., Gift of Wallace and Wilhelmina Holladay. © Estate of the artist, represented by Kraushaar Galleries, New York.

50. ANDRÉ LHOTE, *Bacchante*, 1910. Oil on canvas, 105 x 103 (41⅛ x 40½). Petit Palais, Musée d'Art Moderne, Geneva. © ADAGP, Paris and DACS, London 2002.

51. ODILON REDON, *The Cyclops*, c. 1914. Oil on canvas, 64 x 51 (25¼ x 20⅛). Collection State Museum Kröller-Müller, Otterlo.

52. GUSTAVE MOREAU, *Galatea*, 1896. Oil and tempera on cardboard, 45 x 34 (17¾ x 13⅜). © Museo Thyssen-Bornemisza, Madrid.

53. HENRI FANTIN-LATOUR, *Helen* (detail), 1892. Oil on canvas, 78.5 x 105 (30¾ x 41⅜). © Photothèque des Musées de la Ville de Paris/Photo – Pierrain.

54. HENRI ROUSSEAU, *The Dream*, 1910. Oil on canvas, 204.5 x 298.5 (80½ x 117½). The Museum of Modern Art, New York, Gift of Nelson A. Rockefeller. Photograph © 2002 The Museum of Modern Art/Scala.

55. ARNOLD BÖCKLIN, *Calm Sea*, 1887. Oil on canvas, 104.1 x 152.4 (41 x 60). Kunstmuseum Bern.

56. PAUL GAUGUIN, *Manau Tupapau (The Spirit of the Dead Keeps Watch)*, 1892. Oil on canvas, 73 x 92 (28¾ x 36¼). Albright-Knox Art Gallery, Buffalo, New York, A. Conger Goodyear Collection.

57. PAUL GAUGUIN, *Nevermore, O Tahiti*, 1897. Oil on canvas, 60 x 116 (23⅝ x 45¾). Courtauld Institute Galleries, London.

58. ERNST LUDWIG KIRCHNER, *Girl under a Japanese Parasol*, c. 1909. Oil on canvas, 92.5 x 80.5 (36⅜ x 31¾). Kunstsammlung Nordrhein-Westfalen, Düsseldorf. © Photo AKG London/Erich Lessing. © by Dr Wolfgang & Ingeborg, Henze-Ketterer, Wichtrach/Bern.

59. ERNST LUDWIG KIRCHNER, *Reclining Nude with Mirror*, 1910. Oil on canvas, 83.3 x 95.5 (32¾ x 37⅝). Brücke Museum, Berlin.

© by Dr Wolfgang & Ingeborg, Henze-Ketterer, Wichtrach/Bern.

60. EDVARD MUNCH, *Reclining Female Nude*, 1912–13. Oil on canvas, 80 x 100 (31½ x 39⅜). Hamburger Kunsthalle, Hamburg/Bridgeman Art Library. © Munch Museum/Munch – Ellingsen Group, BONO, Oslo, DACS, London 2002.

61. MIKHAIL LARIONOV, *The Katsap Venus*, 1912. Oil on canvas, 99.5 x 129.5 (39⅛ x 51). The State Museum of Art, Nizhny Novgorod. © ADAGP, Paris and DACS, London 2002.

62. EGON SCHIELE, *Reclining Woman*, 1917. Oil on canvas, 96 x 171 (37¾ x 67⅞). Leopold Collection, Vienna. Photo AKG London/Erich Lessing.

63. EGON SCHIELE, *Two Women*, 1915. Watercolour, 32.8 x 49.7 (12¾ x 19½). Graphische Sammlung Albertina, Vienna.

64. MOÏSE KISLING, *Nude of Arletty*, 1933. Oil on canvas, 98 x 195 (38⅝ x 76¾). Petit Palais, Musée d'Art Moderne, Geneva. © ADAGP, Paris and DACS, London 2002.

65. MOÏSE KISLING, *Large Red Nude*, 1949. Oil on canvas, 95 x 165 (37⅜ x 65). Petit Palais, Musée d'Art Moderne, Geneva. © ADAGP, Paris and DACS, London 2002.

66. AMEDEO MODIGLIANI, *Reclining Nude on a White Cushion*, 1917–18. Oil on canvas, 60 x 92 (23⅝ x 36¼). Staatsgalerie Stuttgart.

67. AMEDEO MODIGLIANI, *Reclining Nude with Arm Folded across Her Forehead*, 1917. Oil on canvas, 65 x 100 (25⅝ x 39⅜). Collection Richard S. Zeiler, New York. Photo AKG London.

68. AMEDEO MODIGLIANI, *Reclining Nude with Necklace*, 1917.

69. AMEDEO MODIGLIANI, *Nude with Coral Necklace*, 1917. Oil on canvas, 73 x 116 (28¾ x 45⅝). Solomon R. Guggenheim Museum, New York.

69. AMEDEO MODIGLIANI, *Nude with Coral Necklace*, 1917. Oil on canvas, 66.4 x 99.4 (25⅛ x 39¼). © Allen Memorial Art Museum, Oberlin College, Oberlin, Ohio, Gift of Joseph and Enid Bissett, 1955.

70. AMEDEO MODIGLIANI, *Nude on a Blue Cushion*, 1917. Oil on linen, 65.4 x 100.9 (25¾ x 39¾). Chester Dale Collection, National Gallery of Art, Washington, D.C. Photograph © 2002 Board of Trustees, National Gallery of Art, Washington.

71. UMBERTO BOCCIONI, *Simultaneous Nude*, 1915. Oil on canvas, 52 x 82 (20½ x 32¼). Collection Tominelli, Milan. © Photo Scala.

72. GIORGIO DE CHIRICO, *Nude of Woman on the Beach*, 1932. Oil on canvas, 135 x 171 (53⅛ x 67⅜). Galleria Nazionale d'Arte Moderna, Rome. By permission of the Ministero per i Beni e le Attività Culturali. © Photo G. Schiavinotto. © DACS 2002.

73. FELICE CASORATI, *Midday*, 1922. Museo Revoltella, Trieste. © Photo Scala. © DACS 2002.

74. RAM (RUGGERO ALFREDO MICHAELLES), *Large Nude of Young Women, no. 2*, 1927. Oil on canvas, 91 x 97 (35⅞ x 38¼). Società di Belle Arti, Viareggio.

75. TAMARA DE LEMPICKA, *The Two Friends*, 1923. Oil on canvas, 130 x 160 (51⅛ x 63). Petit Palais, Musée d'Art Moderne, Geneva. © ADAGP, Paris and DACS, London 2002.

76. TAMARA DE LEMPICKA, *Beautiful Rafaela*, c. 1970. Oil on canvas, 53.3 x 75.8 (21 x 29⅞). Private collection. Photo © Christie's Images Ltd, 2002. © ADAGP, Paris and DACS, London 2002.

77. MARK GERTLER, *The Queen of Sheba*, 1922. Oil on canvas, 94 x 107 (37 x 42⅛). Photo © Tate, London 2002. Reproduced by permission of Luke Gertler.

78. CHARLES WHEELER, *And So the Story Ends*, c. 1927. Oil on canvas, 58.2 x 101.6 (22⅞ x 40). Art Gallery of South Australia, Adelaide, Morgan Thomas Bequest Fund 1927. Charles Wheeler Estate.

79. FRANCESCO MENZIO, *Reclining Nude on a Red Background*, 1928. Oil on canvas, 75 x 100 (29½ x 39⅜). Carlina Galleria d'Arte, Turin.

80. FRANÇOIS DESNOYER, *Reclining Nude*. Oil on canvas, 59 x 92 (23¼ x 36¼). Musée Bonnat, Bayonne. © Photo RMN – R.G. Ojeda.

81. HENRI MATISSE, *Odalisques*, 1928. Oil on canvas, 54 x 65 (21¼ x 25⅝). Moderna Museet, Stockholm. © Succession H. Matisse/DACS 2002.

82. HENRI MATISSE, *Blue Nude*, 1907. Oil on canvas, 92.1 x 140.4 (36¼ x 55¼). The Baltimore Museum of Art. The Cone Collection, formed by Dr Claribel Cone and Miss Etta Cone of Baltimore, Maryland. © Succession H. Matisse/DACS 2002.

83. HENRI MATISSE, *Sleeping Nude from the Back*, 1927. Oil on canvas. Private collection, Paris. © Succession H. Matisse/DACS 2002.

84. HENRI MATISSE, *Pink Nude*, 1935. Oil on canvas, 66 x 92.7 (26 x 36½). The Baltimore Museum of Art. The Cone Collection, formed by Dr Claribel Cone and Miss Etta Cone of Baltimore, Maryland. © Succession H. Matisse/DACS 2002.

85. ANDRÉ DERAIN, *Nude on a Sofa*, 1931. Oil on canvas, 83 x 183 (32⅝ x 72). Musée de l'Orangerie, Paris. © Photo RMN – F. Raux. © ADAGP, Paris and DACS, London 2002.

86. MAX BECKMANN, *Reclining Nude*, 1927. Oil on canvas, 83.5 x 119 (32⅞ x 46⅞). Joseph Winterbotham Collection, 1988.220. Photograph © 2002, The Art Institute of Chicago, All Rights Reserved. © DACS 2002.

87. RAOUL DUFY, *The Artist and His Model in the Le Havre Studio*, 1929. Oil on canvas, 130 x 165 (51⅛ x 65). Haags Gemeentemuseum, The Hague. © ADAGP, Paris and DACS, London 2002.

88. RAOUL DUFY, *Female Nude*, 1930. Oil on canvas, 46 x 55 (18⅛ x 21⅝). Musée d'Art Moderne, Troyes. © Photo RMN – Gérard Blot. © ADAGP, Paris and DACS, London 2002.

89. MARC CHAGALL, *To My Wife*, 1933–44. Oil on canvas, 131 x 194 (51⅝ x 76⅜). Centre Pompidou-MNAM-CCI, Paris. © Photo CNAC/MNAM Dist. RMN. © ADAGP, Paris and DACS, London 2002.

90. MARC CHAGALL, *Reclining Nude*, 1914. Oil on board, 36.8 x 50.2 (14½ x 19¾). Private collection. Photo © Christie's Images, London/Bridgeman Art Library. © ADAGP, Paris and DACS, London 2002.

91. RENÉ MAGRITTE, *Bather between Light and Dark*, 1935. Private collection, Brussels. © ADAGP, Paris and DACS, London 2002.

92. RENÉ MAGRITTE, *Collective Invention*, 1935. Oil on canvas, 73.5 x 116 (28⅞ x 45⅝). Private collection, Belgium. © ADAGP, Paris and DACS, London 2002.

93. PAUL DELVAUX, *The Acropolis*, 1966. Oil on canvas, 150 x 230 (59 x 90½). Centre Pompidou-MNAM-CCI, Paris. © Photo CNAC/MNAM Dist. RMN. © Foundation P. Delvaux – St Idesbald, Belgium/DACS, London 2002.

94. PAUL DELVAUX, *The Public Voice*, 1948. Oil on panel, 152.5 x 254 (60 x 100). Musées Royaux des Beaux-Arts de Belgique. © Fondation P. Delvaux – St Idesbald, Belgium/DACS, London 2002.

95. MAN RAY (EMMANUEL RADNITZKY) *Pisces*, 1938. Oil on canvas, 60 x 73 (23⅝ x 26¾). Photo © Tate, London 2002. © Man Ray Trust/ADAGP, Paris and DACS, London 2002.

96. MAX ERNST, *The Garden of France*, 1962. Oil on canvas, 114 x 168 (44⅞ x 66⅛). Centre Pompidou-MNAM-CCI, Paris. © Photo CNAC/MNAM Dist. RMN. © ADAGP, Paris and DACS, London 2002.

97. SALVADOR DALÍ, *One Second before Awakening from a Dream Provoked by the Flight of the Bee*, 1944. Oil on panel, 51 x 41 (20⅛ x 16⅛). © Museo Thyssen-Bornemisza, Madrid. © Salvador Dalí, Gala-Salvador Dalí Foundation, DACS, London 2002.

98. MARCEL DUCHAMP, *Étant donnés: 1. La Chute d'eau 2. Le Gaz d'éclairage* (*Given: 1. The Waterfall 2. The Illuminating Gas*), 1946–66. View through door. Mixed media assemblage, approximately 242.5 x 177.8 x 124.5 (95¼ x 70 x 49). Philadelphia Museum of Art, Gift of the Cassandra Foundation. © Succession Marcel Duchamp/ADAGP, Paris and DACS, London 2002.

99. FRANCIS PICABIA, *Woman with a Dog*, 1924–26. Gouache on board, 72.5 x 92 (28½ x 36¼). Private collection. Photo © Christie's Images Ltd 2002. © ADAGP, Paris and DACS, London 2002.

100. ANDRÉ MASSON, *The Earth*, 1939. Sand and oil on plywood, 43 x 53 (16⅞ x 20⅞). Centre Pompidou-MNAM-CCI, Paris. © Photo CNAC/MNAM Dist. RMN. © ADAGP, Paris and DACS, London 2002.

101. VICTOR BRAUNER, *The Triumph of Doubt*, 1946. Oil, ink, wax, and encaustic on canvas, 82 x 101 (32¼ x 39¾). The Menil Collection, Houston, Texas. © Photo Hickey-Robertson, Houston, Texas. © ADAGP, Paris and DACS, London 2002.

102. PABLO PICASSO, *L'Aubade* (*Dawn Serenade*), 1942. Oil on canvas, 195 x 265.4 (76¾ x 103⅜). Musée National d'Art Moderne, Paris. © Photo Scala. © Succession Picasso/DACS 2002.

103. PABLO PICASSO, *Sleeping Nude*, 4 April 1932. Oil on canvas, 130 x 161.7 (51⅛ x 63⅝). Musée Picasso, Paris. © Photo RMN – R.G. Ojeda. © Succession Picasso/DACS 2002.

104. PABLO PICASSO, *Reclining Woman with a Cat*, 1964. Oil on canvas, 130 x 195 (51⅛ x 76¾). Collection Gallerie Louise Leiris, Paris. © Photo Scala. © Succession Picasso/DACS 2002.

105. PABLO PICASSO, *Large Nude Lying on a Bed*, 28 June 1943. Oil on canvas, 130 x 195.5 (51⅛ x 77). Musée Picasso, Paris. © Photo RMN – J.G. Berizzi. © Succession Picasso/DACS 2002.

106. PABLO PICASSO, *Reclining Nude and Man Playing the Guitar*, 27 October 1970. Oil on canvas, 130 x 195 (51⅛ x 76¾). Musée Picasso, Paris. © Photo RMN – J.G. Berizzi. © Succession Picasso/DACS 2002.

107. FERNAND LÉGER, *Three Women*, 1921. Oil on canvas, 183.5 x 251.5 (72¼ x 99). The Museum of Modern Art, New York. Mrs Simon Guggenheim Fund. Photograph © 2002 The Museum of Modern Art/Scala. © ADAGP, Paris and DACS, London 2002.

108. JEAN HÉLION, *Upside-Down*, 1947. Oil on canvas, 113.5 x 146 (44⅝ x 57½). Centre Pompidou-MNAM-CCI, Paris. © Photo CNAC/MNAM Dist. RMN. © ADAGP, Paris and DACS, London 2002.

109. FRANCIS BACON, *Henrietta Moraes*, 1966. Oil on canvas, 152 x 147 (59⅞ x 57½). Private collection, London. © Estate of Francis Bacon 2002. All rights reserved, DACS.

110. MARTIAL RAYSSE, *Made in Japan*, 1964. Photomechanical reproductions and wallpaper with airbrush ink, gouache, pen and ink, tacks, peacock feathers, and plastic flies on paper mounted on fibreboard, 129.9 x 244.5 (51⅛ x 96¼). Hirshhorn Museum and Sculpture Garden, Smithsonian Institution, Washington D.C., Gift of Joseph H. Hirshhorn, 1972. © ADAGP, Paris and DACS, London 2002.

111. BALTHUS (BALTHASAR KLOSSOWSKI DE ROLA), *Nude with a Cat*, 1949–50. Oil on canvas, 65.1 x 80.5 (25⅝ x 31¼). Melbourne, National Gallery of Victoria. Felton Bequest, 1952. © ADAGP, Paris and DACS, London 2002.

112. BALTHUS (BALTHASAR KLOSSOWSKI DE ROLA), *Large Composition with a Crow*, 1983–86. Oil on canvas, 200 x 150 (78¾ x 59). Private collection. © ADAGP, Paris and DACS, London 2002.

113. BALTHUS (BALTHASAR KLOSSOWSKI DE ROLA), *Nude with a Guitar*, 1983–86. Oil on canvas, 162 x 130 (63¾ x 51⅛). Private collection, New York. © ADAGP, Paris and DACS, London 2002.

114. STANLEY SPENCER, *Self-Portrait with Patricia Preece*, 1936. Oil on canvas, 61 x 91.2 (24 x 35⅞). Fitzwilliam Museum, Cambridge. © Estate of Stanley Spencer 2002. All Rights Reserved, DACS.

115. STANLEY SPENCER, *Nude (Patricia Preece)*, 1935. Oil on canvas, 51 x 76 (20⅛ x 29⅞). Private collection, courtesy of Ivor Braka Ltd, London. © Estate of Stanley Spencer 2002. All Rights Reserved, DACS.

116. LUCIAN FREUD, *Naked Portrait*, 1980–81. Oil on canvas, 90 x 75 (35⅛ x 29½). Private collection. © the artist.

117. LUCIAN FREUD, *Naked Girl Asleep II*, 1968. Oil on canvas, 55.8 x 55.8 (22 x 22). Private collection. © the artist.

118. LUCIAN FREUD, *Rose*, 1978–79. Oil on canvas, 91.5 x 78.5 (36 x 30⅞). Sukejiro Itani, Tokyo. © the artist.

119. LUCIAN FREUD, *Naked Girl*, 1966. Oil on canvas, 61 x 61 (24 x 24). Private collection. © the artist.

120. PHILIP PEARLSTEIN, *Model with Crossed Legs and Luna Park Lion*, 1998. Oil on canvas, 92.1 x 121.9 (36¼ x 48). Courtesy Robert Miller Gallery, New York. © Philip Pearlstein.

121. PHILIP PEARLSTEIN, *Model with Dreadlocks, Navaho Blanket and Old African Drum*, 1999. Oil on canvas, 101.6 x 152.4 (40 x 60). Courtesy Robert Miller Gallery, New York. © Philip Pearlstein.

122. F. SCOTT HESS, *The Open Window*, 1997. Oil and egg tempera on canvas, 121.9 x 162.6 (48 x 64). Private collection, courtesy Hackett-Freedman Gallery.

123. GWEN HARDIE, *Venus with Spikes*, 1986. Oil on canvas, 150 x 200 (59 x 78¾). Fundação Calouste Gulbenkian, Lisbon, Centro de Arte Moderna José de Azeredo Perdigão. Photograph Mário de Oliveira/Arq. Fot. CAM/AP. Copyright courtesy of Gwen Hardie.

124. FERNANDO BOTERO, *Reclining Woman with Book*, 1998. Oil on canvas, 128 x 205 (50⅜ x 80¾). Private collection. Photo courtesy the artist.

125. FERNANDO BOTERO, *Odalisque*, 1998. Oil on canvas, 135 x 200 (53⅛ x 78¾). Private collection. Photo courtesy the artist.

126. TOM WESSELMANN, *Great American Nude No. 57*, 1964. Synthetic polymer on composition board, 121.9 x 165.1 (48 x 65). Purchase, with funds from the Friends of the Whitney Museum of American Art. Collection of the Whitney Museum of American Art, New York. Photo by Geoffrey Clements. © Tom Wesselmann/VAGA, New York/DACS, London 2002.

127. TOM WESSELMANN, *Great American Nude 1977*, 1977. Oil on canvas, 138.4 x 238.8 (54½ x 94). © Tom Wesselmann/VAGA, New York/DACS, London 2002.

128. TOM WESSELMANN, *Monica with Tulips (variation)*, 1989–93. Alkyd oil on cut-out aluminium, 148.6 x 196.9 (58½ x 77½). © Tom Wesselmann/VAGA, New York/DACS, London 2002.

129. TOM WESSELMANN, *Nude Lying Back*, 1993. Oil on cut-out aluminium, 154.9 x 193 x 20.3 (61 x 76 x 8). © Tom Wesselmann/VAGA, New York/DACS, London 2002.